Contemporary Botanical Illustration
with the Eden Project

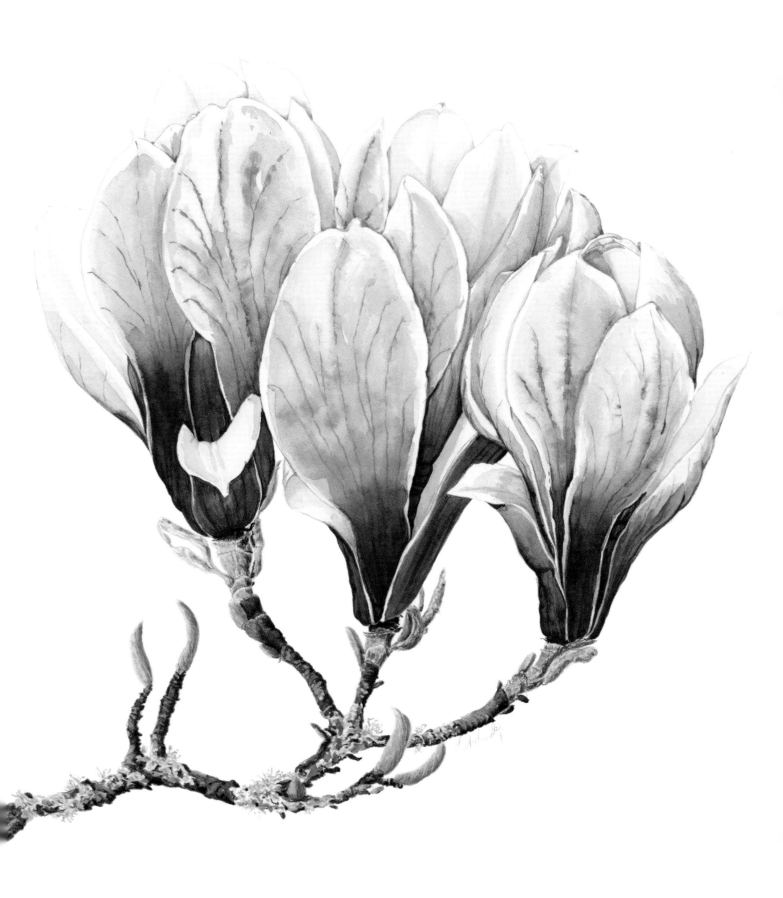

Contemporary Botanical Illustration with the Eden Project

Rosie Martin & Meriel Thurstan

BATSFORD

Dedication

For all my students, who teach me what I need to know

First published in the United Kingdom in 2008 by
Batsford
10 Southcombe Street
London W14 0RA

An imprint of Anova Books Company Ltd

ISBN-13: 9780713490787

A CIP catalogue record for this book is available from
the British Library.

10 9 8 7 6 5 4 3 2 1

Reproduction by Mission Productions Ltd, Hong Kong
Printed and bound by Craft Print Ltd, Singapore

This book can be ordered direct from the publisher at the website:
www.anovabooks.com, or try your local bookshop

Distributed in the United States and Canada
by Sterling Publishing Co.,
387 Park Avenue South, New York, NY 10016, USA

Page 2: The texture of waxy magnolia petals contrasts with velvety buds and dry lichen.

Opposite: The seeds of *Iris foetidissima* glow shiny red in autumn and are a good example of how to paint highlights.

Contents

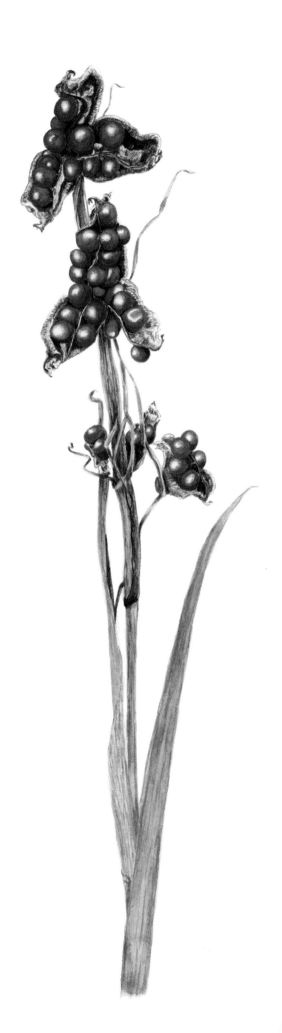

Foreword

Botanical illustration is one of those arts that many people enjoy yet feel is out of their reach as potential practitioners. Not so – it is a teachable art! I have been privileged to see many aspiring artists start and then progress to excellence. This was at Chelsea Physic Garden, where the first Florilegium Society was started by Margaret King while I was Curator in the 1990s. I knew that the paintings were likely to become a valuable on-going archive of the plants growing at the Garden. It was in the tradition of great illustrators who had used Chelsea Physic's plant collections, such as Georg Dionysius Ehret, Elizabeth Blackwell and William Curtis in the 18th century. Many original botanical illustrations were used in the Garden's annual reports in my time there and it was a joy to see artists' work acknowledged.

When it was suggested that a Florilegium Society should be started at the Eden Project, I knew that this could be especially valuable if artists worked on a yearly, thematic basis. And so it has proved, with artists honing their skills, for example, on tropical fruit, some of which can now be seen in the fruit exhibit in the Rainforest Biome.

Clearly, botanical art serves a much-needed purpose. The eye of the illustrator can be taught to record accurately both the detail and the spirit of the plant. With a little guidance from botanists on which parts of the plant are key to determining the species, their art can document in a way that is otherwise impossible except by the latest techniques of complex, composite digital photography.

As well as being a useful art, botanical illustration gives huge pleasure – and indeed profit – to its practitioners, as evidenced by the growing number of societies throughout the country, such as the South West Society of Botanical Artists founded by Meriel Thurstan and Rosie Martin in 2006. The company and advice of other artists can be of great value while talks, workshops and exhibitions can be arranged to reach as wide an audience as possible.

Courses on botanical illustration are now springing up freely. At Chelsea Physic it is second only to garden design as a discipline in demand. Perhaps this is in response to a desire to step away from a busy lifestyle, slow down and really look at beautiful, living plants; for one of the advantages of a 'good eye' is an expansion in perception and consequently of appreciation.

Below: Often a flower's colour will be echoed in the leaves.

This is the second book written by Rosie and Meriel, based on the botanical illustration courses run at the Eden Project. Like its predecessor, it is an excellent primer of the best advice available and I can heartily recommend it. There are many examples of students' work here, reproduced to a very high standard. Clearly botanical art, as well as having a distinguished history, is firmly set as a truly contemporary art.

Sue Minter
Horticultural Director, Eden Project 2001–2006

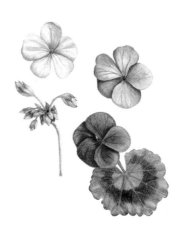

What's in this book?

In this book you will discover many secrets of contemporary botanical illustration from painting black flowers or learning about challenging textures and patterns to advice on mixing difficult and elusive colours such as the neon pink of *Lychnis coronaria* (rose campion) or pale blue-green such as the leaves of helichrysum – and all with a limited palette of colours. You will also learn about how to set up a workplace, which materials to use, painting techniques, tonal evaluation, subjective and objective colour, sketchbook practice and contemporary composition.

With time and lots of practice, there is nothing to prevent anyone, whether a beginner or with some experience, from becoming a competent botanical artist. All you need is the will and, perhaps, some expert guidance. Indeed, there is no better way of becoming a botanical artist than by joining a group or class, where the interaction of fellow students is of inestimable value. Not everyone, though, is able to do this. Our book takes you through the aspects of botanical illustration that are covered on our courses and sets out to describe some of the problems you will encounter on your journey. More importantly, it will make you aware of what you are trying to achieve and how to succeed. It gives you choices and encourages you to make your own decisions, thus improving your observational, technical and general artistic skills.

Right: As with other blue flowers, it is important to use the right shade of blue. Does this painting use cool blues or a warm blues? Read on to learn which is which!

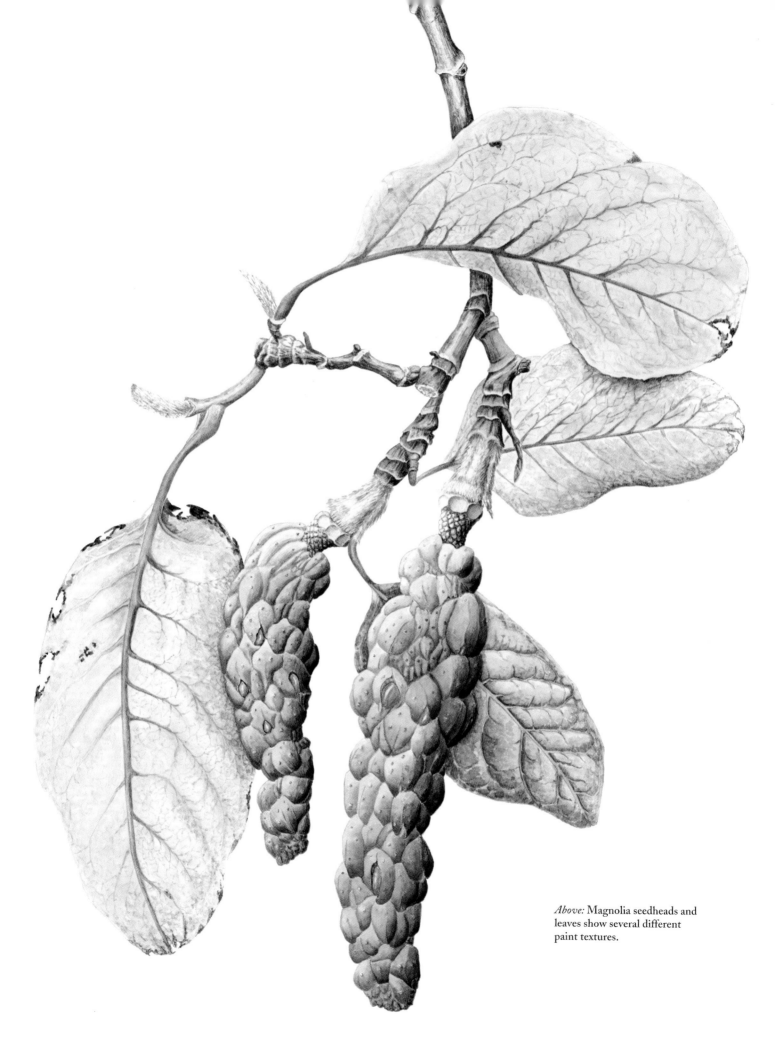

Above: Magnolia seedheads and leaves show several different paint textures.

Introduction

First of all, we need to discuss what is meant by botanical illustration, and whether or not it is the same as botanical art. The Plant Artist website (www.theplantartist.com) gives the following definition, which neatly differentiates between botanical art and botanical illustration:

> **Botanical art:** Art that includes flowers and/or plants as the major subjects with aesthetic, artistic representation. It does not necessarily stand up to scientific scrutiny. Botanical art does not need to concern itself with precise details and can be purely an aesthetic interpretation of plants.
>
> **Botanical illustration:** Accurate, scientific representation of plants, making it possible to identify the plants to the species, in the field. It may include a dissection of the plant as an aid. Even with its scientific use, there is an inherent artistic aesthetic quality that appeals to the viewer and critic alike.

The above definitions conform to the general understanding that is current among botanical artists that the art form can more or less be divided into two categories: the sort of picture that would grace the drawing room or adorn a kitchen wall (botanical art, flower painting) and the extremely detailed form for scientific use (botanical illustration). But the two forms may overlap, and many scientifically correct pictures are also desirable in fields other than just as an aid to botanists. Every botanical picture – whether for scientific use, to hang on a wall or to illustrate a book or article – should be botanically accurate, otherwise it is classified as a flower painting. You should ask yourself, 'Could a botanist identify a specimen using my picture?' The type of things to be aware of are the correct colours for flowers, leaves, bark, petals, buds, stems; the way the leaves grow from the stem; the correct number of stamens, petals, sepals, and so on.

We are often asked, 'Why not use a photograph for identification? It is so much quicker than drawing the specimen'. The answer is that botanical artists are able to see all round the subject before committing it to paper and to paint everything in focus regardless of the depth of field, making their pictures so much more helpful for identification purposes than photographs. This is particularly borne out in publications such as *Curtis's Botanical Magazine*, published on behalf of the Royal Botanic Gardens at Kew near London, which shows detailed line drawings of all aspects of a plant, including dissections and parts magnified under a microscope – vital aids to enable botanists to identify a particular specimen. In the same vein, the archives at Kew contain thousands of beautiful pictures that are used as a means of identification. There is a demand for botanical artists capable of this precise and detailed work.

There is nothing new about botanical illustration. The earliest recorded example is from the 2nd century BC, when hundreds of plants were depicted in a limestone bas-relief on the walls of the Great Temple of Tuthmosis III at Karnak to commemorate the king's successful campaign in Syria and to symbolize his fame and power. People have been depicting plants ever since, either because of their beauty, for personal interest or to record their use for humankind. Many illustrations from medieval herbals also survive. Some are fresh and informative; others have suffered from being copies of copies of copies, causing many of the finer points and much of the interesting detail to be lost – a sort of 'Chinese whispers' effect.

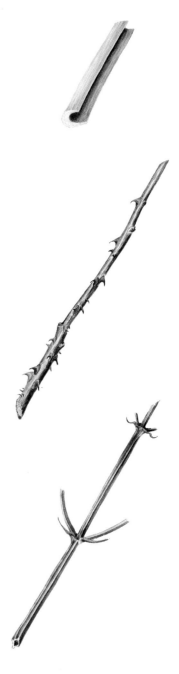

Above:
These three stems, hosta, rose and verbena, show the individual characteristics that are so vital for correct botanical identification, particularly the cross section of the stems.

At the Eden Project in Cornwall, which displays just over one million individual plants representing 5,647 different plant types, the Florilegium Society is recording as many of the plants as possible to form a lasting archive. Dried herbarium samples are also stored, providing a lasting record of the structure and DNA of each plant to aid future identification.

Contemporary

The word 'contemporary' is defined variously as meaning modern, current, characteristic of the present, belonging to the present time. How should we apply this to our botanical paintings to demonstrate that they are truly of the 21st century and not merely echoes of earlier fashions?

It is not easy. Look at pictures of plants from any age since King Tuthmosis and some will definitely appear 'of their time' (such as medieval herbals or Dutch flower paintings) while others are so fresh and sharp that it is hard to determine their age. For instance, the picture of grasses, *The Large Turf*, painted by Albrecht Dürer (1471–1528) looks as if it could have been completed yesterday.

When discussing the term contemporary botanical illustration, some concepts to consider include the following:

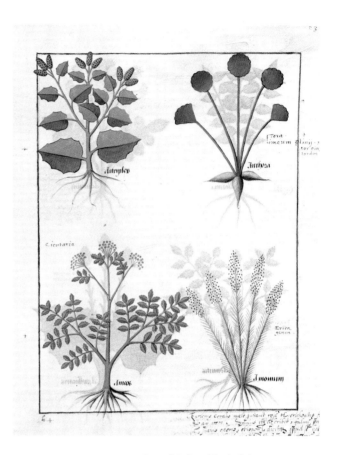

Above: Medieval herbal showing Salt Bush, Anthora, Absinthium and Cardamom (see page 143 for more details).

- Clear, translucent colours.
- The style of mounting and framing – a traditionally painted subject can be modernized by its position in the frame, by the width of the mount or the type of frame used.
- The position of the subject in the format. Rory McEwen was at the forefront of the contemporary movement, for instance placing a single peapod in the centre of a large sheet of paper, or pairing a rose with a clover leaf.
- The use of coloured or black paper as a support.
- A larger-than-life-size painting or portrayal.
- Writing, such as the name of the plant in script, is considered by many to be outdated. If it is used, it should be part of the overall design.
- Subject matter – use a demonstration page, a worksheet or a page from a sketchbook as a finished painting, mounted and framed.
- Japanese artists seem to have an instinctive understanding of design – their crisp style of botanical painting would appear to be part of their national psyche. They have an innate sense of what is contemporary, the roots of which lie in a rich aesthetic heritage.
- Domestic subjects – a string of garlic, apples, red onions, roots, vegetables – demonstrate that our perception of what we want to hang on our walls is influenced by our décor and the fact that the kitchen is now often a communal area, not just a place for the preparation of food.

- Ideas of contemporary and dated painting are cyclical and dictated by fashion.
- We are affected by modern mass-produced art materials, papers and paints – nowadays we have access to very white paper, which affects what is put on to it.
- Everything around us has been designed, either by Man or by nature, and we are exposed to designs and images all day, on television, in advertisements and in magazines. Current fashion trends have been towards minimalism in our surroundings and furnishings, aiming for a cool, clear and uncluttered lifestyle. The Victorian cluttered look is out, as is all the busyness and pattern that went with it, and our minds are more attuned to the simple style. This may be attributable to the speed of modern life and our desire to have quiet, reflective areas as an antidote.

One interesting debate that took place as a result of our question, 'What is contemporary botanical illustration?' tested the theory that in the past, botanical illustration was done for the most part to please a masculine market, largely by male artists. Pictures tended to be stiff, formal and dominant. Now that the market is no longer gender-related and many contemporary botanical artists are female, botanical illustration has changed to show the spirit of the age, flexible but strong, and is softer and more curvaceous than the traditional male pictures. Discuss!

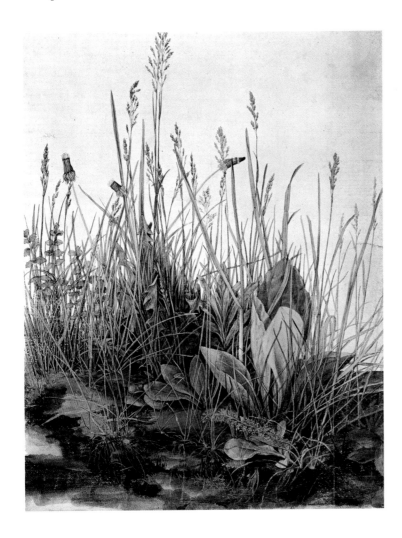

Left: The Large Turf by Albrecht Dürer (1471–1528) could have been painted yesterday (see page 143 for more details).

Above: This delicately drawn
composition of modern carnation
blooms is an interesting way of
presenting a difficult subject.

1. Your workplace and materials

It is important to set aside a special place where you can leave all your materials undisturbed between painting sessions. To paint at the kitchen or dining table and have to clear everything away at mealtimes is frustrating, time-consuming and may cause damage to your work.

A table and comfortable chair are of paramount importance – you will be there for long periods of time. If you can use an adjustable-height office chair so much the better. Sit with your back as straight as possible rather than slumped over your work, to avoid putting too much strain on your spine. Use a table easel or support your drawing board on books, bricks or a block of wood at a comfortable angle. Lay out your materials in a way that allows the most economy of movement. Place your palette, together with your paintbox, in the most convenient position. Try different positions until you find the one that suits you. If you have your materials too far away, or on the 'wrong side' so that you are reaching across your work with a wet or paint-laden brush, there is a danger of dripping water or paint on to your work and spoiling it.

Between painting sessions, it can be useful to stand your work at eye level where you will notice it at intervals during the day. This will enable you constantly to see it anew. An upright piano is a good height to stand your work on (but not everyone has one of those) or prop it up on a shelf or chest of drawers.

Light

As an artist you are essentially depicting the way that light falls on your chosen subject. Without light there would be nothing to see – no shapes, no colours, no shading, no shadows and no indication of the three-dimensionality that gives life to your painting. Your intention should be to harness the light to do much of your work for you.

First, make sure that your paper and your subject are both well lit. The light falling on your subject should be from the side, not full on or from the back, as this accentuates the form and gives good tonal contrasts. Try to sit sideways to a window with no direct sunlight. If you sit in a sunny position not only does the light tend to be yellow but you could also find that there is too much variation in its quality, strength and direction. North light (south light in the southern hemisphere) is more consistent and tends to be blueish or neutral. If you work in artificial light, set up your worktable with a lamp fitted with a daylight bulb, which resembles north light.

Light both your subject and your worksheet, using two lamps if necessary. Position the light source (or yourself in relation to the window) so that your working hand does not cast a shadow – if you are right-handed it is customary for your light source to be from the left; if left-handed, from the right.

Above: This fine pencil drawing of ramsons or wild garlic (*Allium ursinum*) could not have been done without a steady hand and very sharp pencils.

It is a convention in botanical illustration that backgrounds and shadows are not usually shown. Place your specimen on a plain white ground. Observe any reflected light this may cause and consider what effect it has on your picture. Objects in the background can cause confusion and distract the eye. Try pinning a sheet of white paper or card behind your specimen or prop up a white board to accentuate the outlines and make it easier to distinguish them. Having suggested constancy in your use of light however, it is always useful to experiment with unusual lighting just in case the experiment gives an interesting effect. Never close the door on challenge.

Sometimes it helps to mark the direction of your light source with an arrow on your preliminary drawings. Keep these preliminary pieces to hand, perhaps pinned on the wall above your worktable, so that you can refer to them when working on the finished piece.

Paper

At this point it is appropriate to mention the type of paper, sometimes referred to as a support, you are using. The smoother the paper, the finer the detail you will achieve. Paper is measured by weight in grams per square metre (gsm). For pencil work only, you can use a good-quality, smooth cartridge paper (200gsm). Layout paper (approximately 45gsm) is inexpensive and provides a good, smooth surface for experimental, swift, concise, general and detailed pencil work. It is invaluable for preliminary drawings that can later be transferred to watercolour paper.

When you begin to paint you will need a heavier paper, preferably made of 100 per cent cotton. Thin papers tend to buckle and cockle if used with very wet paint and have to be stretched beforehand, a process that is messy, time-consuming and can destroy the fine surface of the paper. Many artists prefer not to stretch hot pressed (HP) paper as this may result in a breakdown or 'furring' of the surface, which is not ideal for the fine detail required in botanical painting. The ideal weight is 300gsm (also shown as 140lb) as this will take quite wet washes without the need for stretching beforehand. Thicker papers are also available. Look for acid-free paper, which is archivally preferred, more sympathetic to the paint and has a longer life.

Watercolour paper comes in a range of surfaces. The most suitable for botanical painting is hot pressed (HP), which is extremely smooth, making it easier for the botanical artist to portray fine detail. It does not take kindly to lots of rubbing out, which roughens the surface and alters the performance of the paint. This is where your layout pad comes into its own, because all changes and experiments can be done on this before transferring the image to your HP paper, either with a light box or traced (see also pages 58 and 91).

Some artists use paper with a 'NOT' surface ('NOT' means quite simply that it is 'not HP'), although they may find it hard to produce fine details.

Right: When working with pencils only, use a good-quality, smooth cartridge paper.

Paper is sold in bound pads, blocks and by the sheet. Most sheets of paper are 56 x 76cm (22 x 30in) and many retailers offer a free service to cut it in halves or quarters if you ask. You will find that most paper has a 'front' and a 'back'. With machine-made paper the back is usually slightly rougher than the front. If you buy loose sheets of paper you can determine the front by looking for a watermark or manufacturer's embossing. Mark each sheet of paper lightly in one corner to indicate which surface is which and experiment painting on both to see which one suits you best. Some papers are whiter than others – some suppliers offer mixed packs of different makes of paper so that you can try all of them at minimal expense. Our assessments of various papers are given below.

Fabriano 5 350gsm HP
- Difficult to paint large areas of wash or blended tones. Paint tends to stay where it is put. Difficult to blend tones and manipulate wet paint.
- Comes into its own with stippling techniques and using fine, small brushes. Favours a drier approach to painting altogether. Very hard paper. Doesn't like erasing. Takes pencil clearly and smoothly.

Our opinion: Really only good for styles that favour stippling with small brushes, with little or no washes. Not good for wet-into-wet or styles that use a lot of water.

Fabriano Artistico 300gsm HP
- Good wash coverage, blended tones, wet-into-wet. Stippling and long, fine lines very good, smooth and even.
- Surface smooth, not too hard – takes minimal erasing.
- Very creamy colour.
- Takes pencil clearly and smoothly.

Our opinion: A lovely paper if you don't mind the cream colour. Good all-round surface for different techniques.

Arches Aquarelle 300gsm HP
- Good wash coverage, blends, wet-into-wet, blended tones. Stippling and long, fine lines very good, smooth and even.
- Surface very hard. Doesn't take erasing. Widely used for its extremely fine finish.
- Cream colour.

Our opinion: Very good all-round surface, if slightly unforgiving. Probably the most widely used paper. Takes all styles and techniques from wet to dry painting.

Magnani Corona Smooth 310gsm
- Good wash coverage, blended washes, wet-into-wet, blended tones. Good for stippling, fine lines and detail.
- White colour.
- Hard, smooth surface that also allows for a bit of erasing (can be erased lightly with putty rubber).
- Takes pencil well – clean and smooth.

Our opinion: A paper suitable for all styles, wet and loose or dry stippling, for people who prefer white paper. This paper seems more versatile than Fabriano 5 as paint can be manipulated and moved around much more. Takes a bit of erasing too. This is a good all-round paper.

Royal Watercolour Society (RWS) 300gsm HP

- Good wash coverage, blended tones, wet-into-wet. Quite a heavy texture, so stippling and long fine lines are a bit difficult.
- Surface rather soft – gives a slightly furry finish.
- Takes a fair amount of erasing.
- Rather more textured than other HP surfaces.
- White/cream colour.
- Too soft and textured to take smooth, clear pencil work.

Our opinion: A paper most suited to a looser, wetter style. Fine detail gets a little lost in the heavier texture. A little too soft for very fine work or pencil.

Saunders Waterford 300gsm HP

- Good wash coverage, blended wash and wet-into-wet. Good blended tones.
- Stippling not quite as smooth as Arches, Sennelier or Fabriano Artistico. Long lines catch a bit – surface not quite as smooth as the above three papers. Takes some erasing.

Our opinion: For looser, wetter styles. Surface a little too soft for very fine, precise detail. Stippling gets a little lost in surface texture, as does pencil work.

Sennelier 300gsm HP

- Good wash coverage, wet-into-wet, blended, graded washes.
- Good blended tones.
- Stippling and long lines are very good, smooth and even.
- Surface not too hard, with slight 'linen' pattern. Some erasing is fine.
- Cream/white colour.
- Accepts pencil very well. Smooth and clear in spite of not being a particularly hard surface.

Our opinion: Very good all-round paper. Takes a fair amount of erasing. Suitable for all styles, wet and dry. An extremely forgiving paper that can take heavy punishment.

Bristol board 250gsm

The smoothest paper of all is Bristol board 250gsm (115lb). It is described as extra smooth, suitable for pencil, pen and ink, airbrush, light wash and crayon. Useful as a support for very dry watercolour work involving stippling rather than washes, or for pencil work, either graphite or coloured, where its intense smoothness works with you to give good coverage and extremely fine definition. It also allows quite a lot of erasing with minimal disturbance to the surface.

Masking your work

All watercolour papers absorb the oils in human skin, which even in tiny quantities can alter the performance of the paint. Mask your work by keeping a piece of paper or acetate under your hand at all times. If you use paper, ideally it should be the same colour and texture as your picture – it is then good for testing brushstrokes and paint colour. Or you could paint through a hole cut in the centre of a sheet of acetate, which allows you to see the whole picture at all times.

Vellum

Another support used by botanical artists is vellum. This is prepared calfskin or goatskin. Kelmscott calfskin is widely acknowledged to be the best, being a cream coloured manuscript vellum that is thick and smooth. Vellum is expensive and tends to have natural blemishes and markings. The blemishes can form part of the overall composition. It does not take kindly to a lot of over-painting or washes, but small areas of wash are fine. After that, you should build up the colour with a series of tiny stippling brushstrokes.

Vellum has many differing surfaces, from textured to very fine. Its colour also varies dramatically from pale ivory to deep coffee. Some vellums take paint more easily than others. With some, the paint adheres smoothly and evenly, with others it glides or slips on a glass-like surface. Vellum needs to be tried, tested and, above all, understood, as it varies as much as the people who use it. Some vellums vary within the same skin, ranging from smooth and pale in some areas to almost gnarled with dark stains in other parts. The surface of vellums can be hard, medium-hard and soft. You might like to treat the skins by buffing lightly with pumice powder, then wiping off with a soft tissue or rag to remove excess powder. If you are using a heavily patterned skin consider incorporating the markings into the overall design of your painting. Careful consideration of your subject matter and placing it in the format becomes part and parcel of vellum usage.

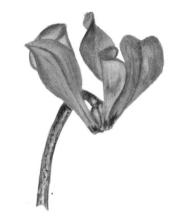

Above: Cyclamen flower painted on vellum.

You can draw directly on to vellum or trace an image from another drawing. With the smooth, pale vellums it is possible to trace drawings on a light box (see page 58) but if the vellum is textured this becomes almost impossible as the pattern, or grain, interferes with the drawing.

Vellum does not favour wet-into-wet washes as the paint tends to sit on the surface rather than soak in, as with paper. If you are used to painting on a hard surface such as Fabriano 5 then vellum will probably seem easier for you than it might for others. Covering large areas with big, bold washes is not suitable for the surface of vellum – it really requires delicate strokes with a small, finely pointed brush.

One advantage of vellum is its ability to have paint removed by lightly scraping it off with a very sharp scalpel or razor blade. Whole areas can be taken off cleanly this way. Pencil work can also be lifted successfully from vellum by gently pressing a putty or kneaded rubber on to its surface.

If you enjoy drawing with your brush and have a somewhat linear style you will probably take to vellum fairly quickly. As a delicate, organic substance, vellum requires a deftness of hand to bring out its magical qualities. The continuous and slow process of building colour and depth by application of small strokes from light to dark will surely reward you with a jewel-like, glowing finish.

Ivorine

Ivorine is another hard, smooth support, similar to Bristol board, much used by miniaturists – as in the case of Bristol board, the paint appears to stay on the surface. The same painting techniques should be used as those recommended for vellum.

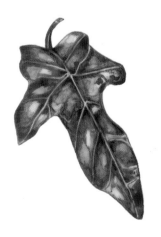

Above: Leaf painted on ivorine.

Pencils

It is important to mention here the quality of pencils and how to use them. Even with something as mundane as a pencil, 'the workman is only as good as his tools'. Different makes of graphite pencil have different values, even though they are ostensibly of the same hardness. Generally speaking you should use a range in grades from the very hard 6H to a medium soft HB.

This chart (below) shows the characteristics of five different brands of graphite pencils in a range from 4H to 4B. As far as possible the same pressure was applied to all samples when making the chart, but you can see how the brands vary. A 4H in one make, for instance, has much the same tonal value as an H in another. For clear definition our personal choice is Caran d'Ache Technograph, which are very hard and clear.

Below left: A comparison between different makes of graphite pencil, showing the differences in the range 4H to 4B.

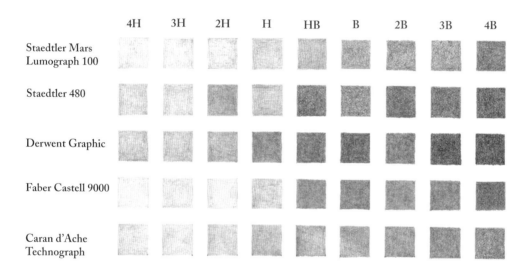

	4H	3H	2H	H	HB	B	2B	3B	4B
Staedtler Mars Lumograph 100									
Staedtler 480									
Derwent Graphic									
Faber Castell 9000									
Caran d'Ache Technograph									

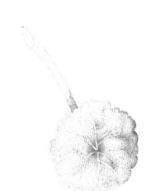

Keep your pencil sharp at all times – correctly sharpened, a pencil should have such a fine point that it hurts when pressed into a fingertip. A well-sharpened pencil can give more variety of line and offers a wider selection of marks and effects. A blunt pencil will lead to an indistinct drawing over which you have limited control. Pencils can be sharpened in several ways. Some electric or mechanical pencil sharpeners can 'eat up' the pencil and may therefore be rather wasteful. Otherwise use a sharp blade or craft knife, which strengthens the wood around the lead and gives a long, fine point. If you have a hand-held sharpener, use it little and often and do not employ excess force. This lessens the chance of the lead breaking. It goes without saying that the sharpener should be sharp. You may like to refine the point of the pencil by holding it a few degrees off horizontal, rotating while rubbing gently on fine sandpaper or an emery board.

Some people prefer to use a mechanical or clutch pencil. The main benefit of these is that they always remain the same size in the hand and are therefore consistently balanced. The recommended size of lead is 0.3mm or 0.4mm, preferably 4H, and many specialist art or graphics shops or Internet suppliers should be able to provide them or be able to obtain them. The finest of these pencils give an even and fixed line but still need to be honed to a fine point.

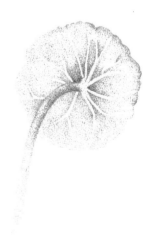

Above: This delicate study, drawn entirely in dots of different pencil grades, gives the pennywort leaves their thick, fleshy character.

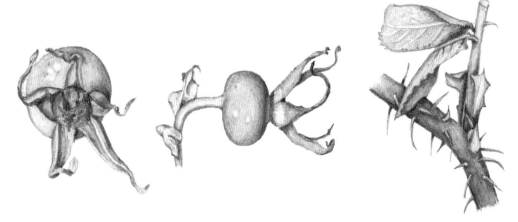

Paints

Although you will potentially be using every shade of every colour throughout the whole colour spectrum in your finished paintings, there are only ten that you really need. Buying every colour available will not make you a better painter whereas learning to mix colours efficiently may. Essential for the botanical artist are a warm and a cool yellow, a warm and a cool red and a warm and a cool blue (see page 20). In addition you will need a vibrant pink and a purple or violet. As you will mix your own greens, a sap green is not vital but can be useful to add to other colours. For very limited use such as painting extremely fine hairs, a tube of titanium white or white gouache can justify its place in your paintbox.

Whether you use pans, half-pans or tubes is entirely up to you. Pans and half-pans are easy to store and use. They can be replenished from tubes or you can squeeze paint from the tube directly on to your palette. If you use tubes, don't waste the paint you don't use – allow it to dry out and you can reconstitute it with water again and again.

Paints are expensive regardless of what shape and form they come in. Always buy artists' quality paints even though they are more expensive than the student range. Your work will benefit from their finer quality.

Above: Only a very well-sharpened pencil could make the fine lines and detailed shading on this study of rosehips, stems and leaves.

Below: Colour wheel showing warm colours (left) and colour wheel showing cool colours (right).

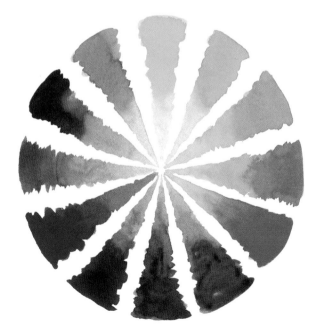

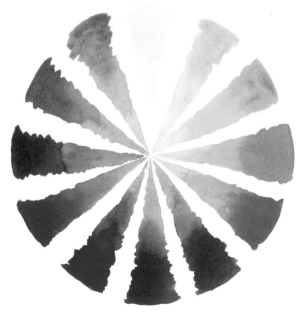

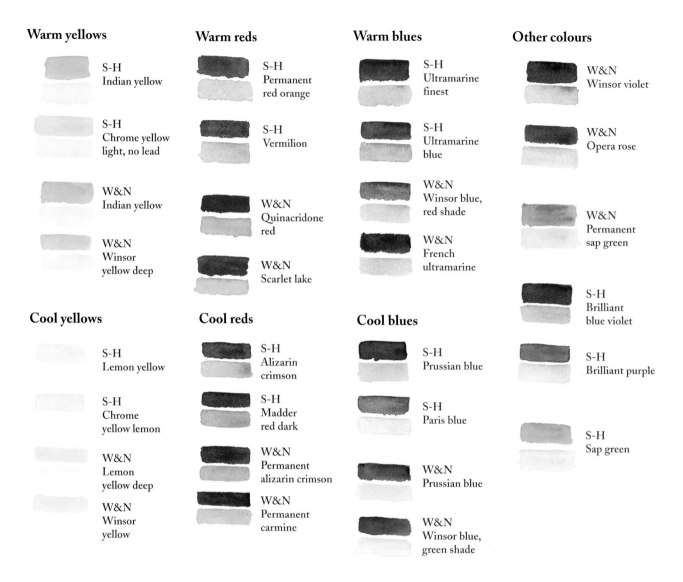

Warm yellows

S-H
Indian yellow

S-H
Chrome yellow
light, no lead

W&N
Indian yellow

W&N
Winsor
yellow deep

Cool yellows

S-H
Lemon yellow

S-H
Chrome
yellow lemon

W&N
Lemon
yellow deep

W&N
Winsor
yellow

Warm reds

S-H
Permanent
red orange

S-H
Vermilion

W&N
Quinacridone
red

W&N
Scarlet lake

Cool reds

S-H
Alizarin
crimson

S-H
Madder
red dark

W&N
Permanent
alizarin crimson

W&N
Permanent
carmine

Warm blues

S-H
Ultramarine
finest

S-H
Ultramarine
blue

W&N
Winsor blue,
red shade

W&N
French
ultramarine

Cool blues

S-H
Prussian blue

S-H
Paris blue

W&N
Prussian blue

W&N
Winsor blue,
green shade

Other colours

W&N
Winsor violet

W&N
Opera rose

W&N
Permanent
sap green

S-H
Brilliant
blue violet

S-H
Brilliant purple

S-H
Sap green

It is a good idea to buy an empty paintbox and fill it with your own choice of paints. Although we recommend a limited palette for beginners in botanical painting, we mention more colours than just the primaries. Inevitably as you progress you will want to add your own favourite colours, so make sure that the box is large enough to take extra paints in the future. You will find that similar colours produced by different manufacturers often have different qualities. Recommended brands are Schminke-Horadam (S-H) and Winsor & Newton (W&N). The two manufacturers' colours correspond with each other; for example, S-H permanent red orange and W&N scarlet lake. Choose one warm and one cool of each primary colour (yellow, red, blue). The colour examples above are shown at full strength and watered down.

Make a 'map' of your paintbox, because it is not always easy to tell the precise colour of a paint from looking at a pan or tube. Cut a piece of watercolour paper to fit inside the lid and rule squares or rectangles to represent the position of your paints. Colour these, label with the name of the paint and cover with transparent, waterproof material such as the corner of a plastic folder or a sheet of kitchen film. Don't forget to update it when you add new colours! This will be a unique and valuable instant colour reference.

Above: Choose one warm and one cool of each primary colour – yellow, red and blue. Recommended brands are Schminke-Horadam (S-H) and Winsor & Newton (W&N).

Coloured pencils and their uses

There is a growing interest in the use of coloured pencils for botanical illustration. The ones mentioned below can be used on their own or combined with watercolour, giving vigour and depth to the subject. (You may also like to experiment with water-soluble coloured pencils, which are widely available but have not been used in this book.)

Reputable makes include Caran d'Ache, Faber Castell, Staedtler, Lyra, Derwent, Berol, Conté à Paris and Prismacolor Verithin. Prismacolor Verithin pencils are made in America. They are not sold in Europe but are available by mail order from US art suppliers. It is fair to say that some Derwent pencils are found to be fairly soft, whereas Prismacolor Verithin or Berol pencils have a harder core and can be sharpened to a finer point for detailed work.

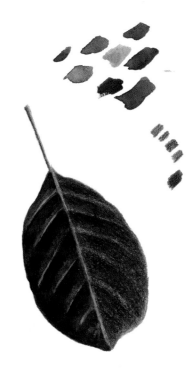

When choosing coloured pencils, look for their ability to draw a fine line and to be burnished, indented and lifted for highlights. Burnishing is done with a blender, or a pale coloured pencil such as white or cream, pushing the colour into the paper and filling in the tooth (the slight roughness of the paper that permits acceptance of pigment). Blending is when two or more colours are laid one over another. They may then be burnished if required. To achieve a highlight, the colour can be lifted off carefully with a scalpel, scraping or picking it out where required. This needs some skill and it is worth practising on scrap paper first. For lowlights and bloom, rub out the colour using an eraser (sharpened into a point if necessary) and then apply white pencil.

Erasing around coloured pencil work can be tricky, especially if you want to remove your original graphite drawing without disturbing the colours. One solution could be to do your original drawing in colour. Erasing shields are available from art and graphics suppliers and are made of very thin metal with cut-out shapes of various sizes. Carefully lay the shield over your work to protect the bit you don't want to erase.

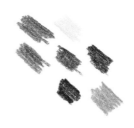

Above: This smoke bush leaf (*Cotinus coggyria*) is portrayed both in paint (left half) and in coloured pencil (right half).

If you have a subject that is covered in tiny white or light coloured spots, such as a strawberry or fig, or fine veins such as on a leaf or gooseberry, try indenting these first by pressing lightly on the paper with a blunt point so that when you apply the coloured pencil it will skim over the surface leaving the spots untouched. You may then fill in the spots with a very fine pencil.

The type of paper to use with coloured pencils is a matter of personal choice, but most artists in this medium would agree that to achieve fine detail it is important to use a very smooth, firm paper such as heavyweight cartridge paper (such as Lana), Hot Press watercolour paper, Daler Rowney Bristol board or Winsor & Newton drawing and sketching paper. Look for acid-free paper with a clean, white, strong surface for repeated working and erasing.

Some artists use coloured pencil in conjunction with watercolour, either shading the work first then applying watercolour washes on top or using the pencils to add fine detail at the end (see the maize on page 133 for a good example of this). Others use coloured pencils alone, with no further painting. Like so much of botanical illustration you will need to experiment to see which method you prefer.

Brushes

The perfect brush for botanical illustration is full-bellied with a fine point. The best and most expensive brushes are Kolinsky sable. To begin with you will need a minimum of three brushes, sizes 1, 4 and 6 – treat yourself to the best you can afford. Winsor & Newton Series 7 are good, as are Da Vinci Maestro, Raphaël and Escoda. In time you may need smaller brushes for detailed work, such as 3/0 or 4/0. You will also need a fairly large, cheap synthetic brush (size 6–8), which you will use primarily for mixing paint. Compare prices from mail-order companies with those of your local art shop – there is often quite a difference.

It pays to look after your brushes carefully:
• Never leave your brush standing in the water pot. Rinse it carefully and dry it before putting it away.
• When not in use, keep brushes wrapped or in a wallet or container that protects the points. A sheet of corrugated paper, rolled and secured with a rubber band, is a cheap method of keeping your brushes secure.
• If a brush becomes bent or splayed, gently work some soft soap into the hairs, mould to the correct shape and leave to dry. Rinse thoroughly before use.
• Try to keep your good brushes for watercolour only; other materials can damage them or shorten their life.
• After using white paint, wash the brush in warm soapy water, rinse and dry.

Other studio equipment

You will need a method of keeping your specimen in the correct position. This might be a '**third arm**', an intriguing contraption of rods, pivots and spring clips used by model makers, or just a simple bottle weighted with sand, a cork with a hole through the centre, a bulldog clip or a block of oasis or crumpled chicken wire in a container. Different specimens have different needs, so you will need to be inventive.

Masking tape is good for all sorts of uses, from securing your paper to the board to positioning your specimen.

A pair of **dividers** with very fine points is a good tool for making accurate measurements and transferring them to the paper. Art and graphics dealers can usually supply them even if they are not held in stock. It helps if you can train yourself to use them in your non-painting hand, manipulating them rather like chopsticks, so that you are not forever changing from brush to dividers and back again.

A **magnifying glass** is essential for detailed work. Different types of magnifying glass include hand-held versions, a binocular magnifier that clips on to spectacles, a headband magnifier with a choice of magnification, a free-standing goose neck magnifier and a magnifying desk lamp that clamps to your worktable and has the advantage of a built-in lamp with daylight bulb. These are available from opticians or mail-order suppliers.

You will need a **pencil sharpener** or sharp knife (see page 18).

An **eraser**, either putty or hard white such as Staedtler or Faber Castell is very useful. Extremely detailed rubbing out can be achieved by cutting a slice of hard, white eraser into a fine point. To get rid of eraser sweepings, use a **feather**, such as the wing feather of a goose or seagull. Wash the feather in a solution of detergent, rinse and dry thoroughly, then stick it into a cork for ease of handling. Using a feather helps you to avoid touching the paper with your hands.

Use two **water containers**, one to wash your brush in, the other for mixing paint. Change the water often so as not to contaminate your colours.

You will need a white **palette**, preferably china not plastic, or you could use a large, plain white china dinner plate.

There are some instances when **masking fluid** can be useful, particularly if you wish to blank out small areas before applying a wash (see page 68), but it can be difficult to use accurately. It must be applied to dry paper and allowed to dry completely before painting over it. When the paint is dry, remove the masking fluid gently with a hard eraser. Exposed areas can then be touched up with a fine brush. Practise on a scrap of paper first, as masking fluid often has its own ideas. Do not use a precious brush as it is no good for anything else afterwards. Keep a cheap, fine-tipped brush especially for this, wash it immediately after use with soap and warm water and rinse well. Or you could use a fine-nibbed pen, a sharpened quill or even a clean, sharpened twig.

Below: Brown sage (*Salvia africana-lutea*) painted in a mixture of the three primaries superimposed on top of yellow.

One last thought

It happens to all of us... You've been painting away busily for hours when you suddenly feel, 'What am I doing? Help! Did I really want to put the paint on in that way?' This is the time to move away from your work for a while. Go and do something else – walk the dog (if you have one), weed a flowerbed (if you have one) or simply make a cup of tea (or coffee – or whatever). Come back half an hour later and bingo, all will become clear once again.

Left: Elegia thyrsifera is a restio (*Restionaceae*) found in the fynbos of Western Cape Province, South Africa. It is painted using primary colours only.

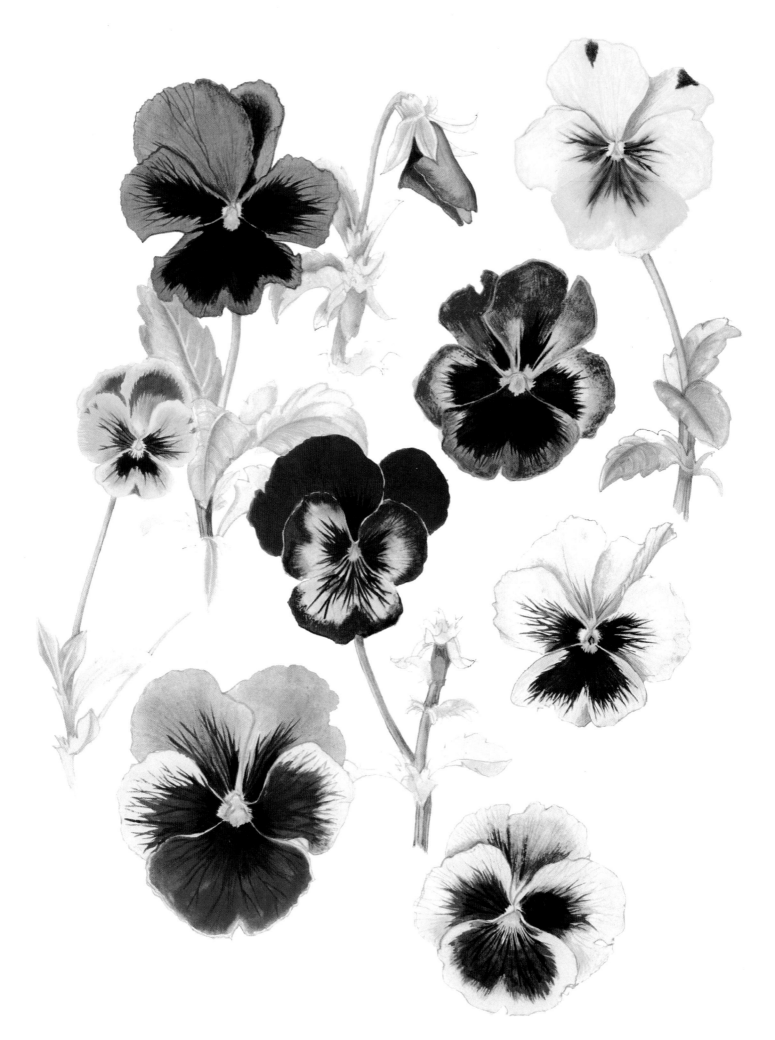

2. Sketchbook practice

Two of the characteristics of botanical illustration are the length of time often necessary to bring a picture to completion and the extremely short life of many specimens. It is not unknown for a botanical artist to take weeks, months or even longer to paint a single picture. Indeed, sometimes it is necessary to put the picture away for a year or more until another specimen is available at the same stage of development.

A good example of this is tulip 'Queen of Night' (see page 98), where the artist just had time to complete the preliminary drawings and colour testing before the flower died, then had to wait to obtain a fresh flower to complete the painting. Compare this with the craft of the landscape painter. The countryside structure can remain the same for ever, with subtle and dramatic changes in season, time, light and foliage, and a watercolour picture can be completed in a matter of minutes. How different! With this comparison in mind, give some thought to how you are going to overcome these problems. You will need to devise a way of capturing the essence of your subject in such a way that you can work on it at your leisure at a later date, with the aid of your sketchbook and copious notes.

The most notable exponent of sketchbook practice was the talented young artist Sydney Parkinson. His outstanding abilities as a botanical artist had been noted by King George III who arranged for him to accompany Joseph Banks in 1768, sailing on Captain Cook's HMS Endeavour to observe the transit of Venus from Tahiti, a thinly disguised cover for going on to search for (and discover) the lands now known as Australia and New Zealand. From the day the ship sailed Banks and his fellow botanist Daniel Solander set dragnets to collect specimens, giving them to Parkinson to record. Once they had made landfall, a further inconvenience for Parkinson was being tormented by flies – 'they not only covered his subject so that no part of its surface could be seen, but even ate the colour off the paper as fast as he could lay it on' (www.plantexplorers.com). The specimens came on board thick and fast and Parkinson was so busy trying to record them all that he was only able to make brief working sketches and colour notes to work on at a later date. In just over a year,

Opposite: Descended from the wildflower heartsease (*Viola tricolor*), all manner of colours, shapes and sizes of the popular pansy have been developed, but most pansy flowers share a velvety appearance to the darker colourings. This look can be achieved by layering washes one on top of another until a sufficient depth of colour is attained.

Below: Milkwood trees and guineafowl at de Hoop Nature Reserve, South Africa, a quick pen and ink sketch.

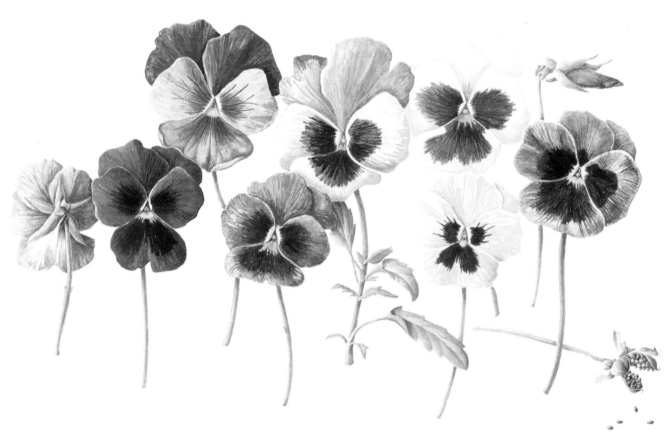

Parkinson made 280 finished and botanically accurate paintings and over 900 sketches and drawings, working on them in the unstable confines of cramped quarters on board a ship either under sail or tossing about at anchor. It is hardly surprising, after this punishing schedule, that he fell ill on the return journey and did not survive the voyage, being buried at sea at the age of 23. Banks employed five botanical artists on his return to England, who used Parkinson's sketches and herbarium samples to make finished paintings. Banks spent £10,000 over the years (a fortune in the 18th century) to have engravings made of Parkinson's drawings. Prints were not run off from these in his lifetime – in fact it was not until 1990, in conjunction with the British Museum, that the plates were cleaned and used to produce a limited edition.

Above: The leaves, a bud, seeds and the back of a flower are all shown in order to give an all-round description of the popular pansy.

Below: A quick sketch, as of this passionflower, is often all that is required to record essential information.

Collecting specimens

Wherever you go and whatever you do, always check carefully that you are able to take samples of plants away with you. Those in charge of national parks and private gardens are usually very happy for people to sit and draw their plants but do not take kindly to people helping themselves – if in doubt, ask for permission.

Unless you have a botanist friend who supplies you with specimens it is advisable to do some research first in your local library or via the Internet to make sure that you choose the best example possible. There is no point in labouring over a picture if the subject is not a good representative of its species. Make a note of its Latin name as well as its common name, its habitat, growth pattern and any other relevant factors. Some plants have two different types of flowers, one male and the other female.

You may also notice that your plant has two different types of leaf. The young leaves of ivy, for example, do not have the tri-lobed characteristic of the older leaves. Also be aware that plants can be affected by their environment. This may change the colour of leaves or flowers, the rate of growth and therefore size, and so on.

If possible, capture all developmental aspects of the plant – buds, flowers, seeds, leaves and roots. This may mean that you would have to return at another season of the year, which is not always feasible. Have a look at the peaches on pages 114–116 for an example of this. Make your painting as informative as possible. Show all aspects of the flower – the back or side can be as informative as the front, and that goes for the leaves too. If your specimen is a parasitic plant you should show its host as well, as this is a good clue to identification. Make comprehensive notes on your page, including examples of all the colours – bud, petals, the front and back of the leaves and the stems.

Keeping specimens fresh

Some of Sydney Parkinson's plant material was pressed and dried as herbarium samples that still survive to this day, while other specimens were wrapped in damp cloth and stowed in metal-lined chests to keep them fresh until he could draw them – there were no refrigerators in those days. You may find that you can overcome much of the problem of deteriorating specimens by concentrating on the most perishable – or changeable – part first. This is usually the flower; not only might it deteriorate quickly, it is also quite likely to change shape, open further (as in the case of a bud), wilt or frustrate the artist in myriad other ways.

Make a drawing of the whole plant and then work up the perishable parts, getting as much information on the paper as quickly as possible. A useful rule of thumb is to draw the buds before they open, then the flowers and finally the leaves, as these are usually the most robust part of the plant.

Sometimes it is necessary to wait for another season so that you can show fruit or seeds. Some artists don't finish a picture for several years because another specimen is not available, particularly when a rare or intermittently flowering plant has been chosen.

If you have to store your specimen, either overnight or for a few days, decide on the best way to keep it fresh. This could be to place it in an airtight container, on a damp cloth or absorbent paper, and put it in the refrigerator or a cool, dark place. If your specimen is too large for a box place it in a sealed polythene bag, making sure there is plenty of air around it, before storing it in the refrigerator. A fairly flat sample can be pressed between sheets of absorbent paper and placed under a heavy weight. It will remind you of its original form and dimensions, even though its colour may fade. Pressed petals can be useful as a colour reference, although some petals are inclined to lose their colour fairly quickly – make notes and prepare watercolour swatches, writing down the names of the colours you used.

Below: Colours used for these pansies were warm and cool yellow, warm and cool red and warm and cool blue (see page 20).

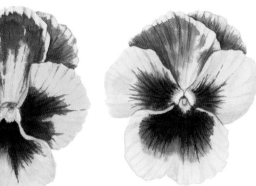

Sketchbook work

You may be able to do the preliminary work *in situ*, which
is where your sketchbook comes in handy. You should end
up with some working sketches and, if you are lucky, a leaf or a
petal for colour matching.

At this stage it might be worth mentioning digital photography. It is a
recognized fact that photographs are not as good as illustrations from the point
of view of identification of plants and plant material, but the digital camera does have
a place in your own equipment as it gives instant results, particularly if you are able to
photograph subjects close up. Use your camera as an extension of your seeing process –
in other words, to record the aspects of your subject that will need clarification when
you come to paint them without the subject in front of you. For instance, you could
record leaf junctions, veins and any other particular characteristics or details. Make sure
you photograph your subject from as many angles as you can. If possible, arrange it so
that the light falling on your subject clarifies rather than confuses. This might put you
into awkward positions – be prepared to lie on the ground, climb a tree or even stand
on someone's shoulders to get the right shot! (see page 142).

Below: The artist was touring
South Africa with a group and
had little time to sketch. She set
herself the task of painting what
she saw from her bedroom
window in the short time
between arriving at new
accommodation and the
evening meal – rarely more
than half an hour. Here she
captured Maskam Mountain,
on the west coast of South
Africa as seen from Vredendal,
with local wild flowers *Senecio*
and *Pentzia*, shown above.

If you have time to record the habitat of the plant or its surroundings, that is a bonus. Some botanical artists include this in the finished picture, especially if the plant grows in an unusual place such as jungle or desert. Look at Margaret Mee's work, or that of Marianne North housed at the Royal Botanic Gardens, Kew, for fine examples of this practice. These artists, whose styles reflect the enthusiasm of plant hunters through the ages, worked extensively in the field, recording disappearing habitats like jungle and rainforest. They both include informative backdrops in many of their pictures.

Take as little gear as possible, not forgetting that you might need a small folding stool. The alternative is to take something waterproof to sit on, or to wear waterproof trousers. Paper is heavy, so don't take more than you need. Coloured pencils are useful for outdoor work and recording colours. If taking paints, pare down your paintbox to the absolute minimum. Travelling paintboxes are available with integral water containers and brushes. If you use watercolour, consider working on two or more pictures at the same time in order to give them time to dry. This could be on separate pages torn out of your sketchbook, or lots of small pictures on one page. Another option is to use two small sketchbooks so that one can be drying while you start another picture in the other.

Once you have found your subject, you will need to get down as much detail as possible in order to gather information about it. Don't worry about technique at this stage, just record as much as you can in whatever way you can.

Before you start, consider the plant's habitat and its habit of growth and note as much detail as possible. Choose a sample that is in peak condition and is a good example of the plant. Sit and look at it for a while and decide how you are going to present it.

Make sure that you portray your plant from the best possible angle to give information on its growing habit and structure. There is no point, for instance, in portraying a flat, dinner-plate-shaped cactus 'sideways-on', as this at best is uninformative and at worst is misleading. You may not be able to move the plant, but you can make sure that you are sitting in the best position in the circumstances.

Don't be too ambitious. If your time is limited, only attempt what you are able to do in that period. Don't get waylaid into putting in too much detail. You can add the finer points later as long as you have noted them. At this stage it is best to study the structure of the plant, the intervals, angles and engineering; the relationship

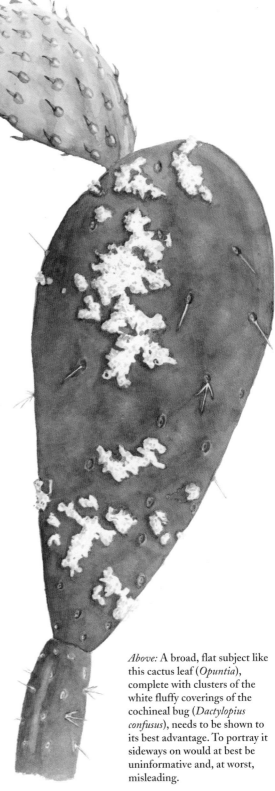

Above: A broad, flat subject like this cactus leaf (*Opuntia*), complete with clusters of the white fluffy coverings of the cochineal bug (*Dactylopius confusus*), needs to be shown to its best advantage. To portray it sideways on would at best be uninformative and, at worst, misleading.

of flowers to stem; how the seeds form. Consider making lots of little individual drawings of the different parts – flower, leaf, bud and seed.

Write copious notes to yourself. You won't remember everything, and you may not have a chance to visit this particular plant again. Make a note of the size of the complete plant, and try to draw everything life-sized. If you can't, then make a note of the actual measurements for future reference.

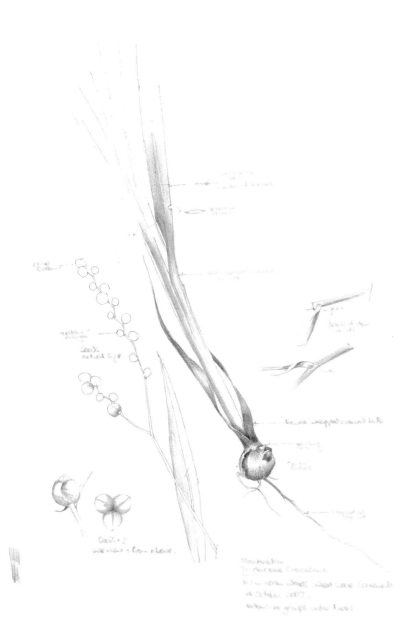

Left: A good sketchbook page. The artist's notes include colour reminders (olive green, yellow orange), two seeds (side view and from above), raised centre vein, section of flat leaf, cross section of stem, leaf emerging 'wrapped' from stem, details of stem joints, leaves wrapped around bulb, new bud forming, 'onion' shape, long central tap root. At bottom right is written the plant's name and the place and date found, with a note 'extensive groups under trees'.

It is worth practising the complex pillowed effect of primrose (*Primula vulgaris*) and cowslip (*Primula veris*) leaves, as well as the delicate pale yellow of the flowers. The single leaf (below) was painted using a combination of primary colours with a little bit of permanent rose. See how the veins have been lightly pencilled in before the initial pale yellow wash was applied. The primrose flowers use the same primary colours.

Below: A sense of three-dimensionality was given by treating the nearest cowslip leaves with a pale yellow wash, while those to the rear were lightly washed with blue. This helps to suggest recession (aerial perspective), which is often seen in landscapes where hills in the distance are paler and bluer than the ones in the foreground.

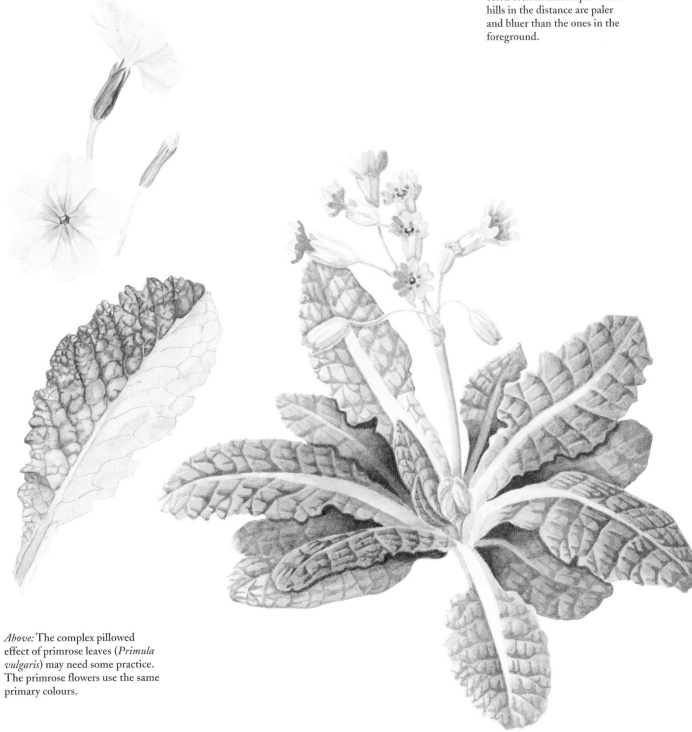

Above: The complex pillowed effect of primrose leaves (*Primula vulgaris*) may need some practice. The primrose flowers use the same primary colours.

This sketchbook page of nasturtium (*Tropaeolum majus*) shows how to tackle bright orange and also demonstrates the technique of showing veins on the undersides of leaves.

In order to prepare for a full plant portrait, first of all draw all the component parts such as the bud, leaf, flower, stem and seedhead. You may find it helpful to dissect the flower and draw some of the components in detail – here there are two drawings of petals, one showing the fine filaments, which have been coloured to make them more obvious. Also draw both the front and the back of the leaf and notice how they differ. In most plants you will find that the veins on the upper side are retracted whereas on the underside they stand proud, causing strong shadows.

Below: The bright orange colour of the flowers and how to tackle the veins on the undersides of leaves are the main information provided by this working sketch of nasturtium (*Tropaeolum majus*). The colours were mixed from scarlet lake, lemon yellow and ultramarine blue. The artist's notes recommend 'a paler green than the upper surface' for the back of the leaf.

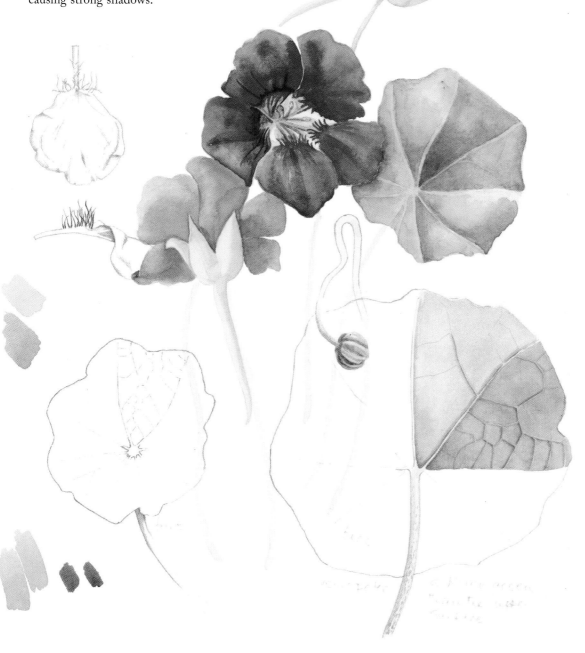

Depending on your situation you may only have time to paint small sections of your subject. If this is the case, paint in one or two petals, a section of stem and a leaf, or part of a leaf. Make sure that you show the most important areas and make notes on the page indicating colour and tonal distribution. The more information you can give yourself now, the easier it will be to piece the whole thing together at a later date.

A brightly coloured flower such as a poppy can be so demanding that the most important aspect of portraying it might be to record the colour first, giving you subsequent peace of mind in order to draw it. A red poppy is not just a red flower – just sit and look at it and see how many reds there are. Greens, too, can differ in one plant. They may be yellow-green, or blue-green, shiny or shaded. Make a note of the differences and, if you have time, put swatches of different colours into the correct positions. If you don't have time to use colour, make notes to remind yourself later.

Get down as much drawing as you can, asking yourself, 'Have I got enough information to remind me about this plant later?' Some people need less information than others and only experience will tell you how much you require.

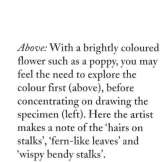

Above: With a brightly coloured flower such as a poppy, you may feel the need to explore the colour first (above), before concentrating on drawing the specimen (left). Here the artist makes a note of the 'hairs on stalks', 'fern-like leaves' and 'wispy bendy stalks'.

Left: Notes on this part-coloured drawing include 'poppy bursting through', 'maroon', 'hairs', 'stray stamens' and 'frilled' petals.

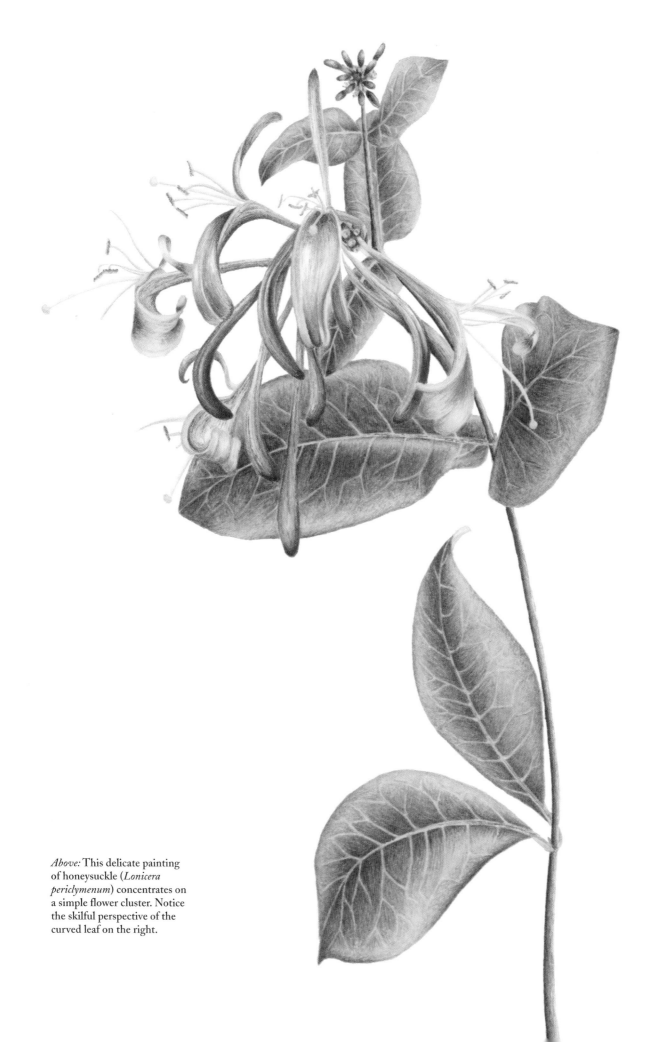

Above: This delicate painting of honeysuckle (*Lonicera periclymenum*) concentrates on a simple flower cluster. Notice the skilful perspective of the curved leaf on the right.

3. Composition

A technically perfect painting can be spoiled by poor composition, so before you even start to draw you should look carefully at your subject and consider how you are going to place it on the paper.

What size is your subject? Make sure that your paper is large enough to accommodate it and, if it is not to fill the frame entirely, leave enough space round the edges to ensure that it will not be cramped in its mount and frame. This is particularly important when you are painting a single specimen such as this beech branch covered in fungus (right).

It might help you to rule very lightly a margin of 5–7.5cm (2–3in). This can be carefully erased later or could be covered by the mount. Sometimes the surround is as important as the painting itself and the two work sympathetically, as in the painting of a larch twig (below), which is cropped by the positioning of the mount – shown here by a fine line.

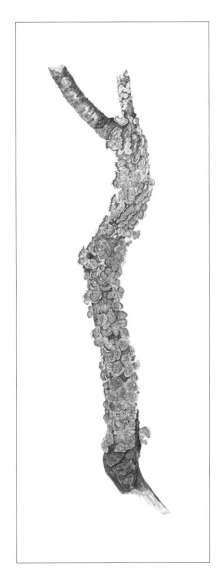

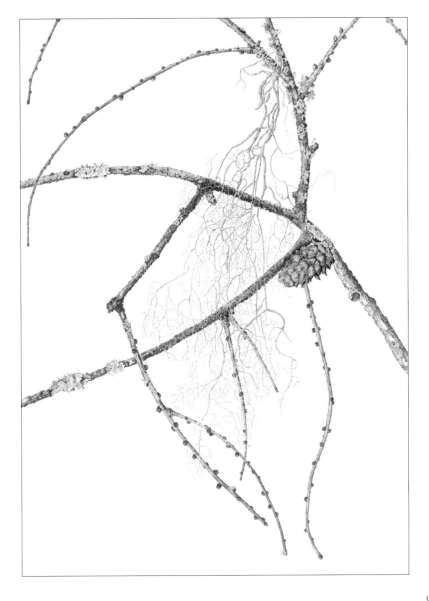

Above: A simple subject, such as fungus (*Stereum hirsutum*) on an old beech branch, makes a visually pleasing picture. Care must be taken when framing such a subject, because the white (negative) spaces around it are important in the overall impact of the picture.

Left: Lichens add interest to this larch twig. The picture is enhanced by the frame around it, which indicates the mount and crops some of the twigs.

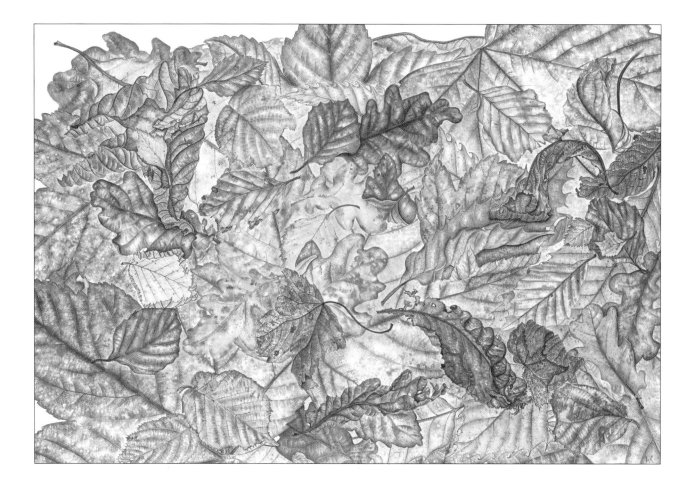

What format will your subject take? It could be a complete plant showing flowers, buds, stems, leaves and even the root. Or you might choose to show a series of flower parts, a loose bunch of flowers, a row of leaves or just the seedpods.

Autumn leaves create a rich tapestry of yellows, ochres, reds, browns and oranges. In these two pictures the subject has been treated in widely contrasting styles. The illustration above suggests a forest floor in autumn. In order to emphasize the carpet-like covering of leaves, the subject has been taken to the very edges of the paper so that there is very little white showing between the leaves and the mount.

The illustration on the right, on the other hand, is a detailed portrait of a single spray of blackberry (*Rubus fruticosus*) accurately portraying the turning colours of the leaves. The stem is hard and smooth with a uniform sheen; the leaves are tough and becoming dry; some have even dried completely and are beginning to curl. At the top of the spray are the fruits, some still unripened. Colours used are alizarin crimson, scarlet lake, ultramarine blue, lemon yellow and Indian yellow. Deep red blemishes have been added using wet-into-wet techniques and when completely dry the veins and secondary veins were carefully portrayed with a fine brush. Precision and carefully controlled brushwork are apparent throughout this painting.

Above: This arrangement of fallen leaves suggests a forest floor in autumn.

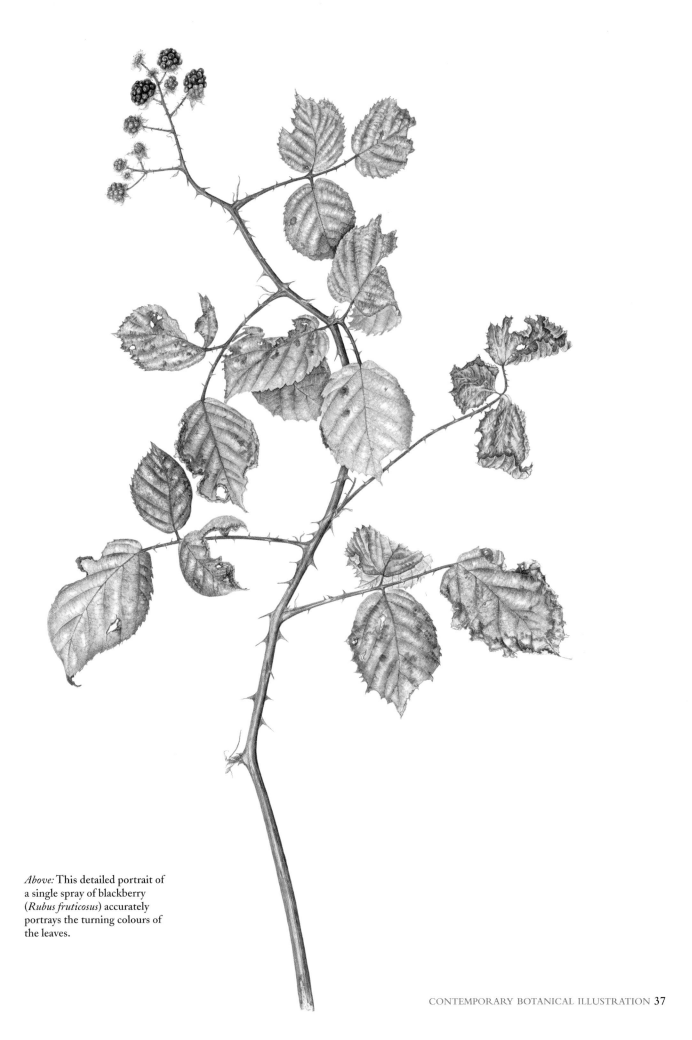

Above: This detailed portrait of
a single spray of blackberry
(*Rubus fruticosus*) accurately
portrays the turning colours of
the leaves.

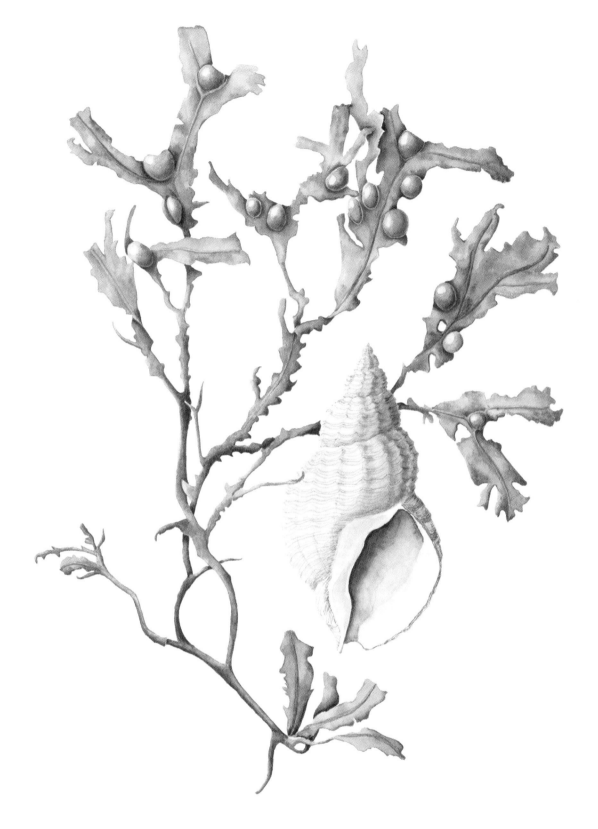

Seaweed can be a difficult subject to paint and benefits from some other indicator of its habitat such as a shell. This strand of bladderwrack (*Fucus vesiculosus*) has been set off by a Cornish whelk shell. Bladderwrack was discovered to be a good source of iodine in the early 19th century and has since been used as a treatment for goitre, the swelling of the thyroid gland. It is an anti-inflammatory and is also used in remedies for obesity, rheumatism and rheumatoid arthritis. Farmers and gardeners spread it on the land as a potash fertilizer.

Above: The addition of a Cornish whelk shell to this painting of bladderwrack (*Fucus vesiculosus*) adds interest and gives an indication of the seaweed's habitat.

Rhododendron falconeri (right) originated from Sikkim in the Himalayas and was found at the Lost Gardens of Heligan; the flowers are almost completed but the leaves have still to be painted. The picture will benefit from the strong green leaves that will offset the creamy yellow of the flowers. This is a good example of how you should not be put off by the initial stages of a painting and is a subject that will require a further season to complete. The finished picture will show the large, full truss of cream-coloured flowers above magnificent, large, rough, wrinkled leaves with rusty, brown, hairy backs. It also gives us increased understanding of the light/dark contrast theory, where pale with pale rarely works, but pale with dark (as it will be when finished) will work well.

Filling a page of A1 paper – 594 x 841mm (23.4 x 33.1in) – the medley of spring flowers overleaf will take at least another season before it is finished. Notice all the different greens, and how they fit so well with each other. See also how the petals of the white flowers (wood anemones and snowdrops) appear whiter than the paper they are painted on. This is an optical illusion, as no white paint is used. The artist says:

'This picture was inspired by a drift of snowdrops growing in the wild beside the River Dart in Devon, and initially I thought I would cover the whole sheet with these, growing up through the bracken and dead grasses as they appear in the first months of the year.

I started detailed drawing, then painting with two fine brushes and the basic primary watercolours, completing the various stages of the flowers from tight, upright, sheathed buds to the mature 15–20cm (6–8in) stems with wide open, hanging flowers. I chose the background wash colour on a particular misty morning as it seemed just right.

Then as the other spring flowers slowly replaced the snowdrops – the delicate wild daffodils, wood anemones, wood violets, wood sorrel, blackthorn blossom and lesser woodrush – I felt it would be an interesting composition to create a window effect, the snowdrops bounded by a natural frame of honeysuckle and other things, including lichen-covered twigs, which I love painting. I like working in this interwoven way, as perceived in nature. I can imagine a couple of cobwebs being included as I near completion, and I hope to complete the picture next spring as I like to work with live specimens.'

Above: The flowers of the majestic *Rhododendron falconeri* are almost complete but the leaves have still to be painted.

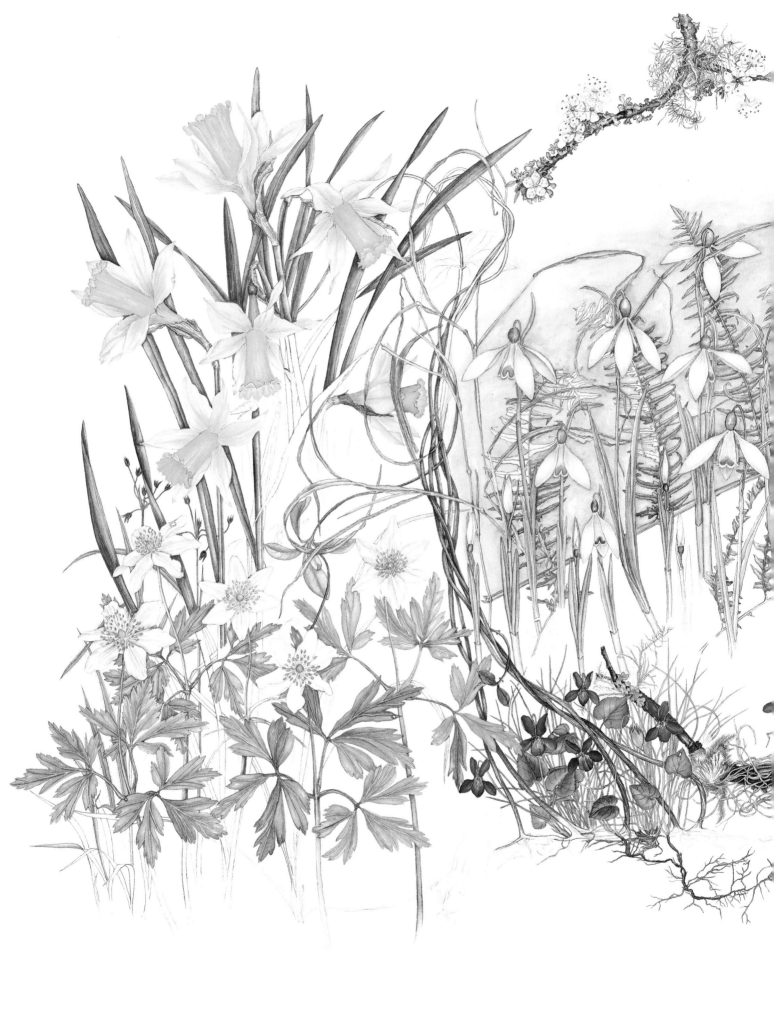

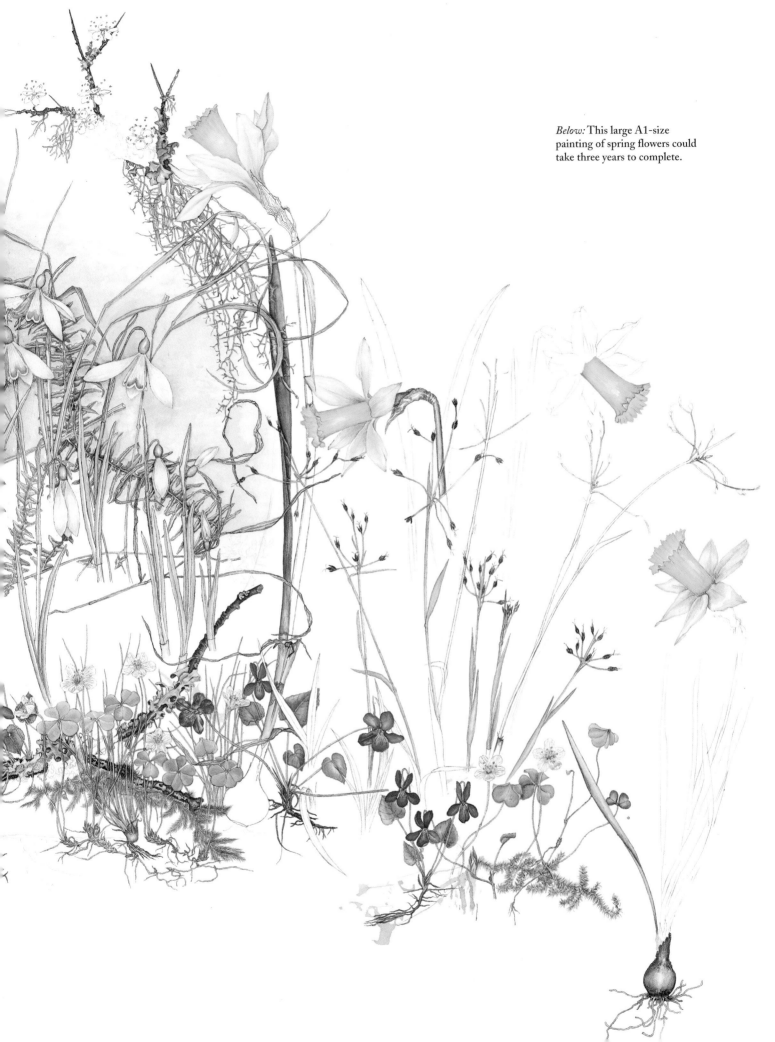

Below: This large A1-size painting of spring flowers could take three years to complete.

Another way of indicating the growth and habit of a plant, especially one that is too large to fit on to a standard-size piece of paper, is to choose a representative section and paint a single leaf, a flower spike and seedpods, and to indicate the overall shape of the plant in its entirety with a line drawing scaled down to fit into the overall arrangement (below). Consider the arrangement of a collection of stems, which when done well can look unusual and different. Try arranging them crossing over each other, and then with space between for a more open formation and decide which you prefer.

Left: The Indian shot plant (*Canna indica*) is a highly ornamental perennial plant that can grow to 200cm (80in) high. Its common name comes from the fact that its seeds were found to be uniformly spherical and extremely hard, making them a good substitute for musket shot.

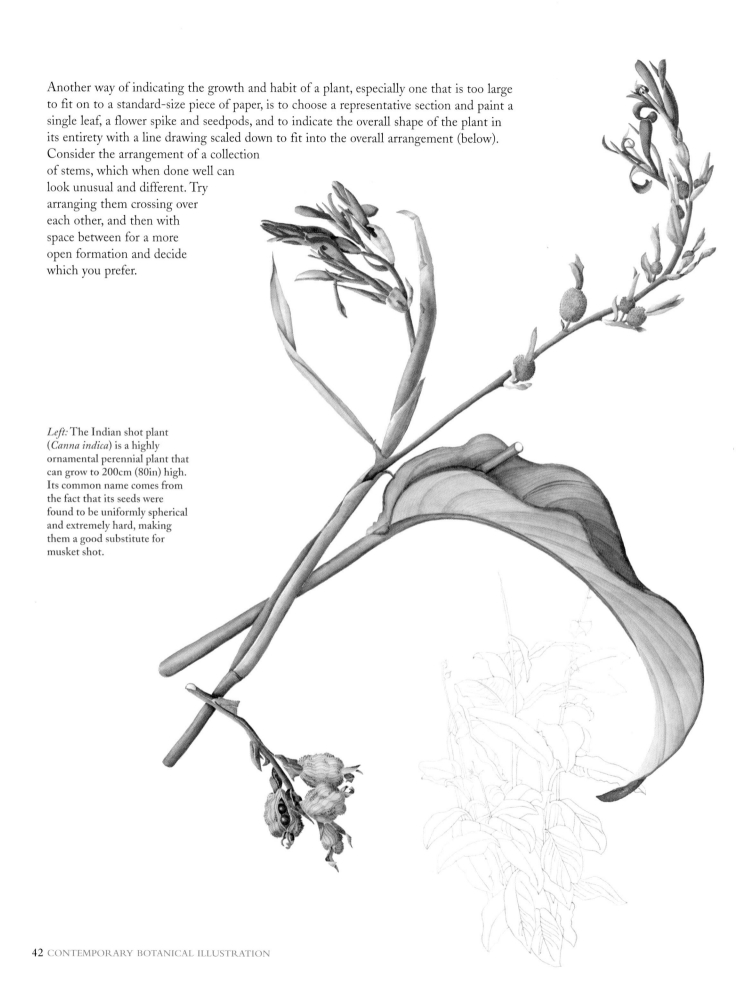

The different characteristics of the stems of cotoneaster, bramble and rose (below left) are accentuated by placing them parallel to each other. The cotoneaster is dead and dry, with sharp, rough thorns in no apparent order around the stem. The bramble, or blackberry, has leaves around the stem at three regular positions (leaves not shown) with buds growing from the axils. The rose has an oval stem, thicker and smoother than the other two, which branches in a three-part spiral similar to that of the bramble.

Sometimes the most important part of a plant is not immediately obvious. In the case of madder (*Rubia tinctorum*) it is the root, or rhizome, that is of prime importance. Before the advent of chemical dyes, madder was the main cotton dye in Europe, giving a range of red to purple colours. A member of the *Rubiaceae* family, it is related to the plants that give us coffee and quinine. Rather than show the whole plant, just a stem of leaves and flowers is painted here, with the reddish-brown root straggling out behind it. Red and green are complementary colours, red being dominant. Here it has been placed well behind the green leafy stem so as not to attract too much attention to itself, but still to give a tantalizing glimpse of its character.

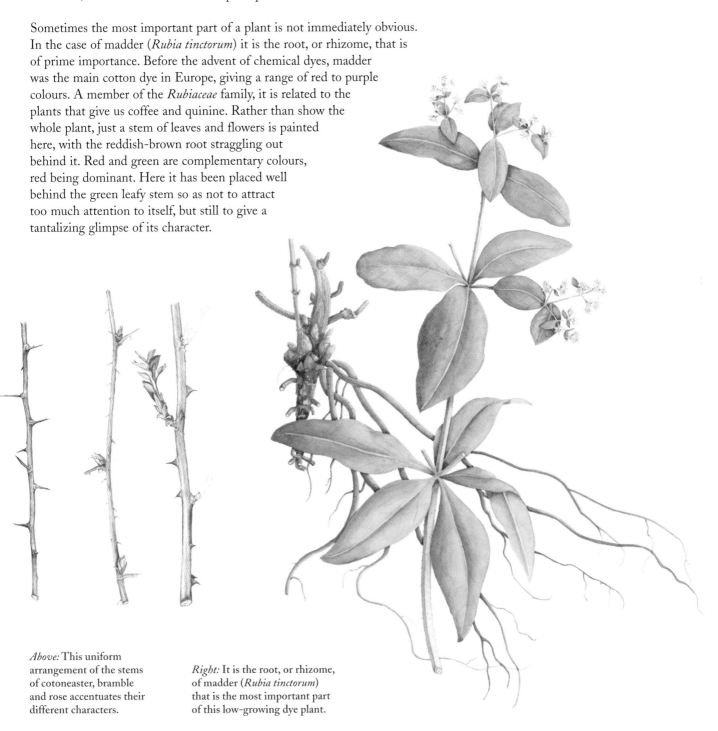

Above: This uniform arrangement of the stems of cotoneaster, bramble and rose accentuates their different characters.

Right: It is the root, or rhizome, of madder (*Rubia tinctorum*) that is the most important part of this low-growing dye plant.

If you choose to show a series of similar plant parts, remember that the eye can 'count' up to five items; more than that can look jumbled. Decide whether you want to show a busy design or a simpler portrait.

Right: The colourful fruiting stems of cuckoo pint, or lords and ladies (*Arum maculatum*), are a difficult subject to make interesting, as they are so stiff and plain. But by placing one crossing behind another, and including a smaller immature stem and a horizontal one with the berries falling off, the artist has brought some movement and interest into the picture.

A simple portrait.

A busier design.

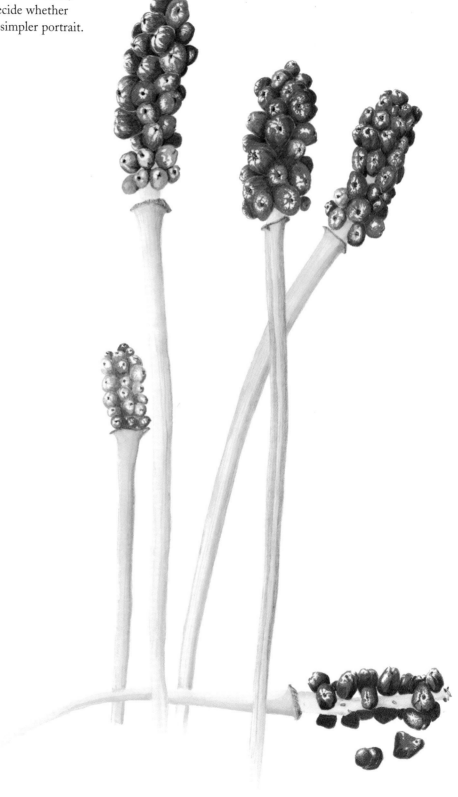

You may wish to add features such as a dissection of a flower or seed, enlarged areas or simply more detailed studies of leaves or petals. Consider carefully the placing of these. They should be close enough to give a cohesive appearance without crowding the main illustration, but not so far away that they seem detached from the main subject.

Right: This is a working drawing, but ably demonstrates how small details of parts of the subject can be placed on the paper in a pleasing way. The artist has made notes to herself: 'Bulb solid, spherical, papery surface, large, craggy, matt. Roots long, solid, numerous, round, branched at ends. Soil adhering to small roots. Leaves upright in sheaves. Root smooth, round, solid. Rootlets rough, curled, earth-covered, whiskery.'

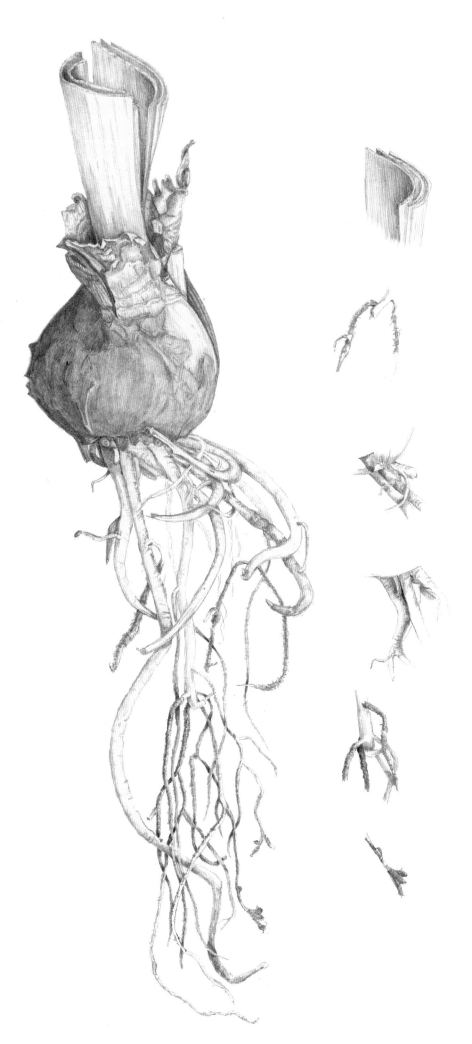

Two ways of showing a plant with more detailed studies of its component parts.

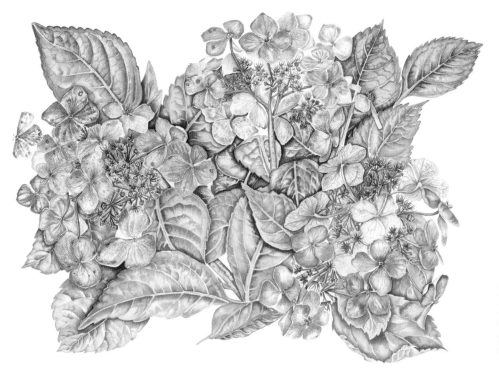

Left and below: Two different treatments of the same subject, hydrangea. One picture masses the flowers and leaves to fill the page; the other shows a simple stem with one flower head.

It is not always necessary to adhere strictly to what you see in front of you. A certain amount of 'tweaking' is permissible in order to make a pleasing composition. You may need to change a particular aspect in your subject to make a satisfying arrangement on paper, but take care not to compromise the plant. To determine the position for the orchid stem opposite, the artist made a tracing of the picture, which was then photocopied. She then added various arrangements for the stem until she found the most favourable position, placing it in a variety of positions relative to the flowers, which remained constant. Figures A–E show different stem arrangements and figure E, with a short, slightly inward-facing stem, was the composition finally chosen.

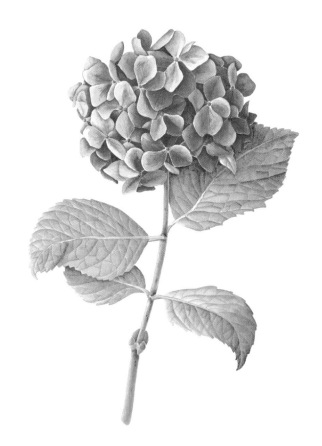

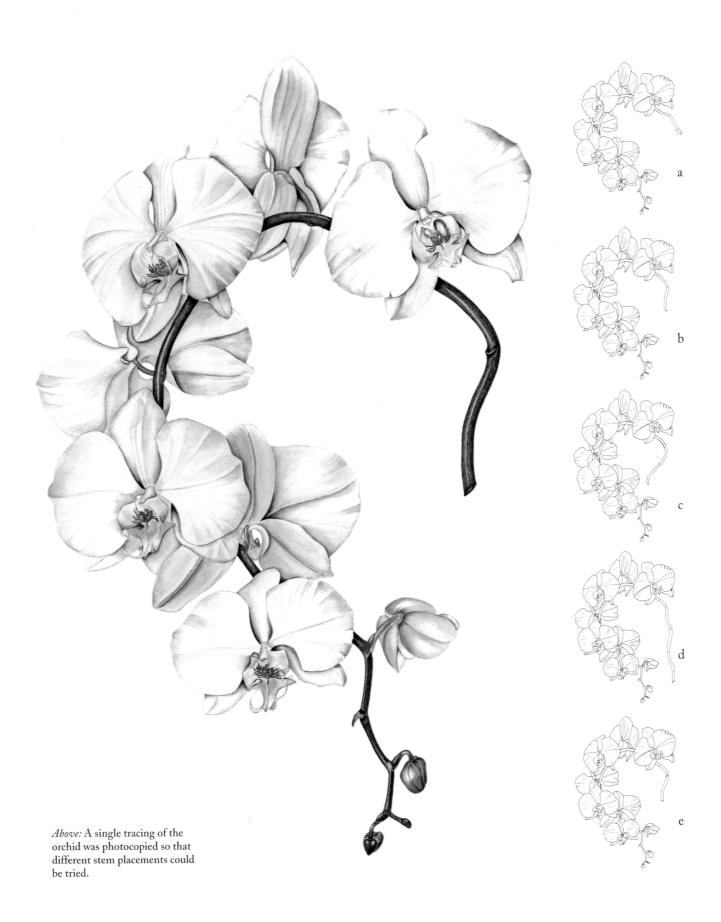

Above: A single tracing of the
orchid was photocopied so that
different stem placements could
be tried.

a

b

c

d

e

Printers will tell you that images are more appealing if they face towards the opening edge of the paper, or in line with the direction in which we read text, which in the Western world is from left to right. You might like to consider whether your subject needs to favour a particular direction and why you choose to place it where you do. How do you feel about these two arrangements (below)?

Sometimes a pleasing presentation can be made by selecting a detail of your picture, for instance, to go on a greetings card (see page 139).

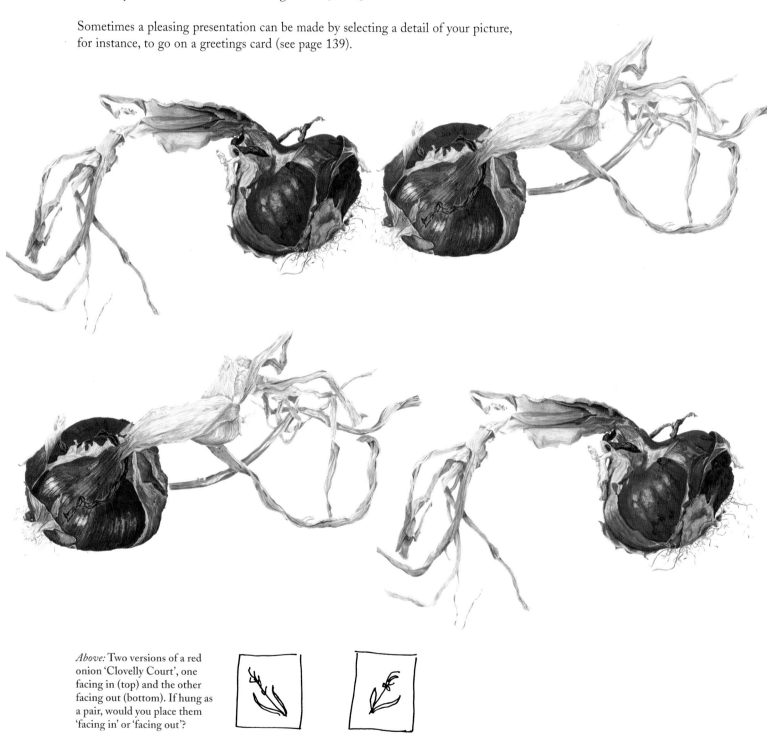

Above: Two versions of a red onion 'Clovelly Court', one facing in (top) and the other facing out (bottom). If hung as a pair, would you place them 'facing in' or 'facing out'?

In the same vein, would a group of pictures designed to hang together be easier on the eye if the images in the outer pictures face outwards rather than inwards? How do you feel about these arrangements?

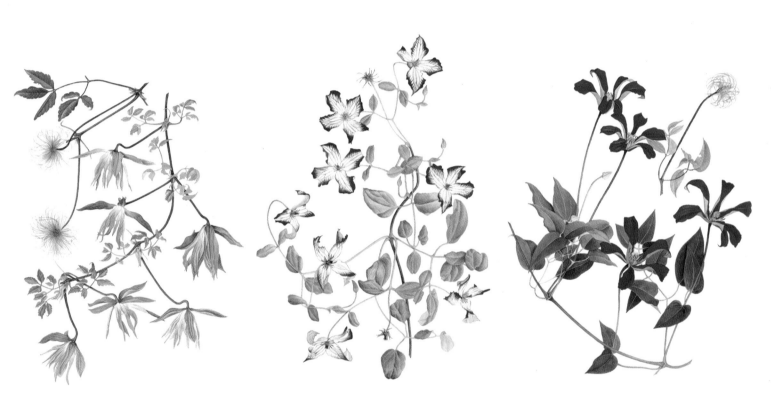

Outgoing aspect.

Facing inwards.

Above: Pictures that make up a set can be displayed to best advantage by hanging them side by side.

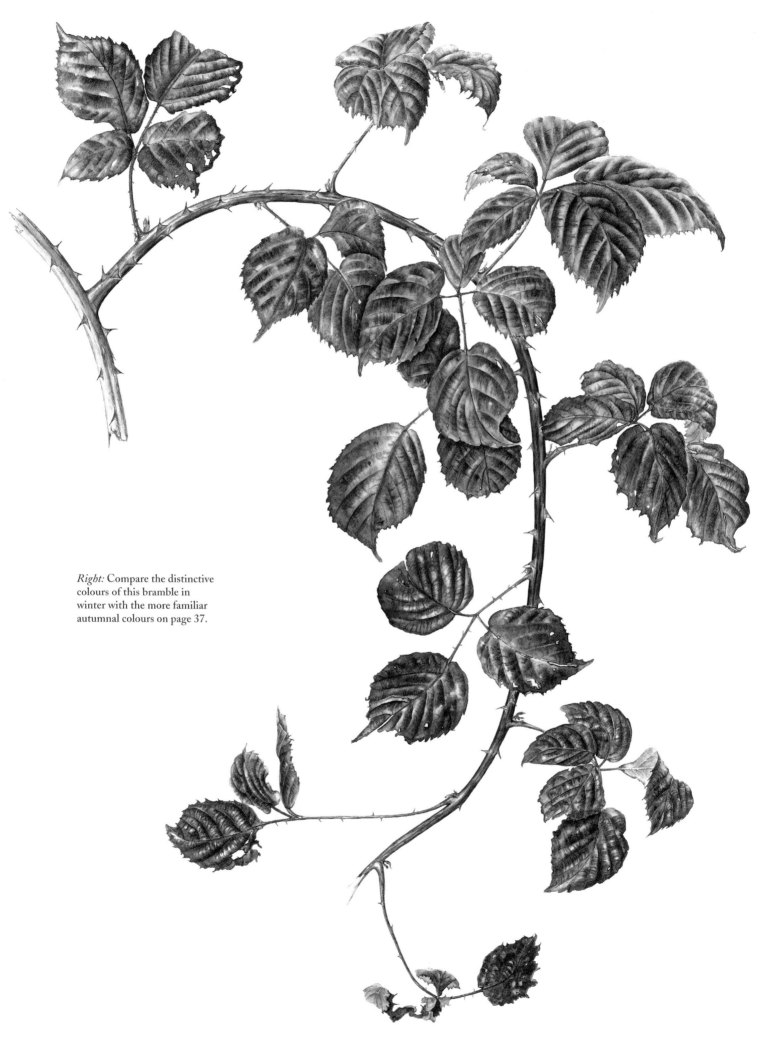

Right: Compare the distinctive colours of this bramble in winter with the more familiar autumnal colours on page 37.

Ikebana

The ancient Japanese art of ikebana (flower arranging) has many underlying principles that can also be applied to contemporary botanical illustration. Ikebana means 'living flower' and dates from the 6th century. It was developed from a ritual flower offering at Buddhist temples. Harmony between man and nature lies at the heart of ikebana, which is based on three parts symbolizing heaven, earth and man. A thousand years later ikebana had become a full-blown art form practised from its inception by artists, religious figures, educated people and military rulers. A highly disciplined classical form developed, based on complex theories.

Modern ikebana still emphasizes these principles. They are as complex as they are simple and can be used as a guide for the pleasing composition of a botanical painting. In ikebana, as long as the soul of the flower is captured, it is debatable how it is placed in the vase, provided it appears to be growing in perfect harmony with its new environment. In a painting, the true character of the plant must be captured and should work in harmony with the shape, size and colour of its 'container', the paper.

'A flowering branch is treated as though it has emotions – happy, sad, aged and bent by the weather, young and tender. Similarly, great attention is given to light and dark, colour, line, angle and form, mass and proportion.' This is a simplified version of the description of ikebana in *The Essentials of Ikebana* (see Further Reading, page 141). These illustrative words are very similar to those our students follow in their drawing training when they are encouraged to write down all descriptive words relating to their subject before starting to draw. This not only encourages them to look carefully at the subject and understand the individual nature of the plant but also gives them reference points to look back upon as they draw. (Even for the keenest student, it is probably not necessary to follow the earliest versions, which demanded that the proponent even breathed in a certain way in order to achieve oneness while bending a branch or clipping a stem.)

There are other parallels with contemporary botanical painting, one of which is whether the style or personal interpretation of the artist should take centre stage. The debate continues: how to respect the conventions while developing the art form? How relevant or significant is the artist's personal viewpoint? What, if anything, is the point of change for an art form that so clearly defines its boundaries? The styles of ikebana range dramatically from the early formal style, *rikka* (standing flowers), to the more modern, casual compositions called *nageire* (to throw in). Even in today's modern movements the underlying message remains resolute: the life of man and the life of the flower are inseparable.

The modern or contemporary style of ikebana naturally enough finds many critics in the same way that change in any art form does. The purposes of new interpretation are many: to broaden concepts; to contribute deeper significance to that which is and has gone before; to stimulate the imagination of the practitioner and viewer; to disarm, charm, disturb, captivate and stimulate; to expand perceptions. We can adopt these ideas while still adhering to some fundamental truths within the context of botanical illustration. A sound knowledge and grounding can develop judgement and feeling for composition and what works. The real purpose is to search out and present new, not merely novel, concepts. The contemporary does not necessarily seek to displace time-honoured principles; more to introduce fresh concepts, which aim to add depth and brilliance to the already respected traditions.

It is the symmetry, asymmetry and symbolism of ikebana that makes it so attractive. Rather than looking random and even messy, the finished piece of ikebana has strength, vitality, tranquillity, grace and a Spartan elegance that is both impressive and humbling.

Figure A shows an ikebana-inspired arrangement of flamingo lily (*Anthurium andraeanum*) and lotus (*Nelumbo nucifera*) seedheads. The simple, bold and sculptural arrangement is anchored by the large mass of the red anthurium at the base. The texture of the holes in the lotus seedheads is very different from the plastic surface of the anthurium. The colour of the anthurium could be varied as an experiment in colour variation and weight distribution.

Figure B is an arrangement of irises, vine and variegated foliage. The tall, stately irises and dark, twisted vine emanate from a cluster of variegated foliage. The three very different subjects both contrast and balance one another. The mass of foliage stabilizes the asymmetric wandering of the vine and the tall, upright irises give solidity to the group's differences.

All three subjects in figure C – the bird of paradise (*Strelitzia reginae*), bamboo leaves and pink Japanese anemones – contrast yet harmonize through their combined colours and vastly differing shapes. The top three strelitzias face in different directions and are echoed by the one at the base, which blends with three deep pink Japanese anemones. The jewel colours are all strong enough to act alone and in unison. The strong colours and upright stems of the strelitzias are softened by the delicacy of the light green bamboo leaves.

The highly contrasting black and white subjects in figure D – black bamboo and white Japanese anemones – make a stylish composition that demonstrates both the power of black and white and also the strength of density (bamboo) and delicacy (anemone). The small diagonal bamboo twigs arrest the extreme verticals of the main stem while the delicate anemone flowers soften the dark austerity of the bamboo.

a

These ikebana-inspired sketchbook compositions use subjects that display very different properties. The object of this exercise is to combine these different features to give a contemporary feel to the compositions. The artist has tried to balance tone, colour, line and form. The spaces between the subjects receive as much attention as the subjects themselves.

Right: A sketchbook page of four ikebana arrangements, giving a good idea of tone, colour, line and form.

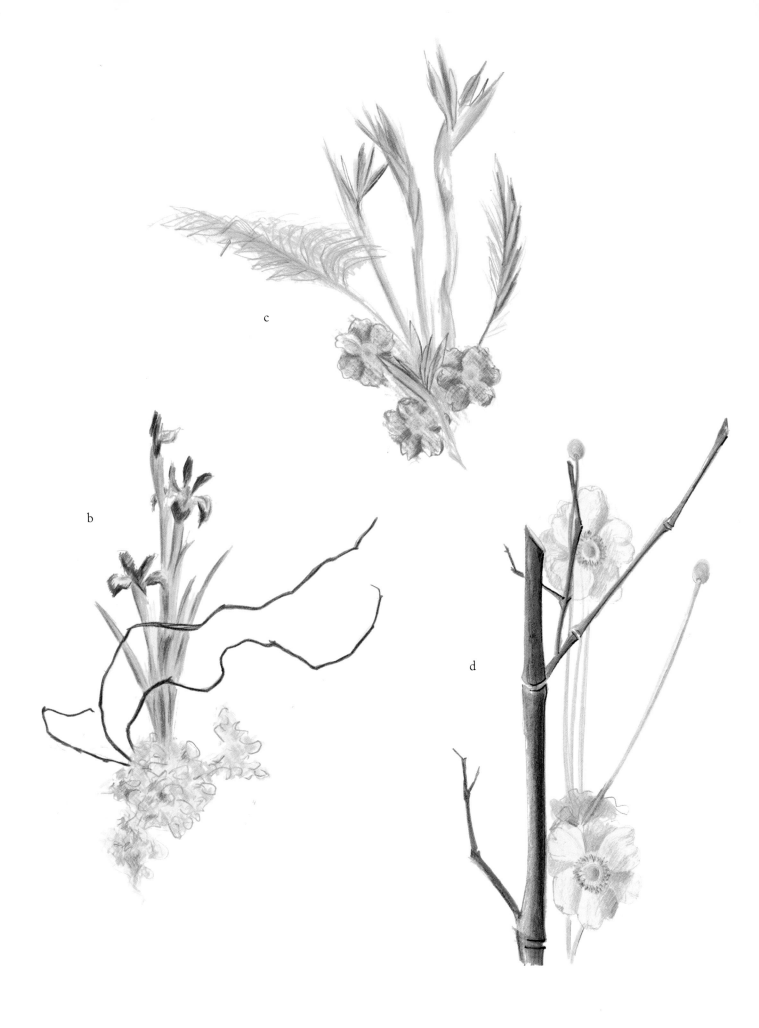

b

c

d

Exercise – composition

Research ikebana using the Internet or visit your local library. Select a few elements that are themed in some respect, for example, different parts of the same plant – root, bud, seed, fruit, flower and so on.

Alternatively, select unrelated elements (naturalistically speaking) that have some kind of relationship, such as beech nuts and fungi whose habitat is beech woods, companion plants in a symbiotic relationship, or plants having a visual relationship either objectively or subjectively. Using these elements, compose two line drawings, one showing how you would usually arrange a subject or subjects, and the other, using exactly the same number and type of components, inspired by ikebana principles.

Below: A loose, traditional arrangement of a bluebell flower spike, leaf and seedheads (left) contrasts with the tight upright arrangement inspired by ikebana (right).

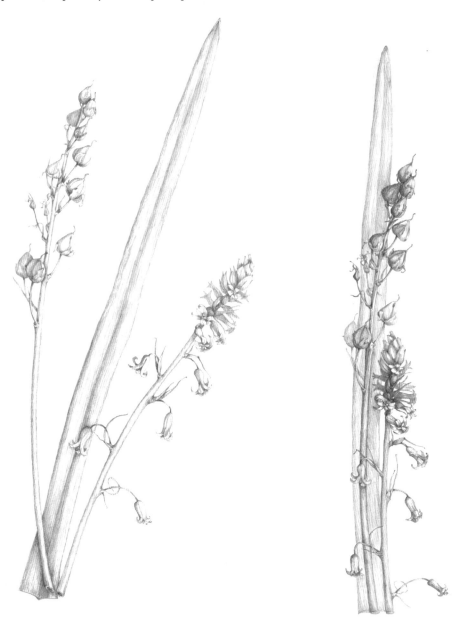

Above and left: Asparagus spears in a traditional arrangement (above) and a more unusual revolving configuration with ikebana influence inspired by 'life cycle' (left).

Left: This exotic dragon fruit *Hylocereus undatus* is so complex that it lends itself to a well-constructed pencil drawing.

4. Pencil drawing

There will always be those few people who can 'draw' with a brush, but for most of us pencil drawing is as important, if not more important, than the ability to paint well. This is because in botanical illustration there is absolutely no point whatever in putting paint to paper until you can draw your subject accurately, establishing the three Ss:

Size: life-size, unless stated otherwise
Shape: the space it occupies
Shading: gives three-dimensionality.

It is vitally important to learn the different uses of pencils and which ones do what, making marks of different strengths and character and learning how to show texture and tone. At the same time you will learn how to look at your subject and make decisions as to its form and where the light falls on it, its position and relationships (one part to another) and the spaces around and between.

There is nothing worse than spending lots of time working up a picture and putting in the last touches only to discover that everything has been wrong since the beginning. In addition to the three Ss above, remember the three Es:

Explain: what is happening in the plant shape?
Emphasize: clarify the bits that are not clear
Exaggerate: show features that may initially appear indistinct while at the same time taking care not to distort them.

Drawing a plant

Before beginning to draw, spend some time looking at your subject and contemplating its shape and how the light falls on it. Try moving it to different positions to get the best composition for your drawing.

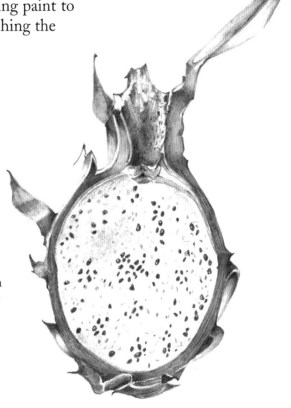

Above: This pencil study shows how the black pips of the dragon fruit appear suspended in the semi-transparent flesh.

- List all the words that describe it – sleek, glossy, hard, furry, matt, pale, scruffy, soft, warty, scaly – and refer to them frequently while drawing.
- Consider whether your drawing should be portrait or landscape shaped. Only occasionally can an upright subject look good on a landscape shape, and vice versa (for more on this see chapter 3, Composition).
- Make trial drawings first on cheap layout paper, so that you have 'learned' the plant before using expensive paper.
- Choose a large enough piece of paper to fit your subject and leave a good margin all round, at least 5–10cm (2–4in).
- Note any basic forms and shapes such as cones, circles, ellipses, cylinders, hemispheres, spheres – as well as the overall shape.

- Work out the central point of your subject and place it in the centre of your paper. You don't want to find halfway through that you have to scrunch up bits of your plant to fit them in.
- In the case of leaves, note the distance from the mid-rib to the leaf edges. Is the distance on one side greater than on the other, or are they similar? Sometimes it is easier to establish these points by looking at the spaces between petals, leaves and stalks. This is called the negative space, and it is part of the overall shape of your subject.
- Plot on your paper, using light markings, the extremities of the shape that your subject occupies, such as the end of the stem, petal tips, leaf tips. Join these with lightly drawn lines, like a dot-to-dot drawing. Take special note of the distance between these points and their relationship to one another, their angles, length and width.
- Make sure the proportions and scale are all correct, and that your drawing is life-size. It is very easy to draw too big or too small at the outset, which will then throw out all subsequent measurements.
- If you draw something incorrectly, don't erase it but make notes as to why it is wrong and start another drawing of that part elsewhere on your layout pad. If you rub out mistakes you have no record of them, and it is our failures that help us to learn. Alternatively try an amended drawing over the existing one. When you are satisfied that the new attempt is correct, erase the faulty section. This will greatly help your draftsmanship skills.
- Once you are happy with your working drawing, transfer it to good paper by means of a light box or tape it to a sunny window and trace through. To do this, tape the working drawing to the glass at eye level, tape your watercolour paper on top, then trace very lightly, with a fairly hard pencil, taking care to be as exact as you can. Any deviations from the working drawings will only be compounded when you start to paint.

To summarize, drawing is a process that is partly cerebral, partly intuitive:

1. Observe
2. Work it out
3. Do.

Non-directional shading

Shading in pencil can be done as either hatching or cross-hatching, or by non-directional shading.

Hatching is a series of fine parallel lines. Cross-hatching consists of similar fine, parallel lines with another set of fine, parallel lines across them. Neither of these techniques is particularly suitable for botanical illustration, since there are few natural surfaces that mirror the criss-cross effect.

Non-directional shading is just that – shading that moves in no particular direction. You will need either a very sharp pencil or one that has worn down to a smooth pad, depending on the strength and density of the shading required. Your hand should make a minuscule circular movement in all directions, gently burnishing the paper until the required intensity of shading is achieved. The aim is to shade the subject with no pencil marks showing, just a smooth tone.

Above: Fine dots and lightly drawn lines help to establish the extremities of the shape of your subject.

Exercise – observation

Although not strictly botanical, this is a very good exercise to improve your observation skills and your ability to draw what you see. Place a white egg in the folds of striped or patterned fabric. Without marking the outline of the egg on your paper, draw just the surrounding fabric, leaving the shape of the egg untouched as plain white paper. Not only does this show how the pattern moves and changes, but it allows the egg to be drawn as a negative space.

Exercise – drawing texture and tone

The purpose of these drawing exercises is to fix your subject in your mind, to teach you how to sum it up, to construct a representation of it quickly and to tackle highly detailed examples of textures that you might encounter in the future. As you become more adept at pencil drawing and discover more about what your pencils can do, it will become clear that a finished pencil drawing can be as beautiful and informative as a skilful painting.

Above: How to draw an egg without drawing an egg.

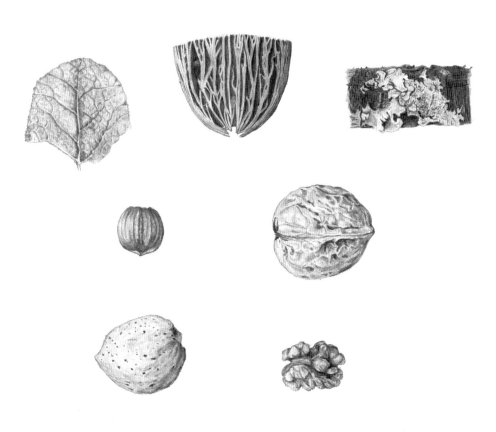

Above: Pencil textures are shown in these examples – a ridged seedpod, lichen, hazel nut, walnut shell and nut, almond and primrose leaf.

Right: Finished pencil drawings can be as beautiful and informative as a skilful painting. This pine cone is a good example of tonal values, texture and three-dimensionality.

Tonal evaluation

Tone represents the light and shade in a picture and is something you need to understand at the outset. In botanical art a piece of work that lacks tone lacks body, life and vitality.

Good pencil work is done by degree. A careful and slow build-up of tones and texture creates the illusion of a three-dimensional image (your subject) on a two-dimensional surface (your paper). Use your full range of pencil grades. The harder pencils (6H–H) are best for the initial drawing and for the lightest of shading. You should be able to achieve all the tones that you need with pencils from 6H to HB. Anything softer than that, particularly the Bs, tend to leave minute particles of graphite on the paper, which easily smudge. They also tend to lift off and muddy the colour if used under a watercolour wash.

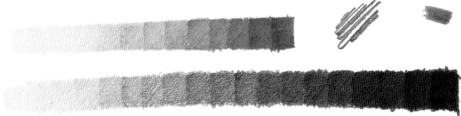

Above: Tones achieved with a 2H pencil (top row) and a B pencil (bottom row).

Above: The upper half of this primrose leaf was drawn with two grades of fairly soft pencil, HB and 2B. The lower half has a lighter touch; the pencils being the harder H and 2H and very hard 6H.

Below: Studies of lychee, passion fruit, fig and physalis, showing both exterior and interior of the fruit.

Whatever grade of pencil you use, employ the lightest of touches. Be aware that if you press too hard you will affect the quality of the paper, which will tend to stretch and cockle. Never, ever, press so hard that the pencil causes a groove in the paper because you may wish to rub out later; this will be impossible and paint will collect in the grooves, leaving lines.

The drawings on these pages illustrate a wide variety of structures, textures, tonal strengths and well-indicated light sources. To help understand just how the 'tonal weight' of the iris leaves and rhizome (right) is distributed, the artist has completed a proportional tonal test strip (below). Notice how the areas of extreme dark are in the minority and the many mid-tones have been carefully registered in their correct proportion. If the darkest tones were to outnumber any of the other tones this would indicate that the finished painting could be too heavy and dark. Similarly, if the darkest tones were too few, the resulting painting could end up lacking in contrast.

Right: The young leaves and rhizome of *Iris* 'Black Taffeta' shows clearly the number of tones present, in preparation for the finished painting on page 103. If the subject dies or changes drastically, this tonal evaluation drawing, along with colour trials and notes, will allow you to reconstruct the plant successfully from all the information gathered.

Below: The tonal test strip helps to explain how the 'tonal weight' of the iris leaves and fleshy rhizome is distributed.

| 1 | 2 | 3 | 4 | 5 | 6 | 7 | 8 |

Exercise – making a tonal strip

Make your own tonal strip using any subject. To begin with choose one that is fairly simple, with clean lines and a minimum of confusing pattern or texture, such as an apple, some simple leaves or a tomato.

Draw and shade your subject. Remember that adjacent similar tones tend to recede or become 'out of focus' while contrasting tones appear sharper and nearer. It is the contrast between light and dark that, literally, gives the 'edge' to your work. Don't hurry over this; it is worth spending time getting it just right. Imagine taking a black-and-white photograph of your subject – what and where would the tonal values be?

Look carefully at your finished drawing, which will probably be more complex than your previous exercise on page 59, and make a tonal strip, assessing how many different tones there are and what proportion of the whole each tone represents. If you learn to identify tonal proportion in this way it will increase your ability to recognize light/dark distribution, and to work out ways of enhancing a painting or drawing visually by adjusting the amount of tone, which in turn heightens the three-dimensional 'feel'. After a while you will be able to look at any subject and make a quick and accurate assessment of tonal proportion.

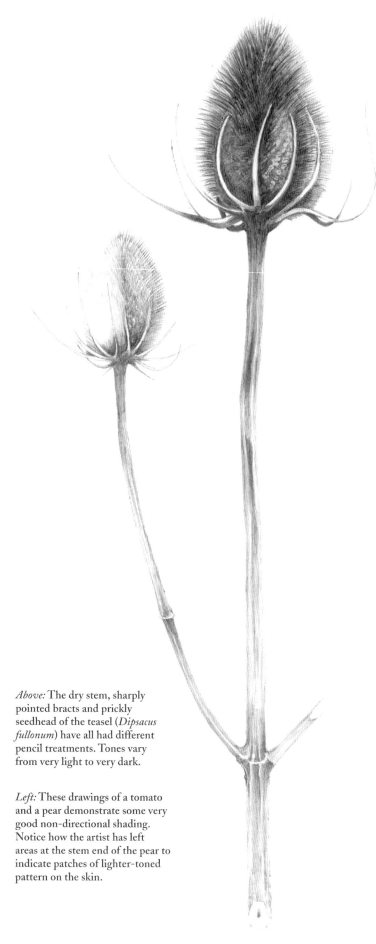

Above: The dry stem, sharply pointed bracts and prickly seedhead of the teasel (*Dipsacus fullonum*) have all had different pencil treatments. Tones vary from very light to very dark.

Left: These drawings of a tomato and a pear demonstrate some very good non-directional shading. Notice how the artist has left areas at the stem end of the pear to indicate patches of lighter-toned pattern on the skin.

Above: It is the contrast between light and dark that, literally, gives the 'edge' to your work, as in these studies of Asiatic lily (*Lilium* sp.) (above) and the Nepal lily (*Lilium nepalense*) (right).

Above: A very fine graded wash
has been used to delineate the
gills of this *Leucocoprinus
ianthinus*, a beautiful fungus
found with some of the plants
in the Rainforest Biome at the
Eden Project. It has greeny-
blue gills and a vile smell.

5. Painting techniques

The most important painting techniques for botanical illustration are:
> Flat wet-on-dry wash
> Graded wash – colours grading from light to dark
> Blended wash – more than one colour blended together
> Wet-into-wet (or wet-on-wet) wash
> Superimposition – laying one colour over another (see page 79)
> Graded tone
> Stippling

The initial wash determines the lightest areas of the subject. This can be a flat wash or you can incorporate other or stronger colours into it when it becomes a graded, blended or wet-into-wet wash. The first three techniques are painted straight on to dry paper. You may find it easier for all washes if you lay your paper flat so that you do not have to contend with the desire of the water and paint to travel downwards.

Flat wet-on-dry wash

Load your brush with well-diluted paint and lay it on swiftly and carefully, covering all the paper before the paint has a chance to dry. A good flat wash shows no brushstrokes and covers the paper evenly. Allow it to dry completely before laying more paint over it.

Graded wash

No surface of a natural subject is so flat that there are no variations in its tone. Tone is present overall, giving three-dimensionality to a two-dimensional picture.

Place a plain-coloured fairly smooth leaf (not a variegated one) on your worktable, with the light falling on it from one side (see page 13). Let your eye flick from one side of the leaf to the other several times and ask yourself which is darker. Inevitably you will see that there is a difference, even if it is only infinitesimal. This difference may be subtly accentuated to give life and form to your painting. You will also notice that the tonal change is gradual – there are no sudden 'jumps' in tone or colour. To achieve this effect in your painting you will need to master the graded wash.

Make a strong solution of dark green. Load your brush and paint in the darkest side of your subject. While it is still wet, by gradually adding water to your brush and working away from the dark side you will dilute the initial colour until eventually it all but disappears. Be careful that your transition from dark to light is even and smooth. You can achieve this by making sure that your brush is neither too wet nor too dry when adding water to the wash.

Above: This delicate study of lily petals demonstrates graded washes and stippling.

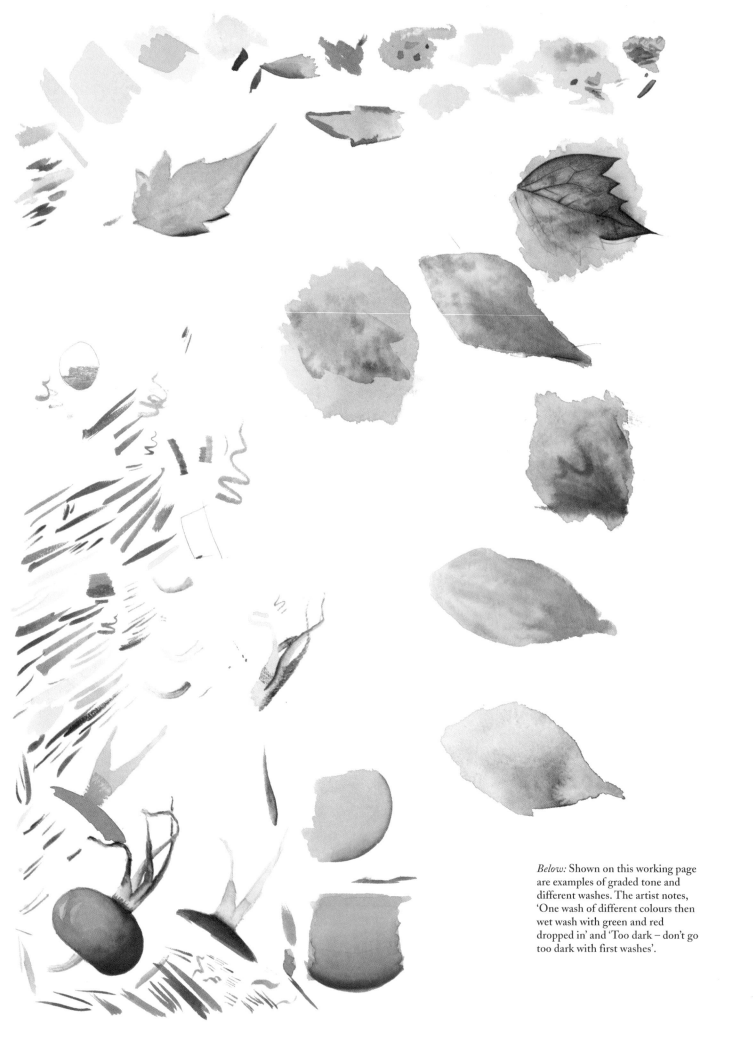

Below: Shown on this working page are examples of graded tone and different washes. The artist notes, 'One wash of different colours then wet wash with green and red dropped in' and 'Too dark – don't go too dark with first washes'.

The graded wash is useful in so many circumstances. You will see it in many of the painted illustrations in this book, but it is particularly noticeable in a very fine form where it delineates the gills of *Leucocoprinus ianthinus* (see page 64), giving them sharp edges and depth on an extremely small scale. (What it cannot portray is the vile smell given off by this particular fungus!)

Some artists like to paint all the shading in a neutral black or grey before applying colour, a technique that is not dissimilar to watercolour over pencil. In this study of a rose leaf (right), there are four leaflets on the right that have been shaded in but not coloured. The three upper ones on the left were treated the same way and then had colour applied, while the two lower ones on the left were painted and shaded with colour from the outset. There is not much to choose between the two techniques, but it can render a subject dull and lifeless if not handled with care.

Blended wash

Whereas a graded wash moves from dark to light, a blended wash changes from one colour to another. It is usually painted on to dry paper, blending one colour into another while they are both wet. A certain amount of care is necessary to ensure that one is not stronger or wetter than the other, thus 'chasing' it off the paper.

Wet–into–wet washes

Before starting, spend some minutes studying your subject. This wet-into-wet technique is particularly good for subjects such as holly leaves, giving them a glossy and lively finish (see page 68).

Graded tone

For this technique a strong mix of paint is carefully shaded to very pale or no colour at all, using a damp brush. It is used to show tonal gradation and determines the three-dimensionality of the picture. You will need to practise so that you can achieve a smooth transition from dark to light, with no hard edges or watermarks.

Stippling

Often, usually towards the finish of a painting, you will need to stipple. This is a form of blended tone, a short, fine stroke with a fairly dry brush, particularly useful when you already have a strong build-up of colour from your washes, when placing more wet paint on the paper would simply lift off the colour already there. Stippling is used to accentuate tone and can be blended into existing washes with a damp brush to smooth out any rough edges. Some painters favour stippling instead of washes and build entire pictures using this technique, carefully working from light to dark using the minimum of water.

Above: An interesting technique is that of painting in the shading before adding colour, but this can make the subject dull and lifeless if not handled with care.

Exercise – holly

Draw a simple outline of the leaf, using a hard pencil (4H) and marking the paper very lightly (see figure A). Mix a good, strong green using Prussian blue, lemon yellow and a little Indian yellow. Painting one half of the leaf at a time, apply clean water to the parts you wish to paint using a fairly large brush (size 4–6). When the paper is still wet but not runny, drop in some of your green mix, carefully avoiding any highlighted areas.

To treat the veins, you may either use masking fluid before you start (see page 23) or take out the veins with a fine, dry brush when the paint is beginning to dry. Alternatively, take out when dry using a damp brush and blot with absorbent paper. Figure B shows where the veins have been taken out with a brush, figure C demonstrates the use of masking fluid, which has not yet been removed and appears as yellow lines. Complete the second half of the leaf in the same way.

Paint the darker areas of of the leaf with a stronger green using a small brush (0–2) and small stipple strokes. Paint in the base of the woody stem and define the pale green leaf margin. Figure D is not finished – the artist has yet to paint in the veins. If you feel it necessary, you may give the highlights a very pale blue tint, either with the initial wash or at the very end.

a

b

Above and left: Use a hard pencil (4H) to draw the outline lightly, then fill in with a wet-into-wet wash of green.

c

d

Above: Alternatively, use masking fluid to retain the white of the leaf veins.

Left: Areas of intense darkness have been completed with small, stippled strokes of strong green paint.

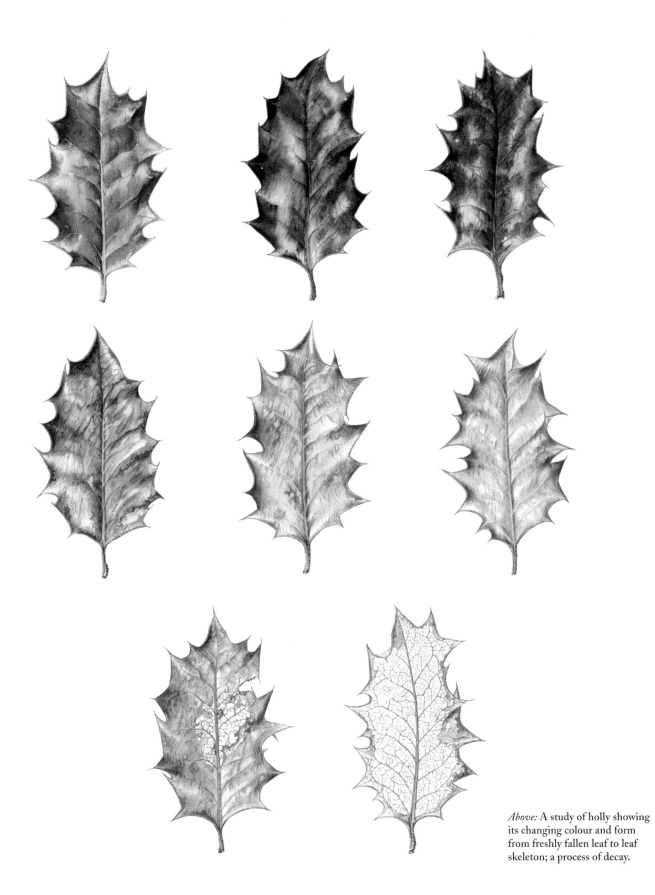

Above: A study of holly showing its changing colour and form from freshly fallen leaf to leaf skeleton; a process of decay.

Exercise – dock leaf

Stage 1

As with the holly leaf, study your subject, then mix the colours you require. In this case you will need a yellow-green and a mix of alizarin crimson and a warm red such as scarlet lake or permanent red orange. Wet the paper and cover with a fairly watered-down lemon yellow. Drop in the crimson and scarlet mix where shown. As with the holly leaf, you should work on half the leaf at a time.

Stage 2

Build up the colours using a fairly dry brush. Leave the veins for the time being; you will come back to these later. Be aware of the light area on each of the 'bumpy bits'. Either leave them clear or lift off the colour afterwards – either method is simple and you may find that you use a combination of the two.

Stage 3

Using a small, fairly dry brush, work up the light and shade with intense colour to give the leaf dramatic contrast. At this stage, paint in the veins. Use a small brush and a variety of browns – light golden brown (raw sienna), reddish brown (Venetian red) and for the darkest bits a blue-brown (Vandyke brown) – to accentuate the dry, crisp edges of the leaf. Also shade where the dry leaf tip curls over, to show the tonal contrast and add depth.

The right-hand side is darker on the leaf, the stem and the main vein, indicating that the light source is from the left. The section of dried seedheads has been painted entirely in shades of brown. Start with light golden browns (raw sienna), following this with red-browns (Venetian red) and dark blue-browns (Vandyke brown).

See page 91 for the equivalent manufactured colours used here, and details of how to mix them yourself.

Right: A small, fairly dry brush has been used to work up the colours of the leaf and to paint the stem of dried seedheads in a range of shades of brown.

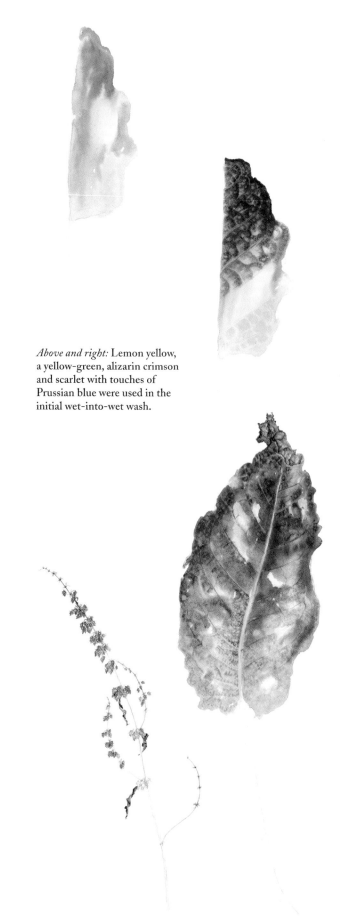

Above and right: Lemon yellow, a yellow-green, alizarin crimson and scarlet with touches of Prussian blue were used in the initial wet-into-wet wash.

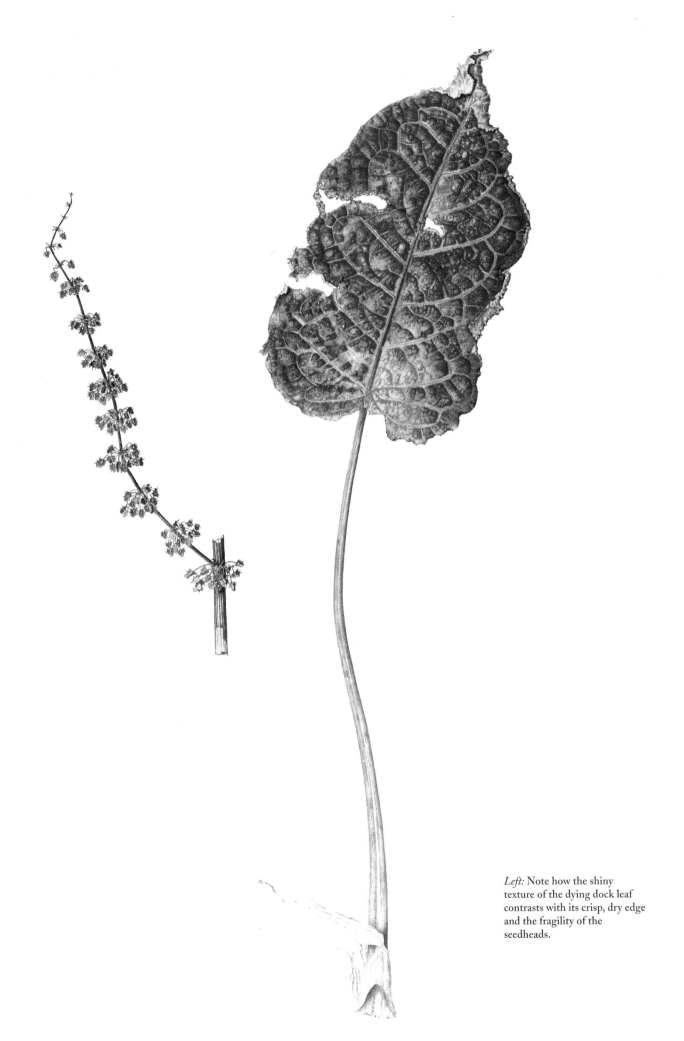

Left: Note how the shiny texture of the dying dock leaf contrasts with its crisp, dry edge and the fragility of the seedheads.

Exercise – fuchsia

These progressional paintings of *Fuchsia* 'Paula Jane' incorporate all the most important painting techniques in botanical illustration.

Stage 1

The initial wash can be an even, wet-on-dry wash or a wet-into-wet wash, superimposed, blended or a combination of these, depending on the individual nature of the specimen in question. Leave highlights untouched at this stage.

Stage 2

Deepen the initial wash in areas such as overlapping where shadow is cast, on leaves or petals where there are darker sections between light veins, and on the dark side of stems. This stage starts to give depth and dimension. Remember to work around the highlights.

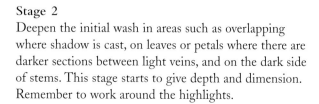

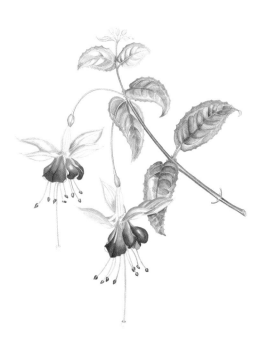

Stage 3

Deepen these areas further using blended tones or stippling. Deepen the tone around veins on leaves and where there is cast shadow. The dark side of the stems is darkened still further using stippling. Again, remember to leave out the highlights.

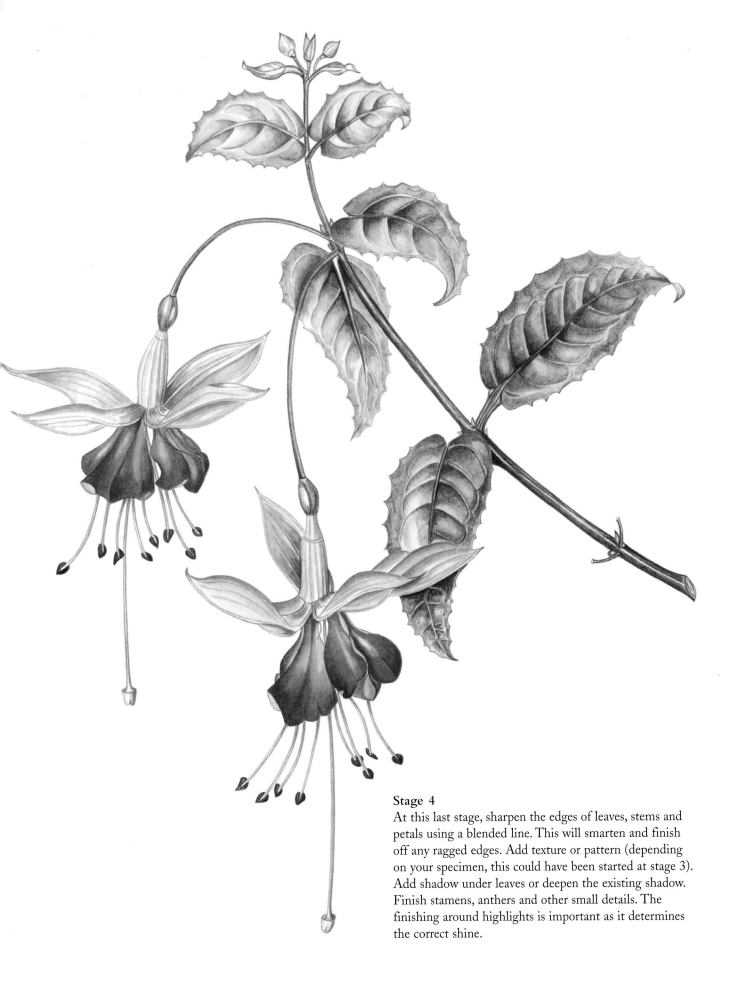

Stage 4
At this last stage, sharpen the edges of leaves, stems and petals using a blended line. This will smarten and finish off any ragged edges. Add texture or pattern (depending on your specimen, this could have been started at stage 3). Add shadow under leaves or deepen the existing shadow. Finish stamens, anthers and other small details. The finishing around highlights is important as it determines the correct shine.

a

c

c

b

b

c

c

a

a

c

c

b

Above: The Johannes Itten
12-hue colour circle shows
primaries (a), secondaries (b)
and tertiaries (c).

6. Basic colour theory

In this chapter we discuss primary, secondary and tertiary colours and how to mix them, as well as warm and cool colours and complementaries, with particular reference to the most important colour in botanical illustration, green. Even if you already have experience of colour and colour mixing, it is never time wasted to revisit the basic tenets of colour theory and practice.

The colour circle

Our colour circle is based on Johannes Itten's Bauhaus 12-hue colour circle (for more on this see chapter 7, Colour Effects and Subjective Colour). The sequence of the colours is that of the rainbow or natural spectrum. These colours are red, orange, yellow, green, blue, indigo and violet – easily remembered by the mnemonic 'Richard Of York Gave Battle In Vain'. The 12 hues are evenly spaced, with the complementary colours diametrically opposite each other – in other words, violet is diametrically opposite to yellow, blue to orange and red to green; yellow-green to red-violet, yellow-orange to blue-violet and red-orange to blue-green.

a. Primary colours

The primary colours are yellow, red and blue. They are called primaries because they cannot be created from other colours. They are shown in the triangle in the centre of the colour circle and also at the corresponding position on the outer ring of the circle. There are many paint manufacturers producing a variety of these primary colours, but few of them make pure primaries. A true primary colour is neither warm nor cool. Throughout this book we refer to 'warm' and 'cool' primaries. For example, scarlet lake is a warm primary as it is an orangey red, whereas alizarin crimson is a cool primary as it is a violet- or bluish-red.

b. Secondary colours

There are three secondary colours:
Orange: made by mixing yellow and red
Violet: made by mixing red and blue
Green: made by mixing blue and yellow.

c. Tertiary colours

There are six tertiary colours. They are made by mixing a primary colour with one of its neighbouring secondary colours. The components are easily recognized on the colour wheel:

Yellow-orange
Red-orange
Red-violet
Blue-violet
Blue-green
Yellow-green.

Exercise – warm and cool colours

For these exercises, in addition to your paintbox you will need a cheap brush (size 6 or 8) for mixing and a small watercolour pad of smooth paper, HP (hot pressed) or NOT (not HP). As we have already said, true primary colours are neither warm nor cool. There are three primary colours, but in the recommended list of paints we give six primaries: two reds, two blues and two yellows. That is because three of them are warm colours and the other three are cool.

Scarlet lake: warm, leaning to orange and yellow
French ultramarine: warm, leaning to violet and red
Indian yellow: warm, leaning to orange and red

Alizarin crimson: cool, leaning to violet and blue
Prussian blue: cool, leaning to green and yellow
Lemon yellow: cool, leaning to green and blue

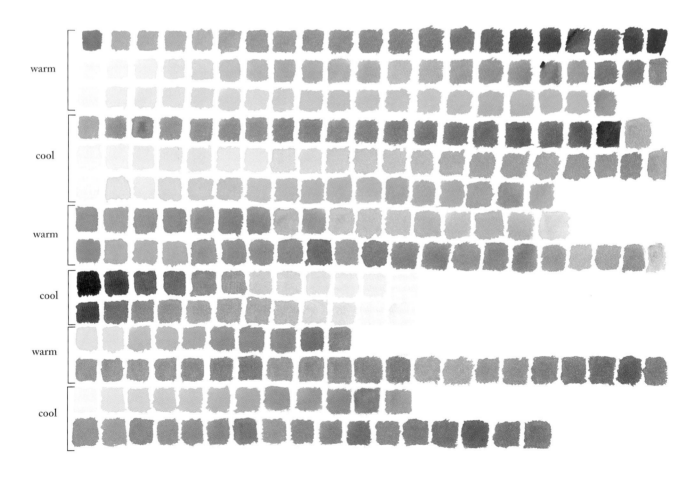

Make a practice page using the colours in your paintbox, dividing them into warm and cool colours. Now try mixing a warm yellow (Indian yellow) and a warm blue (French ultramarine) and see what type of green they make. Then mix a cool yellow (lemon) and a cool blue (Prussian) and notice the difference in the green produced.

Above: In the example above, warm colours have been mixed progressively with other warm colours, cool with cool colours, and so on.

Try the same with a warm blue (ultramarine)/cool red (crimson) and a cool red (crimson)/cool blue (Prussian). The first combination makes violet, the other a slightly more brown-violet. Do the same with a warm red (scarlet)/warm yellow (Indian) and a cool red (crimson)/cool yellow (lemon).

Continue mixing different combinations of the reds, blues and yellows. Write beside each sample the names of the paints you have mixed and whether they are warm or cool.

Greens

Greens are the most important colours in botanical illustration, and there are hundreds of them. The wrong green can 'leap out of a painting' and it is therefore vitally important to get it right. There are cool greens (lemon yellow with Prussian blue) and warm greens (French ultramarine with Indian yellow). And a whole lot of other greens besides.

At this stage it is worth remembering that a little bit of red, being the complementary of green, can be used to subdue or change the nature of a green that on its own could perhaps be too brash.

Below: A page of greens and washes. The artist's notes read 'wet on dry', 'wet on wet', 'graded wash', not enough paint on brush – need bigger brush', 'colours have separated – not very good' and 'rubbish'.

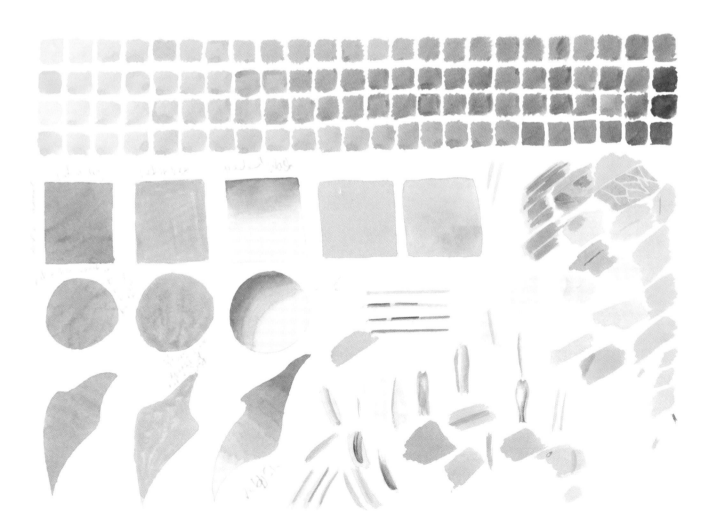

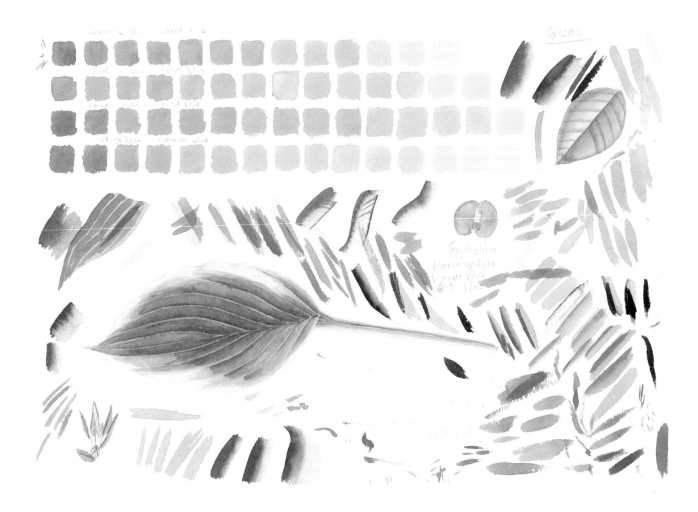

Exercises – colour mixing

1. If you use bought greens, then at least make sure what each colour will do, and what you need to mix with it to change it. But for now, see what you can achieve with the two yellows and the two blues that we recommend. With a limited number of blues and yellows you can make a fantastic range of greens. Paint a selection of colour strips, label them and keep them as colour swatches to help you to choose the correct green for your subject.

2. Mix each yellow in your paintbox with each blue, in varying strengths. You will be astonished at the range of greens you make and will understand why mixing your own greens gives you so much more variety than if you were just to use green straight from a pan or tube.

3. Experiment with secondary colours. You might like to continue along the same lines using reds/yellows and blues/reds, from which you will discover the best mixes for the secondary colours – orange, violet and green (shown as B on the 12-hue colour circle illustrated on page 74). Explore the different hues you can make by mixing warm/warm, cool/cool, cool/warm and warm/cool colours.

Above: The top row shows mixes of warm yellow and warm blue; the second row mixes cool yellow and cool blue; the third row warm yellow and cool blue; the fourth row cool yellow and warm blue. The artist notes 'Euphorbia – warm yellow, warm blue, cool blue', 'Hosta a bit messy, too much missing, colours not quite right, slightly too blue'.

Mix an orange made with cool primary colours (lemon yellow and alizarin crimson). Now mix an orange made with warm primary colours (Indian yellow and scarlet lake). Note how the two oranges differ.

4. Tertiary colours occur when you mix a secondary colour (orange, violet, green) with an adjacent primary (yellow, red, blue), for example yellow/green, yellow/orange, red/orange, red/violet, blue/violet and blue/green (shown as C on the 12-hue colour circle on page 74). Remember also that there are warm and cool colours that will affect the type of tertiary you achieve. Continue to experiment, using warm and cool pigments to make more colours, and see how many different hues are possible. Make a note of the pigments you have used and keep your samples as a useful swatch for future reference.

The basic rule of mixing paints is that you should use no more than two pigments, perhaps with small amounts of a third to temper the hue. The trouble with mixing more than three colours together is that they tend to cancel each other out and you can end up with a muddy mess. However, it is perfectly possible to mix more than three colours together and not end up with mud. It is always worth experimenting on a scrap of watercolour paper to see how far you can go with a mix before the colour loses its character and clarity.

As well as being invaluable reference material, these exercises are also very therapeutic and should be marketed as stress-beaters! When you are confident of your ability to mix the colours you need, try also overlaying one colour on the other. This is called superimposition and gives a clear, lively effect. It is particularly useful, for example, when building up the layers required for the velvety texture of a petal or leaf (see tall bearded iris 'Black Swan' on page 100).

If you are one of those lucky people who have an instinctive recognition of colour and can mix anything easily, then be grateful. Most of us have to practise and practise, doing exercises repeatedly to fix the information in our brains. By practising you will achieve a greater understanding of the qualities of your paints and the different combinations you need to make all the colours you will require for botanical painting.

Above: You can make a wide range of greens, some of which are shown in this lily stigma and unformed seed pod.

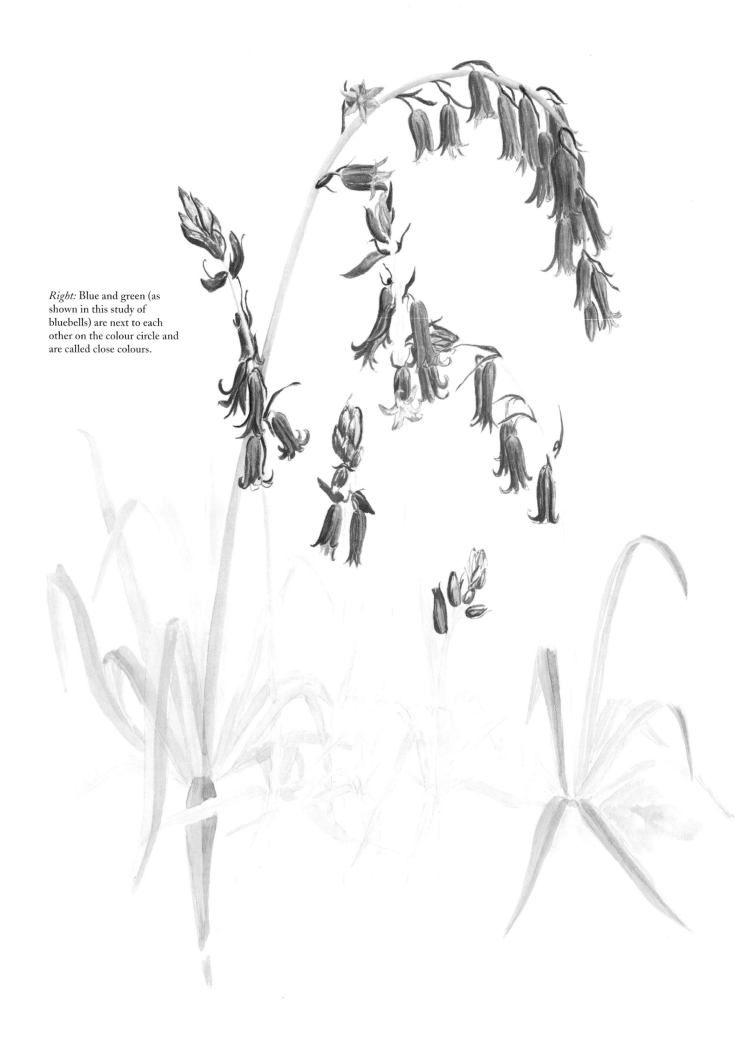

Right: Blue and green (as shown in this study of bluebells) are next to each other on the colour circle and are called close colours.

7. Colour effects and subjective colour

Although coloured pigment has been used in all forms of painting through the ages, the art and science of colour is still in its infancy and artists working with colour are still finding more and more interesting ways of using it. *The Art of Color* by Johannes Itten was published in 1961 and contained the colour theories, diagrams and colour exercises that have helped successive generations of art students to understand the use and behaviour of colour. Itten's famous course at the Bauhaus School in Germany still underpins much art education to this day. Examples used and referred to in the text are based on the Itten principles.

Within the context of botanical painting an understanding of colour relationships and effects is most important. It is not only the mixing of colours that needs to be studied, but also the relationship of colours to one another; the effects of lights and darks, brilliant and subdued; the amount of certain colours used together; complementary pairs and their effects; and discordant colour.

Left: Examples of colour effects. Notice how each colour responds to the one that surrounds it.

Complementary colours

Complementary colours are those opposite each other on the colour wheel: yellow and violet, red and green, blue and orange. These pairs resonate together and complement each other. Think of vivid orange leaves in autumn against bright blue skies or red holly berries resonating with their green foliage. Tertiary colours also fall into complementary pairs as seen on the colour wheel – think of yellow-orange and blue-violet.

Left: Complementary colours are opposite each other on the colour wheel: yellow and violet, red and green, blue and orange.

Some knowledge of colour theory can help with the practical application of paint in many ways. For instance, you may have noticed how areas of shadow can appear to be tinged with their complementary colour. This makes them far more clear and lively than if they were muted by grey. An example of this is to use violet to shade or mute a yellow, red to shade or mute a green – they are complementary colours. (Each pair can also produce a neutral grey when mixed, the same as mixing three primary colours together). This optical phenomenon of shading or toning with a complementary colour is particularly useful in contemporary botanical illustration, helping to give your picture balance, harmony and impact.

The resonance of red and green is clearly demonstrated in this painting of *Ruscus aculeatus*, otherwise known as butcher's broom. It is a member of the lily family, growing as a stiff and prickly evergreen shrub. Its name comes from the fact that it used to be collected, tied in bunches and used by butchers to clean their blocks. What look like leaves are in fact flattened branches, or cladodes. The bright red fruits last until winter, making this a useful decorative plant for Christmas. The shiny berries are a deep scarlet with tones ranging from extreme highlight to deep shade. Notice how many different greens have been used for the leaves.

Right: The resonance of complementary colours red and green is clearly demonstrated in this twig of butcher's broom (*Ruscus aculeatus*).

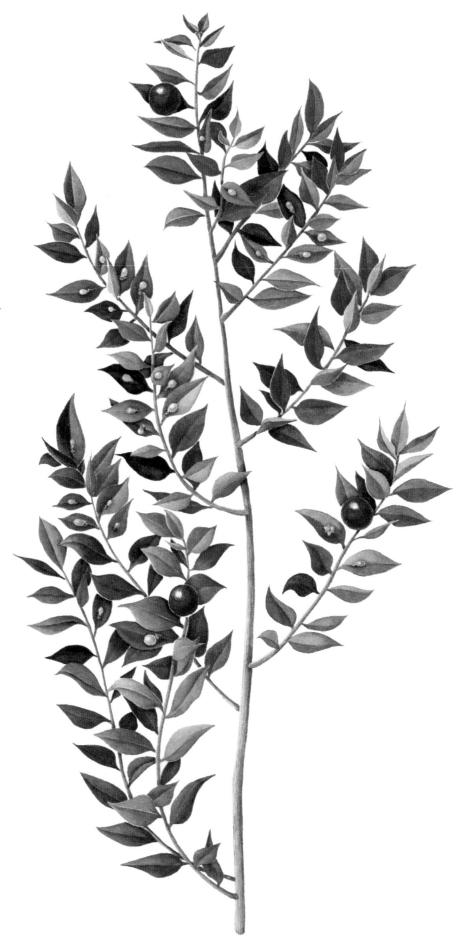

Colour extension

When planning your picture, you might like to give some consideration to the theory of colour extension. Colour combinations have balanced and harmonious ratios as well as unbalanced ratios. These are relevant for all designers, florists and artists. That is not to say, however, that certain colour combinations always have to be shown in these ratios. Ratios are manipulated by the painter. Monet, Brueghel, Constable, Turner and countless other artists modified colour ratios to cause 'a stir' or create 'hot spots', diversions, exclamations, points of interest, attention grabbers and so on. For instance, tiny concentrations of red dotted about could have more impact within a mass of greens than the correct balanced ratio of equal quantities of red and green.

Left: Red and green at the same saturation have the same intensity.

If you paint red and green beside each other, at the same saturation, you will find that not only do they have the same intensity but they also have the same grey tone or tonal value if seen photographed in black and white. Red and green are the most tonally similar colour combination, and a ratio of 1:1, or half-and-half, is the accepted harmonious balance in this case.

Left: Light/dark contrast is most noticeable with yellow and violet.

Considering all the primary and secondary colours, the tonal difference between yellow and violet, when used in their natural state, is the widest. Only one part yellow is said to balance three parts violet, a ratio of 1:3.

Left: Strong cool/warm contrast can be obtained with blue and orange.

Strong cool/warm contrast can be obtained by using blue and orange (blue-green gives the greatest sense of coolness, red-orange that of warmth). The harmonious balance between these two colours is one part orange to two parts blue, a ratio of 1:2.

Colour effects

When walking in the countryside in spring or early summer, notice the different effects of some plants within their environments. Notice how bluebells appear to merge with the green grasses in wood or hedgerow, whereas bright red poppies seem to jump out from the same background. This is because blue and green are next to each other on the colour circle. Often called 'close colours', optically they tend to shimmer or blur. As they are not complementary colours (like red and green) they produce a different effect.

The two squares (below) clearly illustrate the theoretical effects of these colour combinations. The red and blue squares are placed on a similar green ground.

Left: Red and green resonate; blue and green merge.

On the other hand, a brilliant yellow flower such as a buttercup (*Ranunculus* spp.) will stand out in the grass far more than a pale yellow flower such as yellow archangel (*Lamiastrum galeobdolon*). Yellow at its brightest is lively and intense. It is the lightest colour in the spectrum so it will stand out next to the green even though it is close to it on the colour circle. Yellow is also lighter than blue and will therefore have more impact on the green than the blue of the bluebell.

Left: This figure shows the difference between light and dark yellows on a ground of green.

Notice how intensely red-violet flowers, for example, stand out whereas a deep blue flower blends in with its foliage more readily.

Discordant colours

Elements of discord are produced when complementary colours are placed next to each other. Discord may suggest unpleasant, unsettling colours. But in the natural world nothing is inappropriate, therefore nothing clashes. Everything has its place and seems to fit. You can see many colours within the world of plants that theorists might have labelled 'discordant' and they may sometimes appear challenging or unusual, but within their own context they have charm, appeal and impact.

Left: These squares are all examples of discordant colour pairs.

This discordant effect occurs when the natural order of colour is reversed. Normally this progresses tonally from yellow to violet (from light to dark). When the tonal order is reversed, we get a discord. There is nothing more eye-catching in late autumn than the startlingly beautiful discordance of the pale mauve petals and brilliant, deep yellow corolla of Michaelmas daisies (*Aster novi-belgii*). The square below shows how the two colours of the flower resonate.

Left: The pale mauve petals and brilliant, deep yellow corolla of the Michaelmas daisy give a vibrant, discordant effect.

The discordance of pale violet and green (below) shows the unusual effect of the colour tonal order being reversed. The pale violet stands out on its background of dark green, whereas the deeper violet, being the normal tonal order, appears to blend in with the same green background. The discordant pair has a similar colour effect to that of mountain clematis (*Clematis montana*), the pale violet flowers of which always seem to be in stark contrast to their surrounding foliage. Compare this with a deeper purple variety of clematis such as *Clematis* 'Jackmanii', whose flowers merge with the background.

Left: Pale violet stands out against dark green, whereas dark violet blends in.

Exercise – subjective colour

Many people, particularly those starting out as botanical artists, are often heard to say 'What shall I choose to paint?' or 'I don't know whether this or that appeals to me'. Among our students it was noticeable how they often unconsciously chose specimens or subjects that echoed their clothing or accessories: an autumn dock leaf echoing the red, green and yellow of a pair of earrings; a bright pink pelargonium and a matching cardigan; a dark orange shirt and a nasturtium in a similar hue.

An interesting exercise is to divide a large square into several small squares. Paint the small squares with your favourite colours. By doing this, you will gain useful subjective information about what you might like to paint (see pages 86 and 87).

For instance, the colours chosen by artist A are bright and dominant, whereas those of artist B are soft and muted. As you might guess, artist A likes painting bold, colourful and striking subjects, using a strong and varied palette including brilliant pinks, violets, greens and turquoises. Artist B, on the other hand, uses only primary colour mixes and her choice of subject is guided by this clever and restricted palette. She finds her specimens in hedgerows, fields and woodlands.

Subjectively, the artist is emotionally drawn to such subjects and is answering a very personal call. Often these instinctive responses lead the artist to a favourable conclusion when deciding on subject matter.

To be emotionally drawn to a subject will give more convincing results than trying to battle with something for which you feel no empathy. Ask yourself questions such as:

• Do I have a passion for fungi, fruit or vegetables, blossoms or orchids?
• Do I feel stimulated by certain subjects more than others? If so, which are they and why?
• Are there some subjects that I naturally feel at home with?
• Do I want to be challenged by solid three-dimensional subjects or am I captivated by the seeming delicacy of hedgerow plant life?
• Do I lean towards leaf or flower, bark, moss, lichen, or towards more formal beauty such as iris, tulip or lily?

Below and right: The yellow and red tulip reflects the bright colours preferred by artist A.

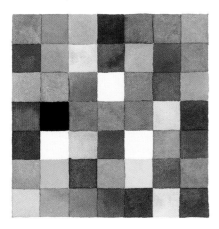

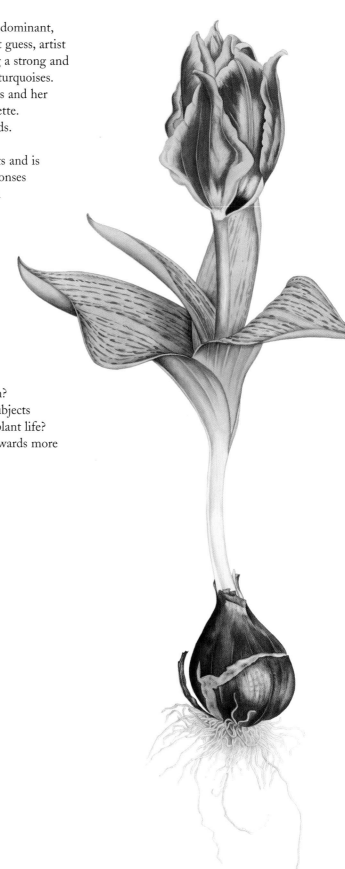

Answers to all these questions can give you insight into where your own subjective leanings might be. Look at your colour squares and ask yourself if any subjects suggest themselves by way of these colour choices. The quest goes on and without doubt will enthral and frustrate you.

The concept of colour theory is difficult to grasp, but armed with the information in this chapter you should find it easier to understand some of the theory underpinning various commonplace phenomena such as complementary colours, saturation values, colour effects, discordant colours and subjective colours.

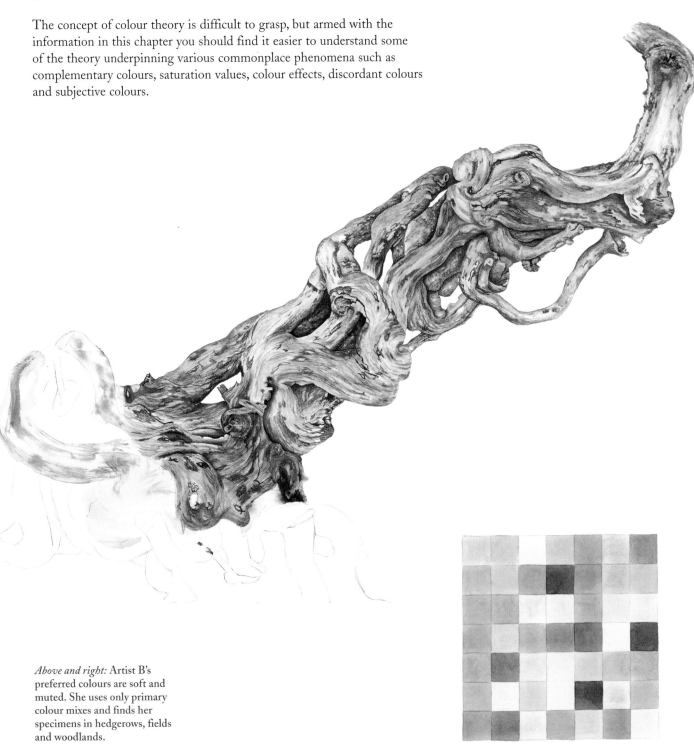

Above and right: Artist B's preferred colours are soft and muted. She uses only primary colour mixes and finds her specimens in hedgerows, fields and woodlands.

Left: A good example of the strength of primary colours is the branch of rowan or mountain ash berries (*Sorbus aucuparia*).

8. Using a limited palette

Primary colour mixtures

This section explores basic primary colour mixtures. In these exercises you will use a restricted palette containing only warm and cool primary colours (two reds, two blues and two yellows). This palette (below) includes: permanent red orange or scarlet lake (warm); alizarin crimson or permanent carmine (cool); Indian yellow or Winsor yellow deep (warm); Winsor lemon or lemon yellow (cool); ultramarine blue or Winsor blue (red shade) (warm); Prussian blue (cool). You will come to understand more clearly what is likely to happen when colours are combined, overlaid and juxtaposed.

Left: Two reds, two yellows and two blues give all the necessary primary colours for successful mixing, shown here at full strength and diluted.

If you have no understanding of colour and its effects, you will find it almost impossible to use colour effectively. For example, many of the very light watercolour mixes are erroneously assumed to have been made using white paint because of their pale or even milky appearance. It is possible to achieve beautiful and elusive colours, tints and shades by using these mixes and simply lightening them by adding water. But in our Challenging Colours section (see page 112) many of these unpredictable colours have in fact been made using pure primary mixes.

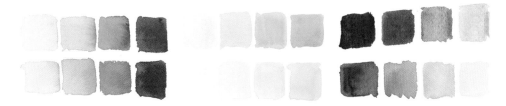

Left: Some unusual shades using primary mixes – flesh tints, light shades of brown, ochre, off-white, deep red, beige, pinks, mauves, gold and greens. The stronger colours are given (a), together with the lighter colour made when diluted with water (b).

Informed and prolonged use of primaries often gives rise to painters who display a highly developed and most unusual palette. This can be a rare asset for a botanical artist. Paintings done with primary mixes have a quiet cohesion. After all, each part of the picture contains all the same colours and shades originating from the primary base, a limited basic palette. There are blends of subtle secondaries and tertiaries – in essence, a colour circle. By using paints either full strength or lightened with water, a whole range of shades can be obtained.

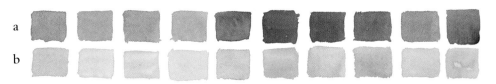

Left: Primary mixes shown at full strength (a) and diluted (b).

The number of achievable shades is infinite. Primary colour mixing does not mean the end of bought colours, it merely gives the painter far greater insight into the endless possibilities of a limited palette and ultimately the wider palette and its range of mixes. A bought green can seem far too garish or dull on its own, but with a little knowledge of colour reaction the same green can be transformed into the green of your choice. Challenging colours, such as different flesh tints, greys and blacks, brown, ochre, coffee and chocolate, beige, ivory and off-white, deeply intense puce and indigo can all be achieved by mixing primaries.

This delicate study of ash (*Fraxinus excelsior*) gives yet another example of how the three primary colours can be used to great effect in producing a range of subtle shades. Study the apparently grey twig and see how in fact it is made up of the palest shades of brown, grey, green and blue. Deeper shades of the same colours have been added to give contrast and three-dimensionality.

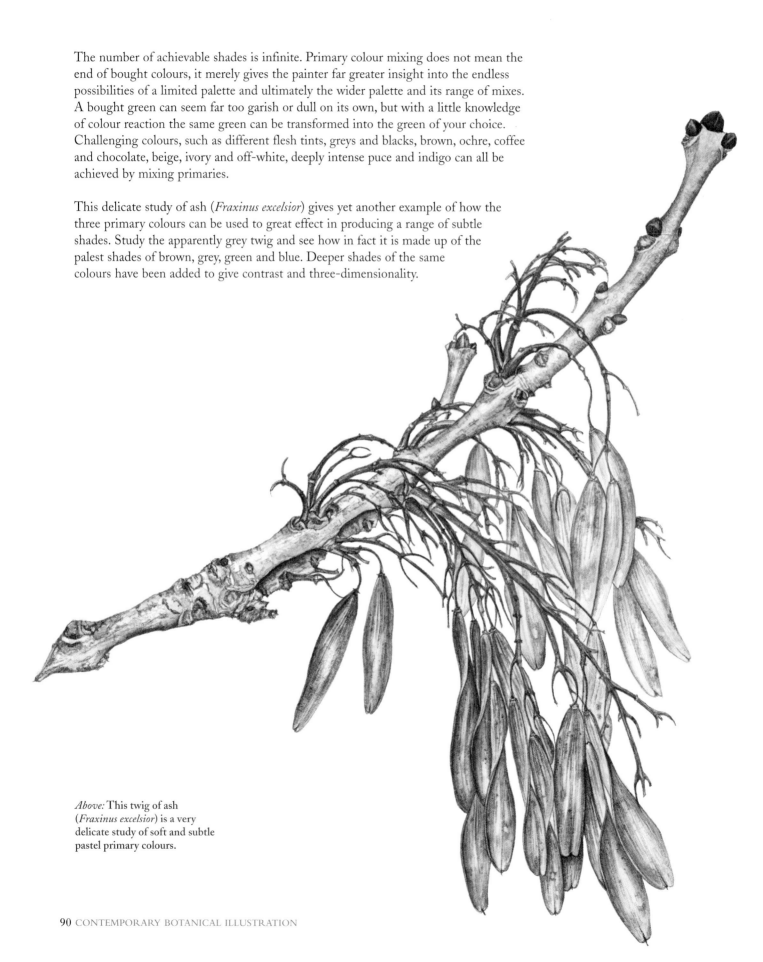

Above: This twig of ash (*Fraxinus excelsior*) is a very delicate study of soft and subtle pastel primary colours.

Exercise – birch bark

This artist works with a limited palette that can be mixed from the primary colours: red, blue and yellow. The colours she uses are alizarin crimson, scarlet lake, lemon yellow, Indian yellow, French ultramarine and Prussian blue.

It is a good idea to practise mixing some of the commercially named colours that can be made from the primaries (see right). These 'named' colours can all be mixed using primaries. The commercial names and colours are shown in the left column, self-mixed and components to the right. These have also been used in the following text to facilitate understanding:

Vandyke brown: a dark, slightly bluish brown made with alizarin crimson, lemon yellow and Prussian blue.
Raw sienna: a warm light yellowish brown made with Indian yellow, a little scarlet lake and a touch of French ultramarine.
Venetian red: a brick red-brown made with alizarin crimson, lemon yellow and a little French ultramarine.
Cobalt green: a pale blue-green made with very dilute Prussian blue and a little lemon yellow.
Olive green: a muted yellowish green made with Indian yellow, French ultramarine and tiny bits of scarlet lake and alizarin crimson.

In the demonstration (overleaf) the artist uses only primary colours, but where she uses a specific mix it has been given the commercial name (for example, olive green, Vandyke brown, and so on). The artist writes:

'I found this piece of bark on the edge of Dartmoor while walking my dog on a wet, misty day. The colours shone in the rain, particularly the contrast between the soft mushroom colour of the pale curls and the rich tones of the inner bark. I drew the bark on layout paper using a 3H pencil, and then strengthened the outline with an H pencil to make tracing easier. After taping the drawing to the window, I transferred it on to the watercolour paper (Sennelier 300gsm HP).'

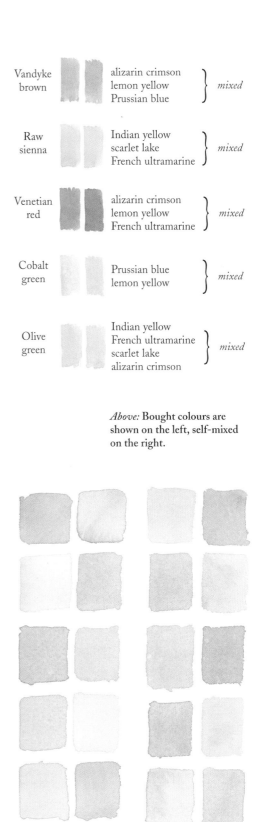

Vandyke brown		alizarin crimson lemon yellow Prussian blue	} mixed
Raw sienna		Indian yellow scarlet lake French ultramarine	} mixed
Venetian red		alizarin crimson lemon yellow French ultramarine	} mixed
Cobalt green		Prussian blue lemon yellow	} mixed
Olive green		Indian yellow French ultramarine scarlet lake alizarin crimson	} mixed

Above: Bought colours are shown on the left, self-mixed on the right.

Above: A variety of pastel shades.

Stage 1

The first wash for the dark bark was mixed from alizarin crimson, Prussian blue and lemon yellow. I used the wet-into-wet technique, wetting the whole area with clean water and then dropping in the paint. If you want to be sure of a colour-free area where the light is striking, don't wet that section of paper. The paint will collect round the edge of the light area and you must blend in the hard lines before it dries.

Alternatively, you can drop in the paint around the edges of the light section and then move the colour with a damp brush to where it is needed. Be careful not to disturb the paper but just glide the brush over the surface. The paper will remain wet long enough to add or remove colour. If the paint puddles you can remove it easily using a damp brush.

Stage 1

The same three colours were mixed into very pale washes for the bark curl. In places I have added a suggestion of raw sienna. The flat bark in the middle was treated in the same way, with touches of olive green and Venetian red. As with the dark bark, before adding any colour the paper was coated with clean water.

Stage 2

Using the same colour as the initial wash, and a fairly dry brush, I started to build up the colour on the dark bark using light, thin strokes in the direction of the grain. Several colours were used for different mixes and also applied individually in places. These were alizarin crimson, Prussian blue and Indian yellow.

Stage 2

To create a soft sheen, I used a thin wash of alizarin crimson with a touch of Prussian blue. I treated the outside 'toothed' area with a light coloured wash and then painted the details.

Stage 3

The curls were painted in the same manner, using alizarin crimson, Prussian blue and lemon yellow to make up several light mixes. The brush strokes followed the curls. I also used raw sienna, olive green and scarlet lake. For the pale bark at top right, I used a thin wash of Indian yellow mixed with alizarin crimson. A touch of cobalt green was added in places.

Stage 3

Stage 4

The patterns in the centre flat section were painted using Venetian red, olive green and raw sienna. In certain areas, soft washes of lemon yellow and Venetian red were applied.

Stage 4

Stage 5

A mix of Vandyke brown and ultramarine was used for the shaded areas under the curls, and the strokes of the grain were carefully painted. Rich tones were added to the dark bark and a damp brush used to smooth out the rough paint strokes. I then placed the painting where I could see it in passing, several times a day. I realized that the curls were not defined enough. I added some French ultramarine and a tiny touch of Prussian blue to my Vandyke brown mix to make a deep, rich, peaty colour. With a dry brush and using thin strokes, I painted the dark bark where it met the curls.

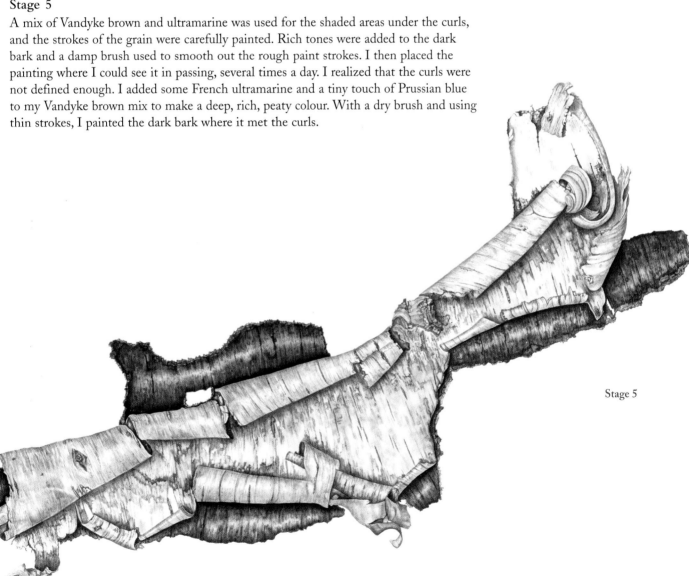

Stage 5

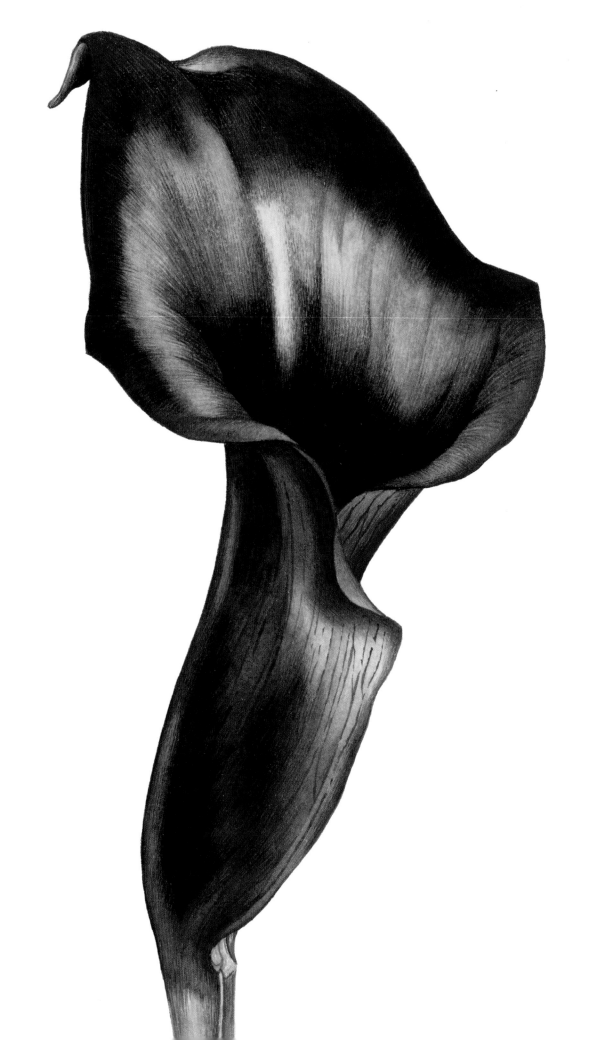

9. Paint it black

Black pigment consists of all the colours of the spectrum, so it is hardly surprising that the mixing of black often arouses curiosity and apprehension. Because of the various colour biases it can often be quite tricky to mix a good neutral black, but with patience and perseverance you will be able to overcome the difficulties.

How black is black?

A mixed black is superior to a ready-made black because it can achieve the subtle variations of shade necessary for different plants. There are greenish blacks, reddish blacks, blue-blacks, purplish blacks and many more. At first glance it may not be apparent that the particular black of your subject is in fact a mixture of various deep, dark colours.

In this chapter you will find colours mentioned that have not been used earlier in the book. It is perfectly possible to mix all the colours needed for 'black' flowers using just the colours in a basic palette, but most artists, by the time they reach the level of confidence necessary for something out of the ordinary like this, have also extended the contents of their paintbox to include a wider range as well as some of their own favourite colours.

In watercolour, because the colour is built up layer by layer, the correct lighter shades of black have to be ascertained as well as the darker shades. As the shades get darker, so the application becomes more difficult. Placing black on black is virtually impossible to see. Think of trying to sew with black thread on a black ground. It is extremely difficult unless you have very good light.

The build-up has to be slow and systematic in order to create smooth, even tonal change and contrast. Slapping concentrated black straight on to an area requiring a very dark tone or shade will only lead to a dead-end because the sheer forcefulness of the black will make blending impossible. Once dense black has been applied to your painting there is no going back, so tread very carefully.

One of the most difficult jobs in botanical watercolour painting is to paint extremely deep shades without the painting looking dull and overworked. The density found in 'black' subjects has an intensity not found anywhere else. The velvety lustre of black iris petals, the smooth sheen of the black calla lily (*Zantedeschia* 'Schwartzwalder') and the soft silkiness of the black tulip are good examples.

The initial stages of your 'black' subject should always be painted using pale versions of the very deepest blacks, and for this reason it is important to practise mixing blacks and greys.

Left: Enlarged detail of Black Forest calla lily (*Zantedeschia* 'Schwartzwalder').

Exercise – tonal strip

Before tackling a black subject it is a good idea to do a few tonal exercises to acquaint yourself with the variety of blacks that you can make using a simple range of colours.

Left: Tonal strip: washes of watered down mixed neutral black built up from one pale grey coat on the left to eight coats, giving a full, dense black on the right.

First mix a neutral black. This is one that leans to no particular colour. You will need a cool and a warm yellow, a cool and a warm red and a cool and a warm blue. For more information on cool and warm colours see chapter 4 of *Botanical Illustration Course with the Eden Project* (see Further Reading, page 141). Dilute this neutral black to make a very pale grey that does not lean towards red, yellow or blue – in other words, an unbiased neutral grey.

Draw a strip of eight squares, about 2.5 x 2.5cm (1 x 1in) on a sheet of smooth cartridge paper. Using a fairly large brush (size 6) carefully paint an even wash over all the squares. Don't overwork the wash, but use a light movement of the brush, barely touching the paper. Allow it to dry. Using the same mix, paint a wash over just seven of the squares and allow it to dry. Continue in the same way (six, five, four and so on) so that in the end you have a square with one layer of wash on the left and a square with eight layers of wash on the right.

On an actual painting you may need to increase the intensity of your final black by adding a little more pigment to the mix. Take care not to make the paint too thick. The right consistency is crucial, so try to resist the temptation to use the paint too dry. See how it is only the final square with its eight layers of wash that looks truly black. It is possible to detect the colours that have gone into the black mix and it is this that gives the black its resonance. As we have said, it is for this reason that a mixed black is preferable to a black 'straight out of the tube'.

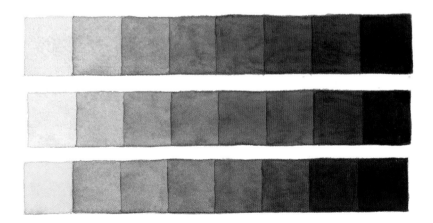

Left: Three similar tonal strips, made using a blue-black, a yellow-black and a red-black. Notice the differences between your blacks and their relative lighter shades. Make a note of the colours you used, and file your sample strips away for future reference as colour swatches.

Now repeat the exercise with three more sample strips. One strip should lean to blue for a blue-black, one to yellow for a yellowy black, and the third to red for a reddish black. If you wish you may go on and experiment with many more 'black' colours – you never know when you might need them and the practice will greatly enhance your mixing capabilities.

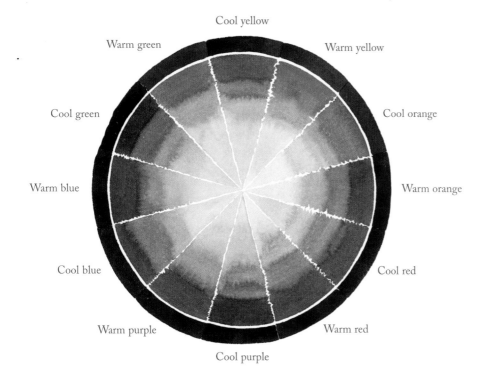

Cool yellow

Warm green Warm yellow

Cool green Cool orange

Warm blue Warm orange

Cool blue Cool red

Warm purple Warm red

Cool purple

Left: This black colour circle shows 12 shades of black. It is easy to distinguish the different components in the light and mid-tones, but in the very outer rim the dark colours are all much the same.

The black colour circle (above) shows 12 shades of black, from their very darkest to their very palest shades. Notice how, towards the centre of the colour circle, it is easy to distinguish the different components whereas in the dark outer rim the colours are really very similar. Copy the black colour circle, mixing your own shades of black. The easiest way to mix the paint for your black colour circle is to mix a large quantity of strong neutral black using the primary colours. Make sure that your neutral black leans to no particular colour and that you have mixed enough paint for all 12 sections of the circle.

Clockwise from the top, starting with cool yellow, take enough paint from your pool of neutral black to cover one segment of the circle and mix it with a small amount of cool yellow. Always test the shade and depth of colour before committing paint to the section. If you wish, you can paint each section separately and then stick them in place to form a circle. This way, if one of your blacks is unsatisfactory, you won't need to start all over again. Paint the dark outer rim section with the cool yellow-black mix. In the inner section, gradually add water as you near the centre so that the lighter shades can be clearly identified. You are in effect painting a graded wash – a wash that grades from dark to light.

When you have finished your cool yellow-black section, move to the next section, which will be warm yellow-black. Take another amount of neutral black from your pool, enough to cover another section, and mix it with a little warm yellow. Test as you go to ascertain the exact shade. Paint the outer rim section with the deepest colour of the warm yellow-black, followed by the inner section grading paler towards the centre as before. You should now have two different yellowish blacks side by side, one cool yellow-black and one warm yellow-black, grading from very dark at the outer rim to very light in the centre.

Continue round the circle. Next will be cool orange, then warm orange, followed by cool red, and so on. Keep checking your blacks as the dark shades look so similar. Take your time and check that you are adding the correct colours to your neutral black in the correct sequence. You may need to experiment with the amounts of added warm and cool colours because mixing is not an exact science. The subjects on the following pages illustrate the use of a variety of these blacks: yellow-blacks, green-blacks, blue-blacks, purple-blacks and so on.

Tulip 'Queen of Night'

This painting shows the build-up from light to dark. Note how the artist has tried out a variety of pale colours with increasingly dark areas on a test section (below). This was done to ascertain the light and dark within the subject. Colours found within the tulip 'Queen of Night' are carmine or alizarin crimson, French ultramarine and a mixed neutral black.

The central petal is lighter than the petal behind it and you can see how it reflects the pale colours in the other petals. Note the depth of black in the petal at the back where its curling lip causes intense shadow. The contrast between the intense lights and darks helps to give the painting its dramatic tension.

This completed flower head was painted using the previous year's detailed tonal drawing. There was not time to start the painting then, so the artist worked from the drawing (below) and used some of the following year's flowers for the correct colouring and nuances.

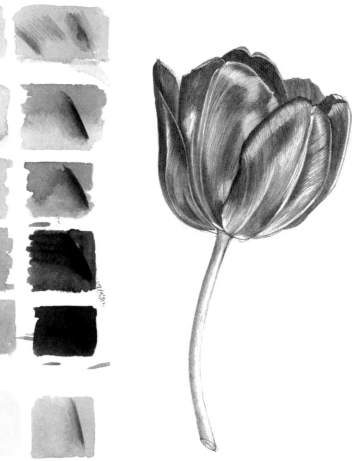

Above: This black tulip, 'Queen of Night', uses carmine or alizarin crimson, French ultramarine and a mixed neutral black. Notice how the artist has tried out the colours and brush strokes before committing to the painting (far left).

Left: The pencil drawing of tulip 'Queen of Night' reminds the artist of the position of areas of light and shade and the tonal range involved.

Black Forest calla lily
(*Zantedeschia* 'Schwarzwalder')

As with all black flowers, 'black' calla lilies are in fact made up of many colours including crimson and blue. Look carefully at your subject before you start, to identify all the colours and where they appear. Tackle this in two sections, the inside of the spathe and the outside.

The colours you will need here are Prussian blue, French ultramarine, permanent carmine, grey (mixed from primary colours) and an orange made of alizarin crimson and Indian yellow. Notice how the tiny areas of cool blue (Prussian blue and grey) attract the eye. Wet the section with a fairly large brush (size 7 or 8) and while the paper is still damp drop in neutral grey all over and then other colours into the grey where appropriate.

Here you will need alizarin crimson with touches of French ultramarine and scarlet lake. As with watercolour painting in general, start with the very palest areas. Build up layers, using slightly darker versions of the colours used and increasing their intensity. Allow layers to dry before applying new layers, blending them with a damp brush. Round about mid-tone, you need to switch from layering the washes to using small, stippled strokes, thus avoiding the risk of disturbing the previous layers.

The stem is painted with an initial wash of a pale, light yellowy green followed by a darker green to give shape. The vibrant yellowy green contrasts agreeably with the deep plum colour of the flower. Finally, when the painting is completely dry, apply the markings in the outer section and around the lip. The three-dimensional effect is enhanced by shading the left side of the flower and stem to show the light source.

Far right: Black Forest calla lily (*Zantedeschia* 'Schwarzwalder'). The layers have been built up using slightly darker versions of each colour and increasing their intensity.

Right: A reminder that time spent looking at your subject and getting a pencil drawing down on layout paper is never wasted.

Tall bearded iris (*Iris* 'Black Swan')

This iris, although appearing black at first glance, has in fact many shades of deep pink, violet, turquoise and blue. The standards (the upright petals) are pinks and purples; the falls (the outer petals) are greys, blues and turquoise.

First mix a lilac-grey using primary colours only and then, using a brush size 6 or 8, paint the standards one at a time with a pale wet-into-wet wash. Drop some French ultramarine and red-violet mixture into the grey wash in areas where they appear on the petals. Painting one fall at a time, use a neutral grey made with primary colours as a wet-into-wet wash over the whole petal. Drop in bits of a cool blue (Prussian) and some touches of French ultramarine. As with the standards, the different hues will mingle to give colour changes within the one petal. As before, paint one petal at a time and allow it to dry.

Slowly increase the level of contrast by mixing stronger versions of the same colours used in the washes, and build up with wash after wash to show the deep velvety texture of each fall and emphasize the slight sheen. Always wait for the previous layer to dry before adding another layer. Lightly blend the edges of each layer into the background with a damp brush. The very darkest shades need to be stippled to avoid disturbing the paint layers underneath.

Finally, put in the veins on the petals with a very fine brush. In the areas where the lighter shades are present the veins show up clearly, whereas in the darkest places they blend in with the background.

Right: A preliminary drawing, like this one of the tall bearded iris (*Iris* 'Black Swan'), acts as an *aide-mémoire* when you begin to paint.

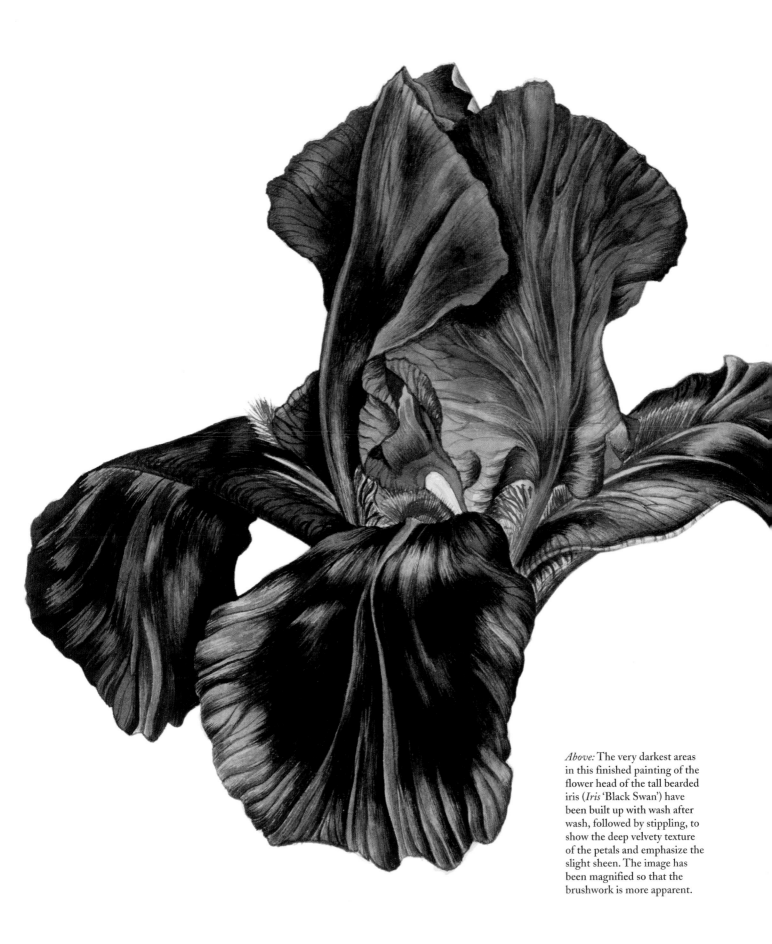

Above: The very darkest areas in this finished painting of the flower head of the tall bearded iris (*Iris* 'Black Swan') have been built up with wash after wash, followed by stippling, to show the deep velvety texture of the petals and emphasize the slight sheen. The image has been magnified so that the brushwork is more apparent.

Seaweed

This strand of seaweed is composed of a greenish yellow-black and a variety of greys from very dark to very light. The colours used are Indian yellow, lemon yellow, French ultramarine and a mixed neutral grey. The working page (below) shows how the artist has practised shapes, colours and shading before committing to paper.

The bladders were painted using a wet-into-wet neutral grey with the mixed green colour dropped into the grey. Gradually the grey-green colour is built up by layering again and blending into the background with a damp brush. The darker shades should be stippled on to avoid disturbance of the previous layers. The thallus (stem) is so narrow that a pale grey wet-on-dry wash can be used and deeper areas are then stippled and carefully blended in.

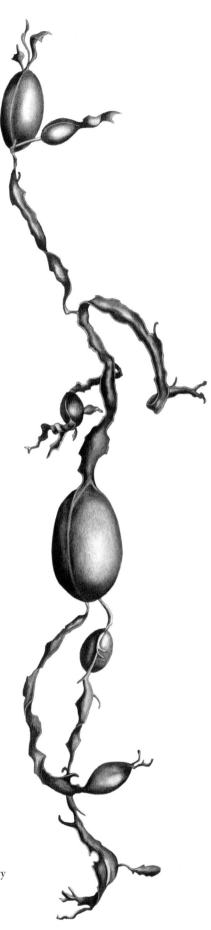

Left: The artist has practised shapes, colours and shading before committing to paper.

Right: This strand of seaweed uses a greenish yellow-black and a variety of greys, from very dark to very light.

Tall bearded iris (*Iris* 'Black Taffeta')

This is a good example of superimposed colour, sometimes called under-painting or multicolour layering. It can be tricky at the best of times, and with blacks and dark colours must be approached with patient observation and forethought.

The leaves of the tall bearded iris (*Iris* 'Black Taffeta') are basically a greenish yellow with a turquoise-grey bloom in places. As if to bring unity to the whole plant, however, the same colours present in the flower also appear around the leaf bases. Deep red, purple and bluish greys are superimposed on to the greens, giving a strong complementary contrast that adds interest and drama to otherwise fairly plain, large leaves.

The narrow shafts of light that can be seen along the edges of the leaves help to separate one leaf from another and break up similar tones. The very dark tones contrast strongly with the lightest tones and the carefully differentiated mid-tones bind the whole together.

First observe which greens and yellows are present underneath the reds and purples. Note where they appear. Pale gold on the rhizome and lower section of the leaf base blends slowly into a pale green as the leaves travel upwards. Lay a wet-into-wet wash as appropriate. Paint the rhizome separately, even though it connects in colour with the leaves. This is a case of not biting off more than you can chew in one go.

Repeat until all leaves have pale gold-green undercoats. When dry, start washing in stronger mixes of turquoise-grey (Prussian blue, French ultramarine and a touch of crimson or carmine). The crimson will give you the complementary effect. If your red areas read as too strong, simply apply a little Prussian blue when the red paint is dry, which will subdue any over-colouring. Add these stronger colours by brushing on paint into the appropriate areas and blending the edges into the background. With each application, always wait until the previous layer is quite dry, otherwise you will get a muddy mess.

At this stage the layers are still light enough not to disturb the under layers. From this point carry on layering up with crimson, purple and blue with a small brush (size 1 or 0), using stippled strokes or dots. You can try burnishing the edges of the paint with an almost-dry brush in order to blend into the previous layer. Take care not to do this with a wet or very damp brush as that would result in disturbed paint. Continue building up these stronger stippled layers and you will see that the darker areas will start to read as black, giving a good tonal contrast between the very darkest and the very lightest areas.

There are many more black flowers that you might like to attempt. Always make sure that you test your blacks as you mix them, to ascertain the light shades as well as the very darkest. Build up the layers with caution and patience and you will surely be rewarded with many beautiful blacks.

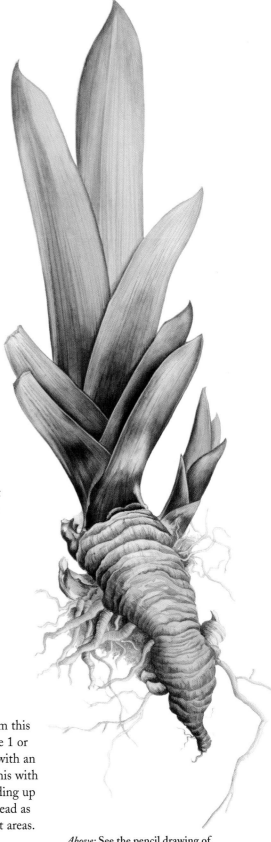

Above: See the pencil drawing of this tall bearded iris (*Iris* 'Black Taffeta') rhizome and leaves (page 61). Compare the areas of pencil shading with their painted counterparts above.

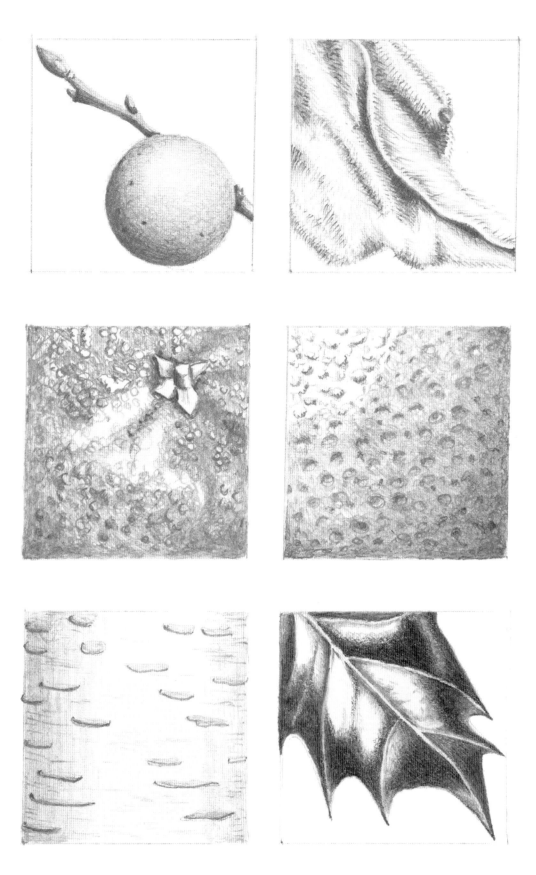

Left: Shine, pattern and furry textures are all featured here, magnified to show the application of fine detail.

10. Challenging texture, pattern and colour

Some textures are far more challenging than others. Different people find a challenge in different surfaces or subjects. Here we show you how to tackle textures, first in pencil only, then using colour. But as always, we urge you to experiment and find personal ways of interpreting challenging and unusual textures.

Challenging texture and pattern

Before embarking on challenging texture and pattern in paint, it is a good idea to do some small samples using just pencils. The illustration opposite shows (from left to right): the rough sphere of an oak apple (oak gall) with small blemishes, a dry furry leaf, the puckered skin of a satsuma, the characteristics of orange peel, the smooth bark and irregular pattern of silver birch bark and the high shine on a dark holly leaf. Refer back to the chapter on Pencil Drawing (see page 56) for further examples of the textures to be found in nature, and look out for your own.

Exercise – textures
See how many different textures you can find and make just a small sample of each one. Don't confine yourself to botanical subjects – knitted or woven fabric, the texture of a stone or shell, a feather, pet fur, all these are good practice. The possibilities are endless.

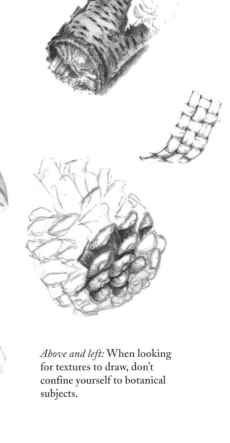

Above and left: When looking for textures to draw, don't confine yourself to botanical subjects.

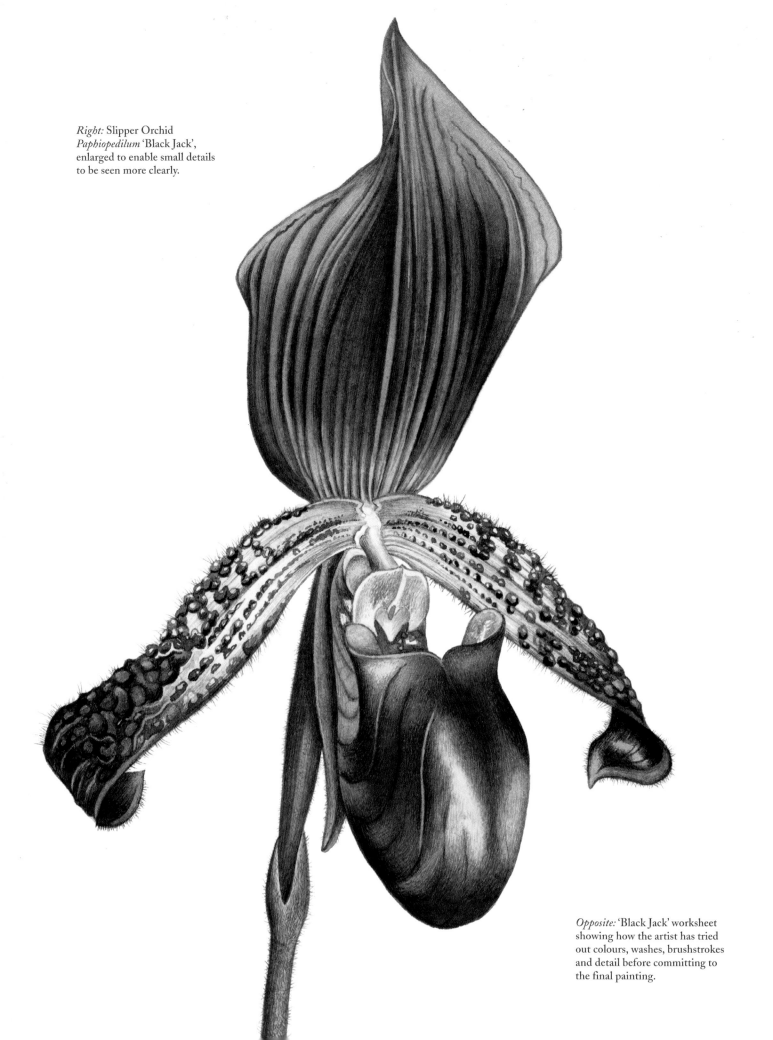

Right: Slipper Orchid
Paphiopedilum 'Black Jack',
enlarged to enable small details
to be seen more clearly.

Opposite: 'Black Jack' worksheet
showing how the artist has tried
out colours, washes, brushstrokes
and detail before committing to
the final painting.

The slipper orchid (*Paphiopedilum* 'Black Jack') is a combination of challenging colours and textures. The dorsal sepal is dark burgundy, ridged with deep black burgundy. The two petals, one on either side, are heavily textured with black, slightly shiny, wart-like protuberances. The lip or pouch is a deep burgundy with a very high shine and veined markings. The stem is stiff and hard with a slight fuzz of fine hairs.

A wet-into-wet wash of pinky blue paint was used for the dorsal sepal. Then dry, fine lines were painted and deepened on one side to give a ridged or pleated effect. These ridges were gradually deepened until almost black. The pouch was painted using an initial light pink wet-into-wet wash with areas of highlight left untouched. When dry, areas of slightly deeper colour were added and blended into the background. These areas were gradually deepened in strength until the correct balance was reached. The highlights had a pale blue wash added at this stage. The veined markings were applied last, using a very fine brush and a very deep burgundy paint.

The petals on either side of the pouch were again painted wet-into-wet, with green at the top, pink at the ends and the middle left blank. When dry, these colours were slightly deepened and then the warty protuberances were painted on top of finely pencilled construction lines that ran along the length of the petal in smooth, parallel strokes. It was important for the artist to have clear guidelines in order for the pattern to follow the correct form. The warty protuberances were carefully painted to leave a small highlight on each. You can either leave out these pinpoints of light when painting or, if you are feeling particularly bold, you can pick the colour off with the point of a sharp needle or the tip of a very sharp scalpel when the paint is dry.

The stem was simply a pale pink wash deepened on both sides so that an area of light was left in the middle. When dry, using a tiny brush and a deep burgundy mix, the hairs were painted down the whole length of the stem. It is worth mentioning here that when painting fine hairs, you should first study their growth pattern, preferably using a magnifying glass – you will find that some lie parallel to each other, others are randomly positioned and in some cases are of different lengths. By doing this you will ensure when applying paint that the correct overall direction is followed. In this orchid, the fine hairs on the stem are all over the place, whereas the ones on the warty protuberances are in bunches.

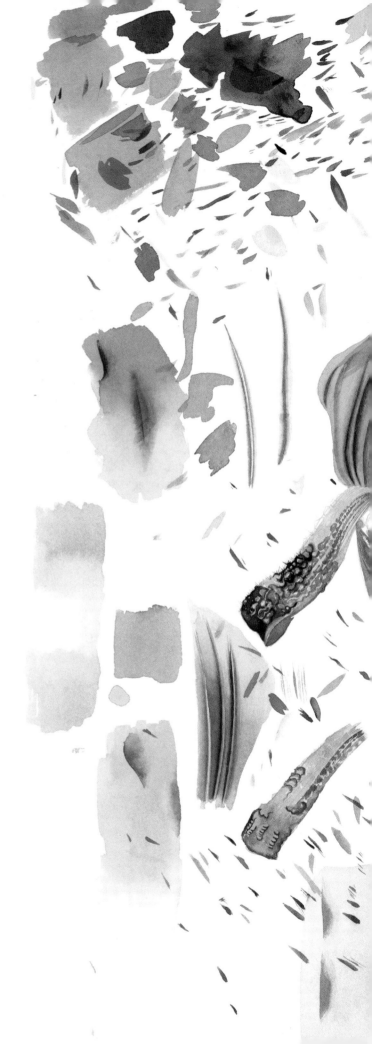

Exercise – dandelion clock

One of the most challenging textures must surely be the dandelion clock, the head of gossamer-light seeds like tiny parachutes, beloved by children who 'tell the time' by counting how many puffs it takes to send all the seeds off into the wind. To paint this, you need two seedheads, one from which you have removed all the parachutes and one that is still intact.

Stage 1
Take the first seedhead, draw it and paint it. Show all the brown seeds still adhering to the crown, and record the hollow stem (see also stage 7).

Above: A dandelion clock is easy to paint if you break it down into eight stages.

Stage 2
Notice how the parachutes on the intact seedhead form concentric circles, narrowing towards the outer edges. With a very sharp, hard pencil, lightly dot in three or four concentric rings around the brown seedhead.

Stage 3
Using a pair of tweezers and a magnifying glass, study one of the parachutes. See how the spokes form a cup shape when viewed from the side, which becomes more and more open as you tip it towards you, until finally it appears as a full circle. Starting with the outer ring, and using your finest brush and a fairly diluted neutral grey, paint in a ring of just the spokes as they appear sideways on, radiating as from a central point. Don't worry about the parachute's stem. You should have a cup shape made of a dozen or so small strokes. You need a very steady hand for this, and a magnifying glass is helpful.

Stage 4
Tip the parachute slightly towards you and paint in the spokes in the next inside ring.

Stage 5
Tip it even further towards you and complete the next inner ring.

Stage 6
The final inner spokes are shown facing you so that they appear as a full circle.

Stage 7

If you are a purist you will paint the brown seeds in stage 1 while at the same time leaving the spokes white. For lesser mortals a perfect alternative is to paint the spokes over the brown seeds, using an opaque paint such as titanium white or white gouache.

Stage 8

Finally, put in the shading, using a darker tone of neutral grey and carefully going over the spokes on the side of the dandelion clock away from the light source. Don't forget to erase all the pencil markings when the paint is dry.

Other patterns and textures

Textures shown below include smooth, hard bamboo, the shiny seeds of the pomegranate, the fine hairs at the base of the poppy seedhead and the crinkled surface of a cabbage leaf. Patterns include the striations on an apple and the spots on a foxglove flower. When doing this sort of exercise it is necessary to show only a small part of each sample – this saves time and does not detract from the importance of the work.

Below: A page of different colours, patterns and textures. Only a small sample of each is needed.

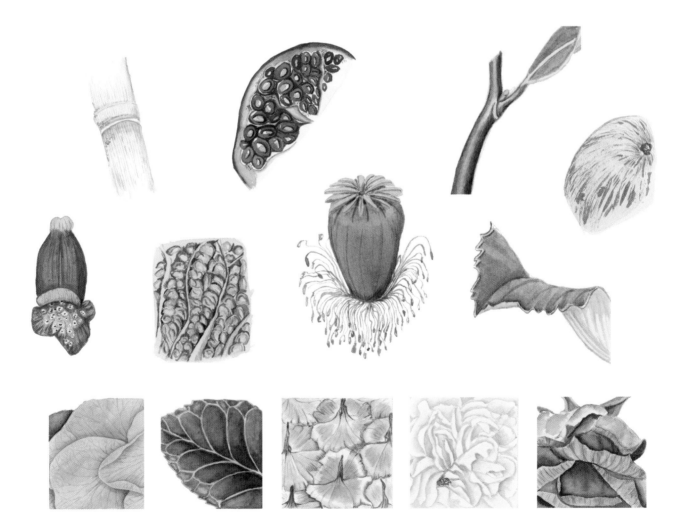

The clematis (*Clematis* 'Bill MacKenzie') (opposite) tumbles from the top of the page in an energetic representation of the growth habit of the plant. Three different textures are apparent here. The yellow flowers are thick and waxy, the leaves are smooth and deeply veined, while the seedheads are soft, fluffy and delicate. The stems of the flowers and seedheads have been kept finer than the main stems, which have been painted in a purple-red shading to a dull greenish red.

Above and opposite: Clematis 'Bill MacKenzie'. Waxy flowers, smooth, deeply veined leaves and soft, fluffy seedheads are characteristic of this clematis. The artist's notes include 'keep stems to flowers and leaves as fine as possible', 'seedheads shiny' and 'stem purple-red'.

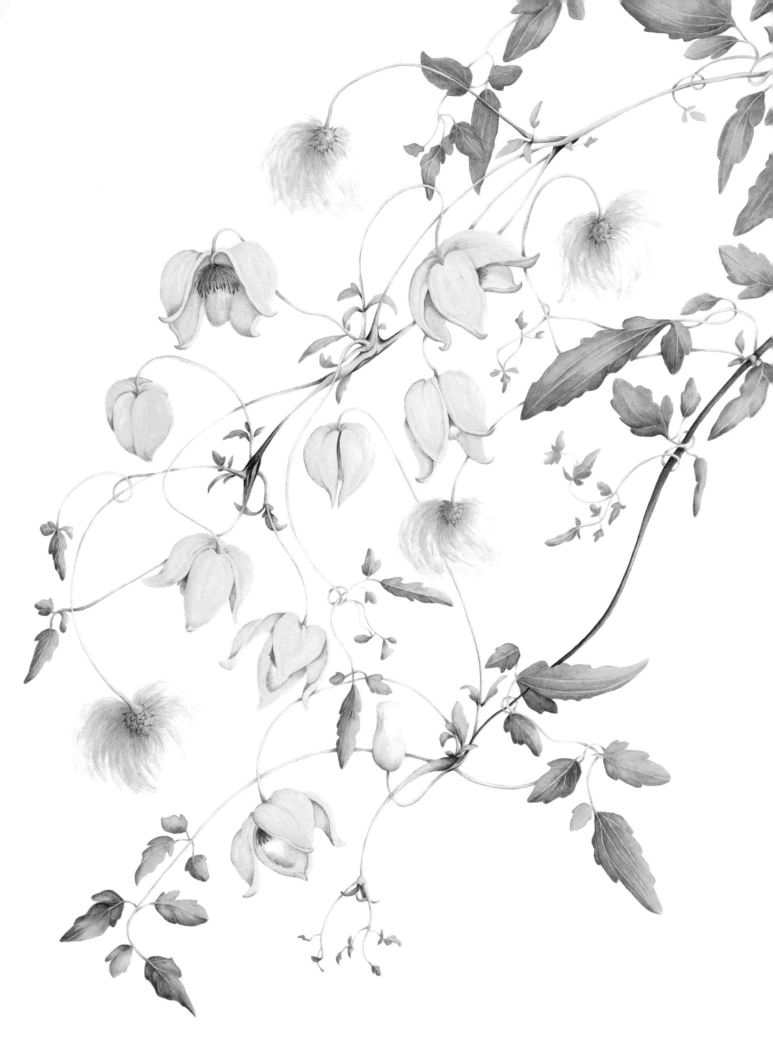

Challenging colours

The colours to be found in any garden or in the countryside are endless. You will find yellow, red, purple, blue, green, grey, black, brown and many others. Don't confine yourself to just leaves and petals – look also for lichens, fallen bark, moss and twigs.

Exercise – colours

When you next spend time in a garden or go for a walk, take a bag with you and collect as many coloured specimens as possible. When you get home, lay them out on a white background, separated into their different colour groups. Using as limited a palette as possible, mix as many of the colours as you can from your paintbox, noting which paints you used. Most of these are possible using just the primary colours, but you may need additional colours to achieve some of the pinks and purples (see above).

Mixing specific colours

There comes a time when your artistic demands will no longer be simple, and greater challenges will arise in the mixing of specific colours. It may be the challenge of a furry leaf, such as *Stachys byzantina*, known as lambs' ears, or the rich dark red of the leaf of the smoke bush, *Cotinus coggygria* (see page 21), but whatever it is, you will need to spend time considering how you will tackle the subject. As with any new technique or

Above left: Some of the actual leaves and petals to be found in a Cornish garden in May, arranged to correspond with the colour circle.

Above right: The arrangement of flowers and leaves, translated into paint.

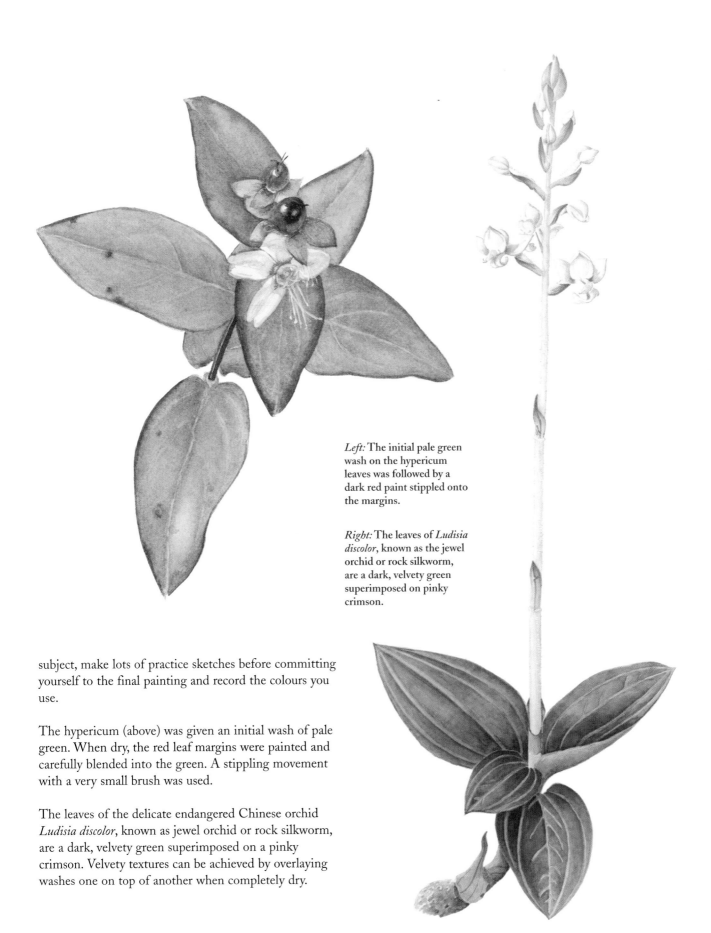

Left: The initial pale green wash on the hypericum leaves was followed by a dark red paint stippled onto the margins.

Right: The leaves of *Ludisia discolor*, known as the jewel orchid or rock silkworm, are a dark, velvety green superimposed on pinky crimson.

subject, make lots of practice sketches before committing yourself to the final painting and record the colours you use.

The hypericum (above) was given an initial wash of pale green. When dry, the red leaf margins were painted and carefully blended into the green. A stippling movement with a very small brush was used.

The leaves of the delicate endangered Chinese orchid *Ludisia discolor*, known as jewel orchid or rock silkworm, are a dark, velvety green superimposed on a pinky crimson. Velvety textures can be achieved by overlaying washes one on top of another when completely dry.

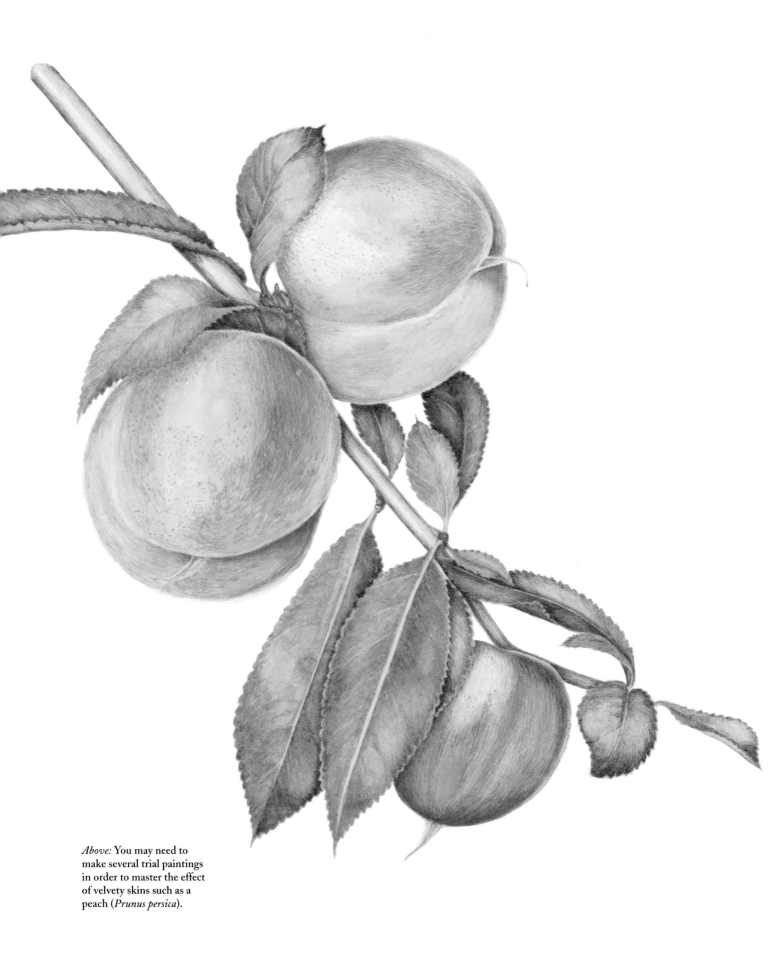

Above: You may need to make several trial paintings in order to master the effect of velvety skins such as a peach (*Prunus persica*).

The leaves of *Helichrysum petiolare*, the liquorice plant (right), are a good example of a difficult subject. They are not only an unusual shade of silvery green, but are also covered in very fine hairs. Hairy or furry subjects provide a good opportunity for using coloured pencils. Here the helichrysum leaves have been given two treatments, one with paint (top) and the other with coloured pencils. Very finely sharpened coloured pencils are able to give a good textured, fuzzy look. You will need a range of blues, yellows, browns and greens, with a dark grey or black for shading. Finally, you might need to add more hairs with a finely sharpened white pencil.

If using paints, mix a blue-green using French ultramarine, lemon yellow, Indian yellow and a tiny amount of alizarin crimson. Dilute it well and try out on a piece of scrap paper to get the correct colour. After the application of the first pale wash use a short, stippled stroke with a very fine brush, so that outlines are not too harsh. Finish by adding fine hairs with your smallest brush (4/0) using titanium white or white gouache.

Peaches are velutinous – a lovely word meaning velvety, covered in fine hairs. This velvety texture can be very hard to portray, and you may need to make several trial paintings before you master the effect. The artist used two base washes, an orangey yellow (Indian yellow with a bit of scarlet lake) and a primary red (alizarin crimson and scarlet lake), which she put on wet-into-wet. She used several layers to build up depth of colour.

Then came the challenge of how to portray the velvety texture. The artist decided to paint it on top of the washes, using an extremely fine (10/0) brush. The watercolour whites, titanium and Chinese white, were not strong enough and simply vanished into the lower layers of paint. Diluted white gouache, however, remained visible when dry. In these samples (right), fruit A had white gouache painted as a wash over the colour, but the result was muddy. Fruit B had stiff gouache put on as individual hairs with a 10/0 brush, but the artist's comment was that life is too short and anyway the hairs were too big and defined. Fruit C had a gouache wash in part, with tiny strokes of medium-thick gouache added. Ultimately, on observation, the fuzz was found to be more obvious when seen at an angle, as on the curves and edges. So in the final arrangement (left), where the edge of the fruit crosses a leaf or stem, a white or light edge is shown with a similar effect on the cheeks of the fruit and a few dilute gouache hairs on the body of the fruit.

Figure D shows a cross-section of the peach, where there is good contrast between the succulent flesh and the hard stone.

Right: Attempts to portray the fuzz on a peach and a cross-section of the fruit.

Paint

Pencil

Above: Helichrysum petiolare (liquorice plant). Not only a difficult shade of green, but hairy too.

a

b

c

d

In this illustration (right),
which shows peach blossom
and its growth habit, there is a
small painting of the juvenile
fruit where a different treatment of
velvety fuzz can be seen. There is also
fine detail on the leaves with their
slightly lighter, serrated edges.
Ultimately, all these elements will be
drawn together to make one picture,
giving a useful diagnostic history of the
peach from bud through to ripe fruit.

Brown flowers

One of the most unusual colours for flowers is brown, a colour normally associated with autumn leaves. The standard dwarf bearded iris (*Iris* 'Indian Pow-Wow') uses a series of very unusual superimposed colours to build up its strange, smoky green, gold and violet haze. The browns are built up using yellows, blues and violets and it is the overlaying of these different colours that produces strange shades that cannot be obtained commercially; in other words, colours that have no name.

To paint the left-hand fall, for example, make an initial wet-into-wet wash using pale violet, pale yellow and pale blue. Because the initial wash is so pale, you can also include the area occupied by the beard. When dry, overlay a mixture of yellowy green and bronze (a mix of green, orangey red and a touch of blue) to accentuate the parts where the deepest colour is found – the fold of the petal's edge on the right and around the centre of the fall. You may need to apply eight or ten layers of the same mix to achieve the required depth of colour. Use a deeper, stronger mix of the same colours to paint in the veins with your smallest brush. The veins on irises are often so subtle that they are almost indiscernible, so use a magnifying glass and make sure that you paint the veins extremely finely using a suitable small brush.

Above: Another treatment of velvety peach skin can be seen in this painting of the juvenile fruit. Other textures are present in the stamens, petals, leaves and stems.

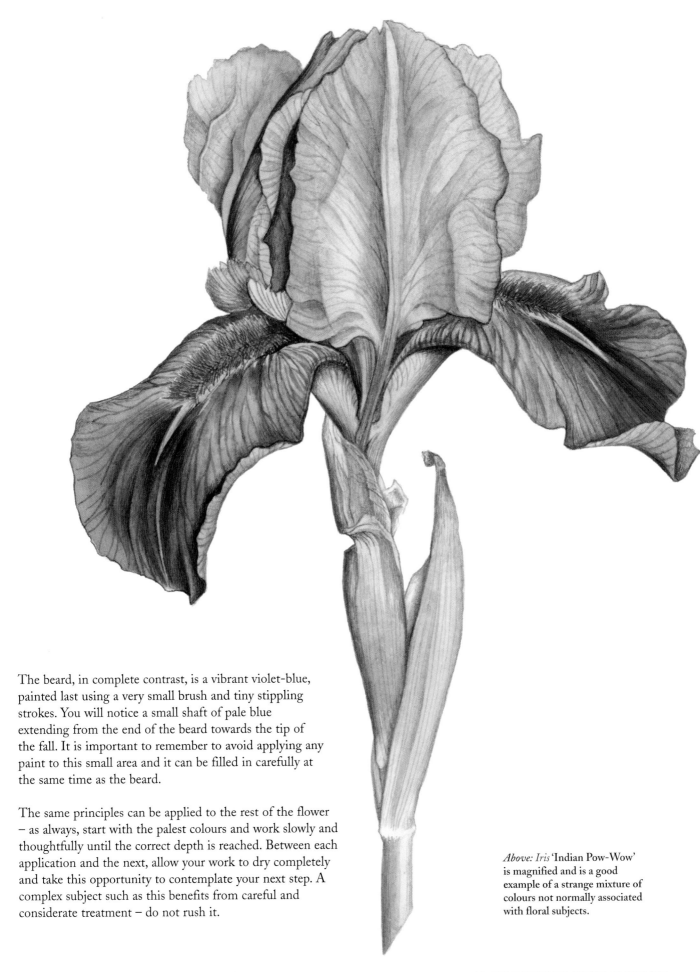

The beard, in complete contrast, is a vibrant violet-blue, painted last using a very small brush and tiny stippling strokes. You will notice a small shaft of pale blue extending from the end of the beard towards the tip of the fall. It is important to remember to avoid applying any paint to this small area and it can be filled in carefully at the same time as the beard.

The same principles can be applied to the rest of the flower – as always, start with the palest colours and work slowly and thoughtfully until the correct depth is reached. Between each application and the next, allow your work to dry completely and take this opportunity to contemplate your next step. A complex subject such as this benefits from careful and considerate treatment – do not rush it.

Above: Iris 'Indian Pow-Wow' is magnified and is a good example of a strange mixture of colours not normally associated with floral subjects.

Green or white flowers

The arum lily (*Zantedeschia aethiopica*) (right) is a good example of colours that can be made using the basic primary palette. The colours run the extreme range of the green-black scale on the black colour circle (see page 97), from creamy off-white to deep greenish black. As with all botanical illustration, correct colour assessment is essential. So before beginning to paint your subject always make up swatches of the colours you will need. All the paints used for the arum lily can be found on the list of primaries in chapter 1, Your Workplace and Materials (see page 20).

For the flower, mix lemon yellow deep with tiny amounts of carmine and ultramarine blue to give a base of light creamy yellow, adding small amounts of self-mixed neutral black to achieve the mid- and dark green-yellows. Overlay more neutral black and last of all put in some small areas of very dark green-black by overlaying with a stippling stroke. The majority of the surface area of the lily is light-to-medium colour. Use very dark accents sparingly for maximum impact. They could be called exclamation marks punctuating the study. For the more vivid greens of the outer surface, add more ultramarine and yellow and some self-mixed neutral black for the shaded areas.

On the subject of texture, the inner surface of the sheath is a series of rills giving an almost quilted appearance. It is important to have some guidelines to make sure that the pattern follows the form of the sheath, curving in the right directions. Blended tone is applied along these quilted lines to give depth and form.

Above: Before beginning to paint, make swatches of the colours you will require. The colours above show a mixture of lemon yellow, carmine and ultramarine with increasing amounts of neutral black added.

Right: Arum lily (*Zantedeschia aethiopica*). Dark accents are used sparingly for maximum impact.

The leaves of this fern-leaved clematis (*Clematis cirrhosa* var. *balearica*) (above) are more grey than green and contrast well with the very pale creamy yellow of the flowers. To achieve the correct colour, mix a neutral black and add a small amount of blue and yellow. Use well diluted for the undersides of the leaves and for the fine stems. The same diluted yellow-grey is used for delineating the petals and for the calyces. Deep red is added to paint the fine spots on the inside of the petals using a fine brush, and is also used to mix the brown for the supporting flower stems. Use a very fine brush to paint the fine hairs on the seedheads.

Above: The grey-green leaves of this fern-leaved clematis (*Clematis cirrhosa* var. *balearica*) resonate well with the creamy yellow flowers.

Pinks and purples

With challenging colours in the pink/purple range you may need additional paints, beyond the simple palette of primaries. Although you will not need all of the following, some of them at least will prove useful. Those marked with an asterisk (*) are found in the list of paints in Chapter 1 Your Workplace and Materials (see page 20):

Opera rose* (Winsor & Newton)
Tyrian rose (Sennelier)
Permanent rose (Winsor & Newton)
Rose doré (Winsor & Newton)
Cobalt violet (Winsor & Newton)
Winsor violet* (Winsor & Newton)
Brilliant blue violet* (Schminke-Horadam)
Permanent magenta (Sennelier)
Mauve (Schminke-Horadam)
Brilliant purple* (Schminke-Horadam)

Left and below: The Roxburgh fig (*Ficus auriculata*) has a blotched, hairy skin and the cut flesh oozes a latex-like sap.

The Roxburgh fig (*Ficus auriculata*) presents several textural challenges. The dark seeds have a dull shine, there are fine filaments at the opening in the base, the cut flesh oozes a latex-like sap and the skin is blotched and partially covered in fine hairs.

This fig (right) is a good example of the importance of a little botanical knowledge about your subject before you begin to paint it, so that you recognize and understand the importance of any special features – such as the opening in the base (the ostiole) that allows entry to a small symbiotic pollinating wasp – and are therefore able to portray them correctly.

Here, the areas of sap were blocked out with masking fluid, which was removed when the paint was dry, then given three-dimensionality with touches of grey-blue. The flesh was painted with a pinky red. The outer skin was given a pale wash of dark red with a touch of deep yellow, then stronger amounts of dark red were dropped in, with the addition of dark blue for the shaded areas. When the paint was dry, the fine hairs were painted with a fine brush and a mix of titanium white and Indian yellow.

The bright pinky red of dulse (*Palmaria palmata*), opposite, a seaweed that grows on the shore between high and low tide in the North Atlantic and North-west Pacific, is made up of alizarin crimson, rose doré, scarlet lake and ultramarine blue, laid on in wet-into-wet washes and also in successive layered washes. The same colours, with the addition of Indian yellow, are used for the crab shell and brittle star skeleton.

Right: Lychnis coronaria (rose campion). The colour of these flowers is well nigh impossible to mix using just the primary colours.

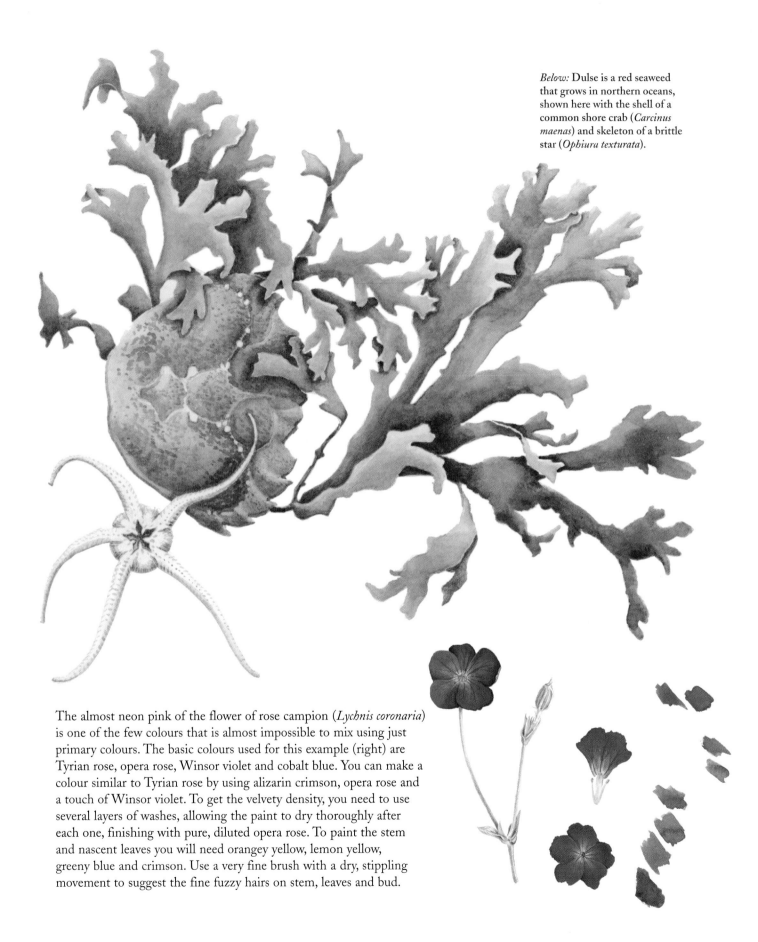

Below: Dulse is a red seaweed that grows in northern oceans, shown here with the shell of a common shore crab (*Carcinus maenas*) and skeleton of a brittle star (*Ophiura texturata*).

The almost neon pink of the flower of rose campion (*Lychnis coronaria*) is one of the few colours that is almost impossible to mix using just primary colours. The basic colours used for this example (right) are Tyrian rose, opera rose, Winsor violet and cobalt blue. You can make a colour similar to Tyrian rose by using alizarin crimson, opera rose and a touch of Winsor violet. To get the velvety density, you need to use several layers of washes, allowing the paint to dry thoroughly after each one, finishing with pure, diluted opera rose. To paint the stem and nascent leaves you will need orangey yellow, lemon yellow, greeny blue and crimson. Use a very fine brush with a dry, stippling movement to suggest the fine fuzzy hairs on stem, leaves and bud.

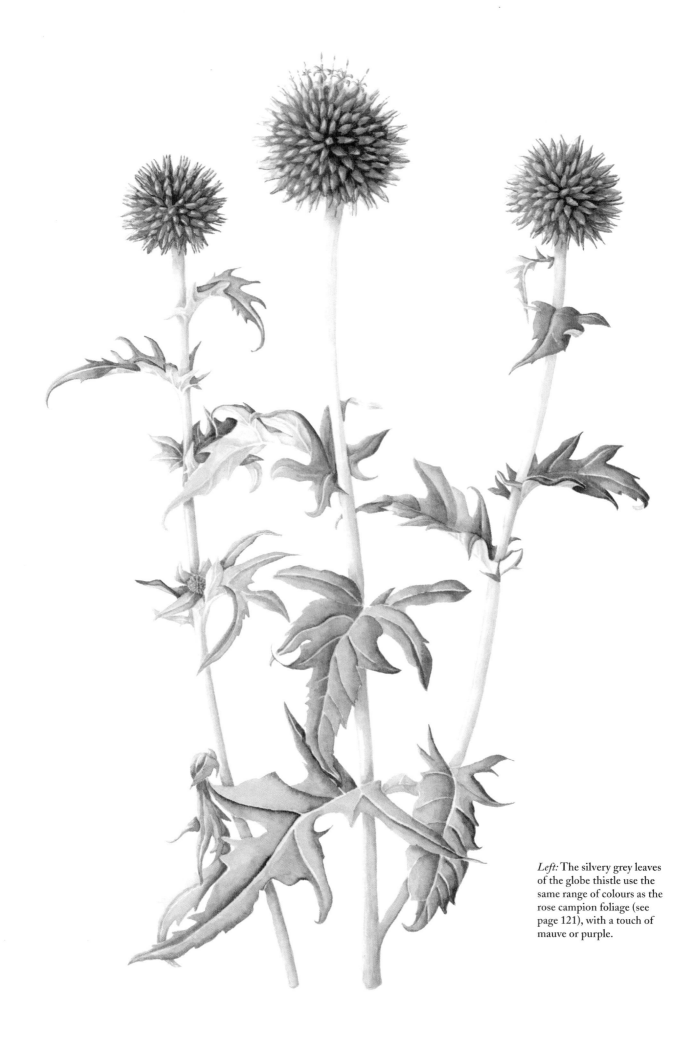

Left: The silvery grey leaves of the globe thistle use the same range of colours as the rose campion foliage (see page 121), with a touch of mauve or purple.

Blue subjects

You can use the same range of leaf colours as the rose campion to paint the silvery green leaves of the globe thistle (*Echinops bannaticus*), opposite, with a bit of mauve or purple to echo the colours in the flower heads. The stem is painted with a much-diluted version of the leaf colour.

The flower heads present quite a challenge. Each small floret needs to be carefully drawn in position and then painted with a tiny brush and a pale wash of light mauve, darkened towards the shaded side. Use a deeper version of the same colour to delineate between the florets, and finally wash a medium strength mauve over the side of the globe away from your light source to give three-dimensionality. The tiny petals of any florets that have opened should be painted last with your smallest brush.

Another blue subject is blue bean shrub (*Decaisnea fargesii*), also known as dead man's fingers (above). In spring it has long drooping panicles of yellow flowers, but the shrub's real glory comes in autumn when its pods hang like fat blue-sprayed fingers.

Above: Care was taken to select the correct blue for the pods of blue bean shrub (*Decaisnea fargesii*), also known as dead man's fingers.

Strelitzia nicolai (giant or black bird of paradise)

Surely one of the most bizarre flower clusters is that of *Strelitzia nicolai* (giant or black bird of paradise), known familiarly to this artist as Nick. The bracts and flowers on this large, evergreen, palm-like perennial are usually found high above the ground, making them inaccessible to the artist.

Nick was painted from a variety of studies that included drawings and photographs, some of which were taken standing on a friend's shoulders (see page 142). The picture took 21 days to complete and required a variety of sympathetic media – watercolour, coloured pencils, gouache and graphite pencil.

The bracts were painted first, using a wet-into-wet wash that included green, purple, pink, orange and blue. Once the paint was dry, the colours were built up with deeper shades of watercolour, making sure that the lowlights were left alone.

The sticky orange sap was painted using watercolour with a little orange gouache added to give it a slight opacity. Around the edges of the sap some white, yellow and orange coloured pencil was added to give extra depth. The very dark areas consisted of about 12 layers of paint, each layer getting subsequently darker, building up a rich lustre. Graphite pencil was stroked over some of the paler areas to give the impression of solid woody bulk.

The waxy flowers emerging from the bracts were painted with very pale washes of blue, brown and cream. The bases of these flowers often contained pink-purple blushes, which were stroked on when the initial wash was dry. Finally, some areas of the flowers had a particularly thick texture for which white coloured pencil, used very heavily, was ideal.

The picture was designed to be accurate but also to create a challenging and dramatic up-to-date image for contemporary botanical illustration. Nick could be quite at home on the set of a science fiction film. Challenging textures, patterns and colours are just that – challenging. To deal with them can be a very laborious process, but well worth it in the end.

Below: The worksheet for *Strelitzia nicolai* demonstrates the importance of testing shapes, washes and colours before committing to the final painting.

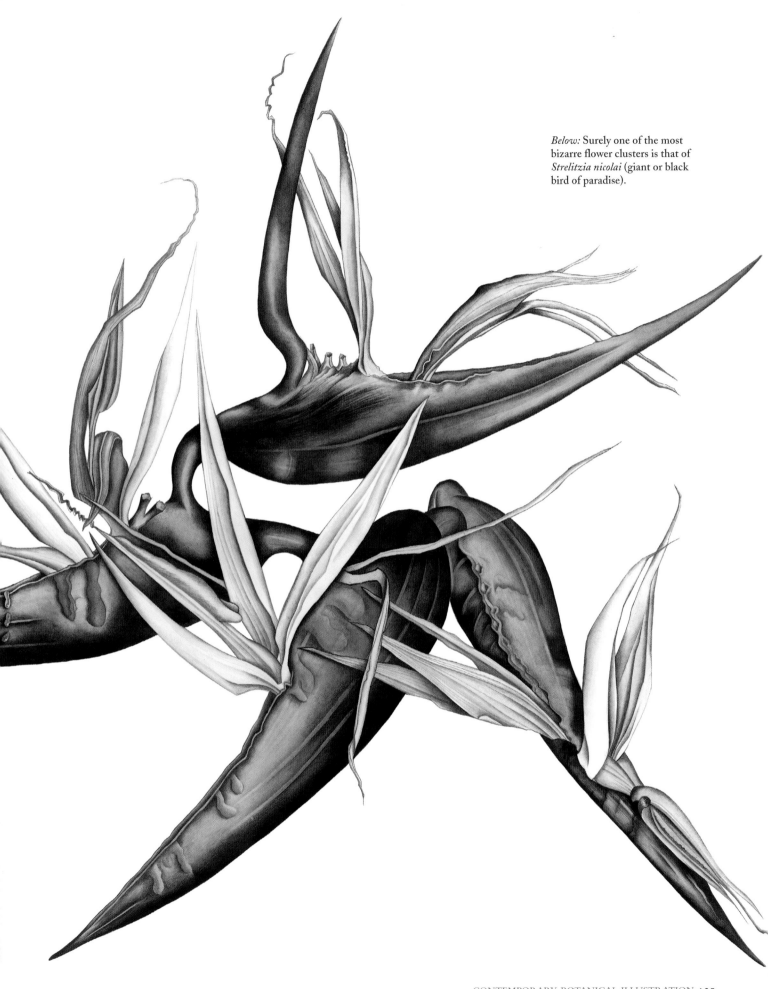

Below: Surely one of the most bizarre flower clusters is that of *Strelitzia nicolai* (giant or black bird of paradise).

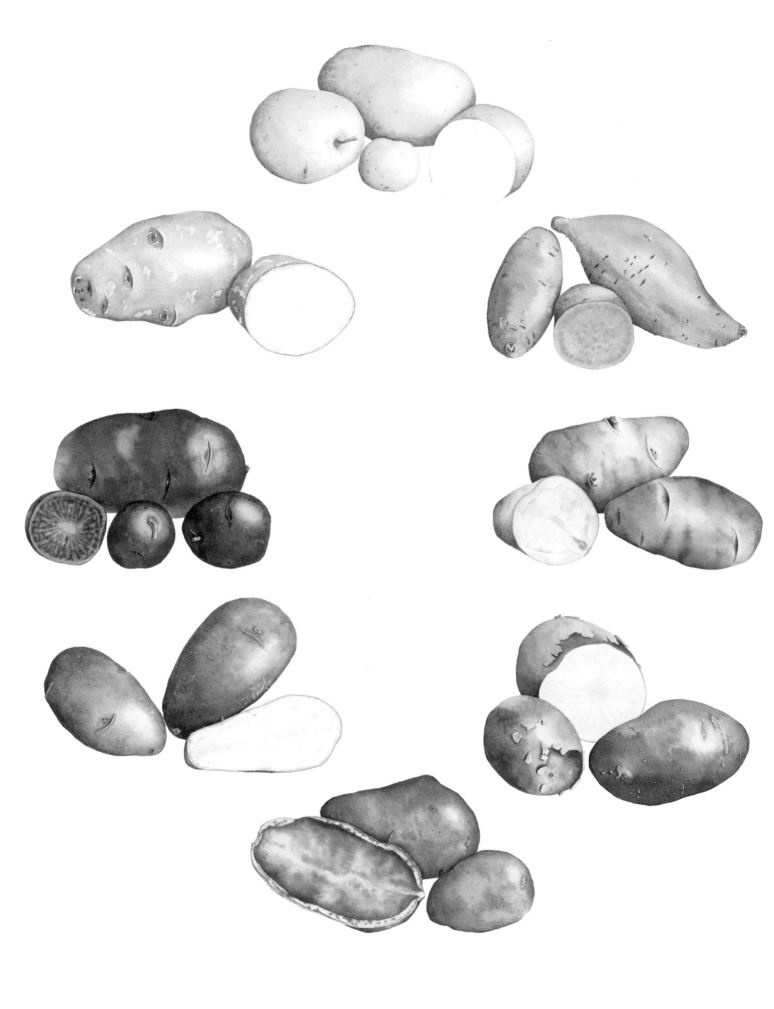

11. Understanding your subject and adding interest: food plants

Not everyone likes painting flowers best. Some botanical artists prefer fruit and vegetables and there is certainly a widespread appreciation of such pictures. Just as it is good to be able to find out a bit about the floral subject you are painting, so a little knowledge about your fruit or vegetable adds interest to a pleasing portrait.

Potatoes

That most common and under-rated vegetable, the potato, has hundreds of different forms and colours. Here we show a potato colour circle, ranging from yellow through orange, red and purple to blue and finally green. There are several blue varieties to choose from, and one is spoilt for choice when looking for pink- and red-skinned spuds.

The sweet potato and the green potato are a bit of a cheat. Whereas all the others are members of the potato family (*Solanaceae*), the sweet potato (*Ipomoea batatas*) is a member of the bindweed family (*Convolvulaceae*) – but it earns its place here because it completes the colour spectrum. The green potato was left exposed to sunlight whereupon it produced chlorophyll and in the process became toxic. All these potatoes (except for green potatoes, which should never be eaten) retain their colour when cooked, even 'Blue Congo'.

You will need just the primary colours for these vegetables, using mainly wet-into-wet washes, layering them to get the required depth of colour. Light coloured blemishes may be carefully masked off with masking fluid at the start, allowing free-flowing washes to be applied. When the paint is dry, carefully rub off the masking fluid with an eraser and neaten the area with a small brush and the appropriate colour. It is easy to get ragged edges when washes are applied one over another, so carefully neaten them with a fine brush at the end.

Left: A colour circle, made up of potatoes (*Solanum tuberosum* cultivars), including (clockwise from top) 'Luna', sweet potato (*Ipomoea batatas*), 'Early Rose', 'Amorosa', 'Highland Burgundy Red', 'Adam Blue', 'Blue Congo' and 'Early Market'. The latter was allowed to turn green (and toxic) in sunlight to complete the colour spectrum.

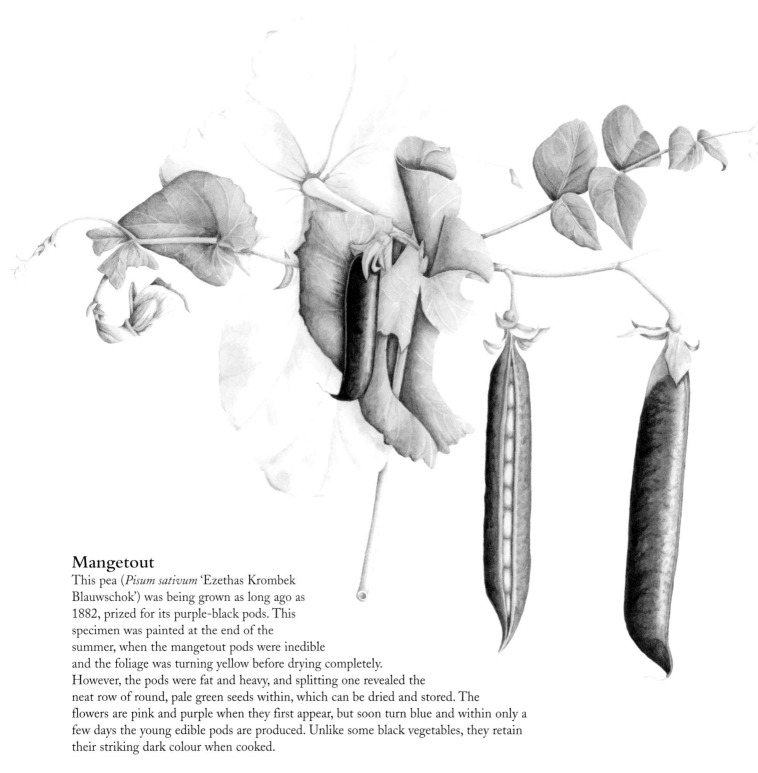

Mangetout

This pea (*Pisum sativum* 'Ezethas Krombek Blauwschok') was being grown as long ago as 1882, prized for its purple-black pods. This specimen was painted at the end of the summer, when the mangetout pods were inedible and the foliage was turning yellow before drying completely. However, the pods were fat and heavy, and splitting one revealed the neat row of round, pale green seeds within, which can be dried and stored. The flowers are pink and purple when they first appear, but soon turn blue and within only a few days the young edible pods are produced. Unlike some black vegetables, they retain their striking dark colour when cooked.

The pods were painted purple-black, leaving areas of untouched paper to indicate the highlights. The leaves and verdant stems were painted blue-green, whereas the older leaves in the background were shown in a range of yellow and light brown. The darker areas on the yellow leaves were put in with purple (the complementary colour of yellow on the colour circle).

Above: In the autumn the foliage of *Pisum sativum* 'Ezethas Krombek Blauwschok' yellows and dries and the seeds become hard and are no longer edible as mangetout.

Oyster mushroom

This delicate pencil study of an oyster mushroom shows
both the cap and the underside, where the gills extend down the
stem, or stipe. Notice how the gills are accentuated by the juxtaposition
of light and dark, the pencil shading being heaviest on the inner part of the gill
and almost non-existent at the outer edge, with an extremely sharp delineation
between the two. In contrast to the busyness of the stem, the cap has been treated with
carefully graded shading, giving it a smooth, rounded character. Particularly pleasing
are the areas where a predator has nibbled pieces away.

Papaya

The papaya *Carica papaya*, called 'fruit of the angels' by Christopher Columbus,
originated in Mexico although it is now grown in most tropical countries and can be
found in supermarkets virtually all year round. The shiny, black and somewhat bitter
seeds are sometimes ground as a substitute for pepper. This picture was painted initially
with watercolour washes, and then completed with a very subtle and clever use of
coloured pencils.

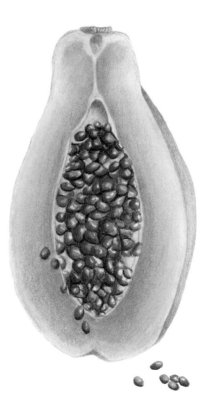

Above: Much prized for its
flavour, the oyster mushroom is
a good example of light and
dark shading.

Left: The study of a papaya,
Carica papaya, also known as
pawpaw, was done initially with
a watercolour wash and then
completed with coloured pencils.

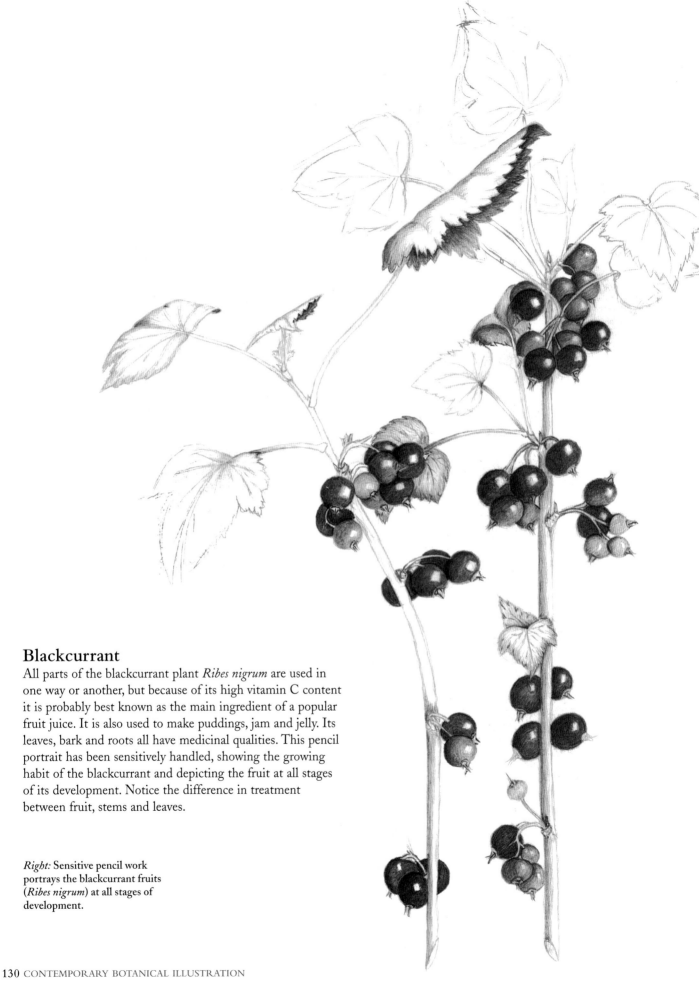

Blackcurrant

All parts of the blackcurrant plant *Ribes nigrum* are used in one way or another, but because of its high vitamin C content it is probably best known as the main ingredient of a popular fruit juice. It is also used to make puddings, jam and jelly. Its leaves, bark and roots all have medicinal qualities. This pencil portrait has been sensitively handled, showing the growing habit of the blackcurrant and depicting the fruit at all stages of its development. Notice the difference in treatment between fruit, stems and leaves.

Right: Sensitive pencil work portrays the blackcurrant fruits (*Ribes nigrum*) at all stages of development.

Garden rocket

The pungent, acrid and peppery leaves of garden rocket (*Eruca vesicaria* subsp. *sativa*) are easy to grow and have been in use for well over a thousand years. Medieval cooks valued it for its ability to season soups and stews, before the advent of pepper. The seeds, steeped in honey, were smeared on the face to clear spots and blemishes and were also believed to 'stir up bodily pleasure'.

This painting (right) clearly illustrates how the rocket leaves grow from, and are attached to, the stem and shows the crimson sepals and dark red veins on the petals that are so characteristic of this plant.

This picture also demonstrates how a feeling of three-dimensionality is achieved by leaving the leaves in the background lighter and less well defined than the ones in the foreground. A similar effect can be realized by treating those at the back with a final wash of very pale blue and those in the front with a wash of very pale yellow. This phenomenon is known as aerial perspective, which is particularly noticeable on a much larger scale in a landscape, where the foreground is clear, bright and defined, but features towards the horizon, such as ranges of hills, become increasingly pale and blueish (see also the cowslip on page 31).

Right: Garden rocket (*Eruca vesicaria* subsp. *sativa*). Three-dimensionality has been shown by making the leaves in the background lighter and less well defined than the ones in the foreground.

Sweetcorn

Sometimes one medium lends itself to a subject more than another. While the illustration below uses only watercolour, the two pictures of sweetcorn (*Zea mays*) opposite were made using a combination of coloured pencil and watercolour. Following an initial watercolour wash, coloured pencils were used to take the pictures to their final stages. Pencils should be kept sharp at all times, and you will find that a stippling movement is most suitable for a subject like this. After the colour has been applied, burnish the picture with a blender or a white or champagne-coloured pencil to fuse everything together. This smoothing or blending should be done little by little, following the shapes and adding brilliance and vibrancy.

For finer details, watercolour is probably most suitable. Paint the filaments (silks) with a small brush, looking for the areas of dark mass and leaving the lighter areas surrounding them. Add some paler silks over the darker ones with white gouache. To paint the kernels, do each one individually, working from the highlight outwards. Use first a fairly pale yellow, then darker and darker to an orange, rather like a bull's-eye. Burnish the kernels individually with a circular motion to blend the colours smoothly. Define the dark areas between the kernels with a fine watercolour brush and deep brown-purple watercolour.

You may also find that watercolour is more amenable than coloured pencils for hard definition, such as the shading behind the down-turned leaves. It is also useful to neaten the edges of your painting and make them sharp and well defined.

Right: These two strong portraits of a maize cob (*Zea mays*) use a combination of watercolour and coloured pencils.

Below: A staple food of large areas of the world, sweetcorn (*Zea mays*) can be eaten fresh or dried and ground into flour. The cross sections through the cob are an interesting detail.

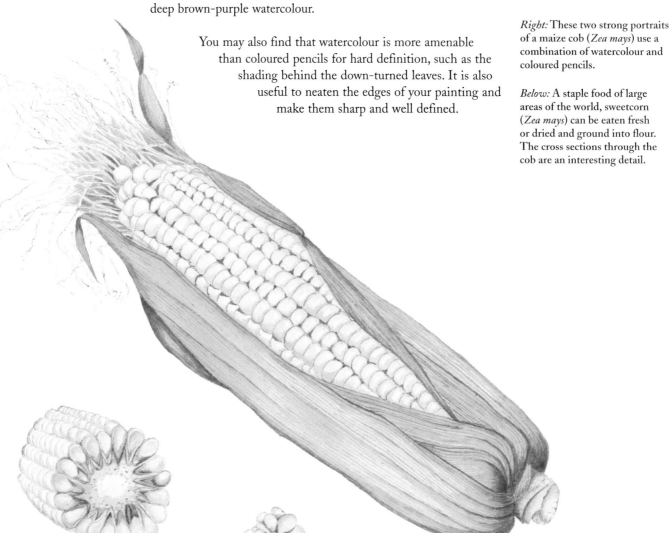

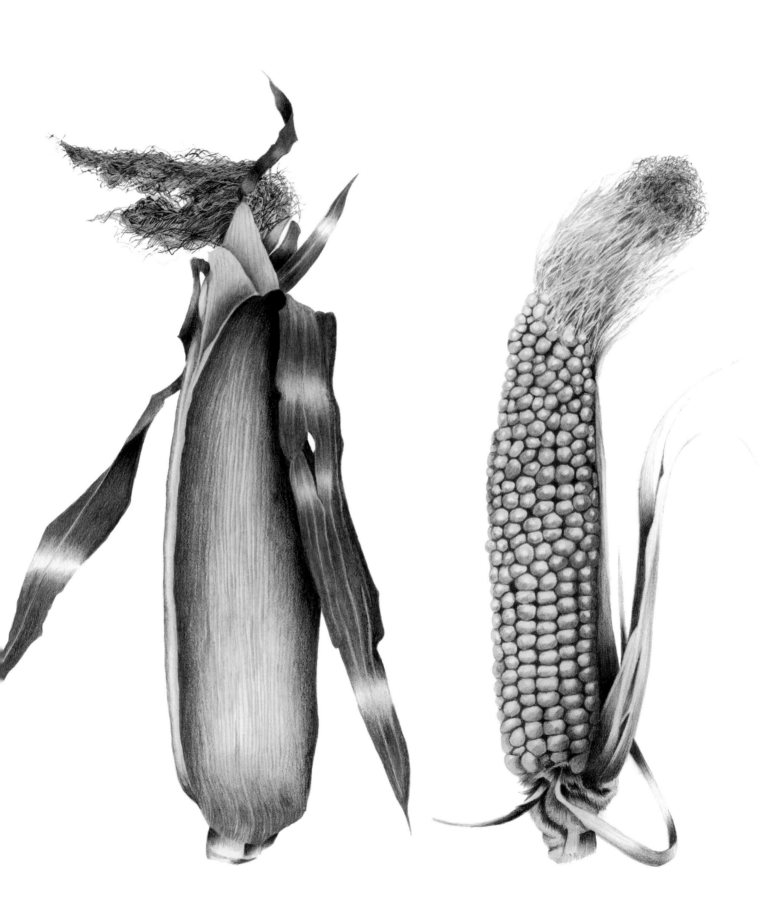

Coconuts

These immature coconuts (*Cocos nucifera*) were grown at the Eden Project in the Rainforest Biome, which provides the tropical conditions needed for successful growth. The coconut tree has a single, smooth, grey stem that can be as tall as 30m (100ft) and produces up to 75 large fruits annually, each containing one seed. Inside the seed is the coconut flesh and a liquid known as coconut milk. This picture characterizes the growth of the young seeds and captures their exuberant yellow and green colouring.

Above: The coconut (*Cocos nucifera*) is also known as the tree of life because in some areas of the world it provides everything necessary for survival.

Below: Brash, pungent, easy to grow and store – the onion (*Allium cepa*) was worshipped by the ancient Egyptians.

Onion

The onion (*Allium cepa*) is one of the most widely used vegetables, being the basis of many savoury dishes. It is a bulb, a member of the *Alliaceae* family, and was used as food as long ago as the Bronze Age. It was worshipped by the ancient Egyptians, who believed that eternal life was symbolized by its spherical shape and concentric rings.

The onion is a brash, confident, assertive vegetable, never one to take a back seat. This illustration (right) captures its character with exuberant use of the primary colours. Three different textures are immediately apparent: the crinkly crispness of the dried leaves; the dry, papery texture of the outer skins; and the soft, silky shine of the inner vegetable.

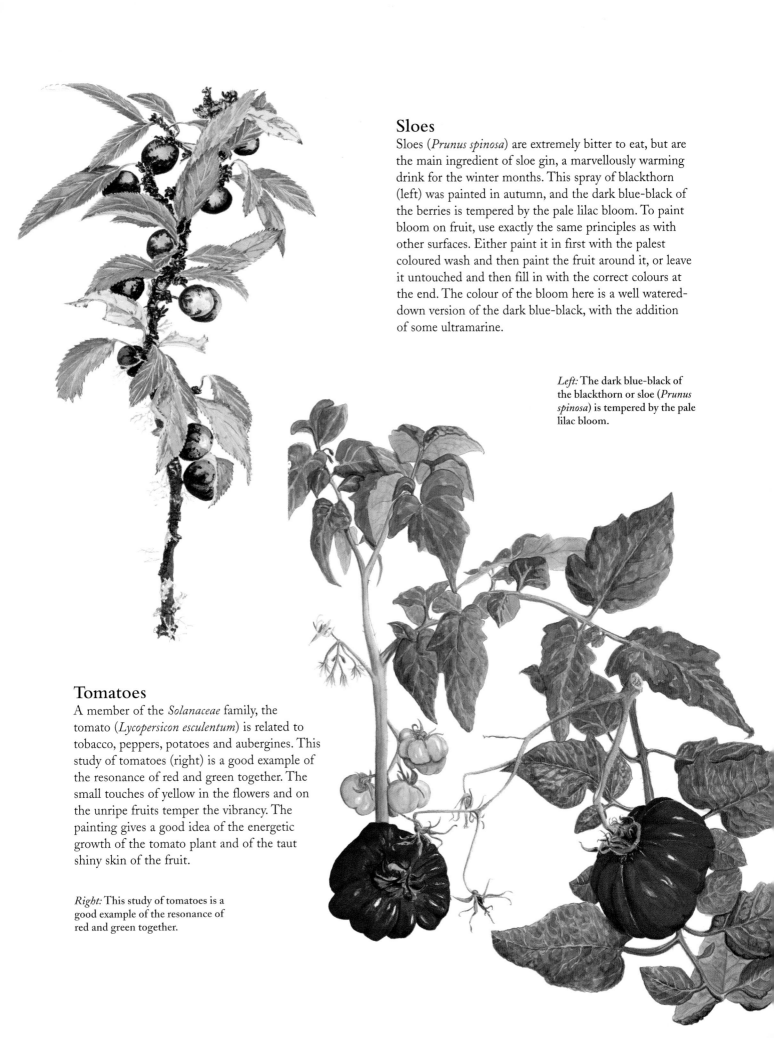

Sloes

Sloes (*Prunus spinosa*) are extremely bitter to eat, but are the main ingredient of sloe gin, a marvellously warming drink for the winter months. This spray of blackthorn (left) was painted in autumn, and the dark blue-black of the berries is tempered by the pale lilac bloom. To paint bloom on fruit, use exactly the same principles as with other surfaces. Either paint it in first with the palest coloured wash and then paint the fruit around it, or leave it untouched and then fill in with the correct colours at the end. The colour of the bloom here is a well watered-down version of the dark blue-black, with the addition of some ultramarine.

Left: The dark blue-black of the blackthorn or sloe (*Prunus spinosa*) is tempered by the pale lilac bloom.

Tomatoes

A member of the *Solanaceae* family, the tomato (*Lycopersicon esculentum*) is related to tobacco, peppers, potatoes and aubergines. This study of tomatoes (right) is a good example of the resonance of red and green together. The small touches of yellow in the flowers and on the unripe fruits temper the vibrancy. The painting gives a good idea of the energetic growth of the tomato plant and of the taut shiny skin of the fruit.

Right: This study of tomatoes is a good example of the resonance of red and green together.

New Zealand spinach

New Zealand spinach (*Tetragonia tetragonoides*) is a herb with arrow-shaped leaves and is easy to grow. It is used in the same way as spinach and usually only the new leaves and stems are harvested. It is said to be bothered by few pests, but obviously something enjoyed taking chunks out of this example.

A frequently asked question is whether you should portray the blemishes on your subject. It is really a matter of personal choice, but the story goes that in order to identify some ancient varieties of Cornish apples, botanists referred to old botanical paintings. By studying the ravages of various insects depicted on the fruit and leaves, they were able to identify the predators and thus were aided in their identification of the apples.

Notice how this stem is triangular. It is customary in botanical illustration to show the stem as a cut section, thus explaining its shape and composition, which can be an important diagnostic feature.

The colours used in this simple study of New Zealand spinach were ultramarine blue, lemon yellow and Indian yellow, with touches of alizarin crimson to mute the green.

Right: One diagnostic feature of New Zealand spinach, (*Tetragonia tetragonoides*), is its triangular stem.

Opposite: The scarlet runner bean (*Phaseolus coccineus*) is another good example of the resonance of red and green.

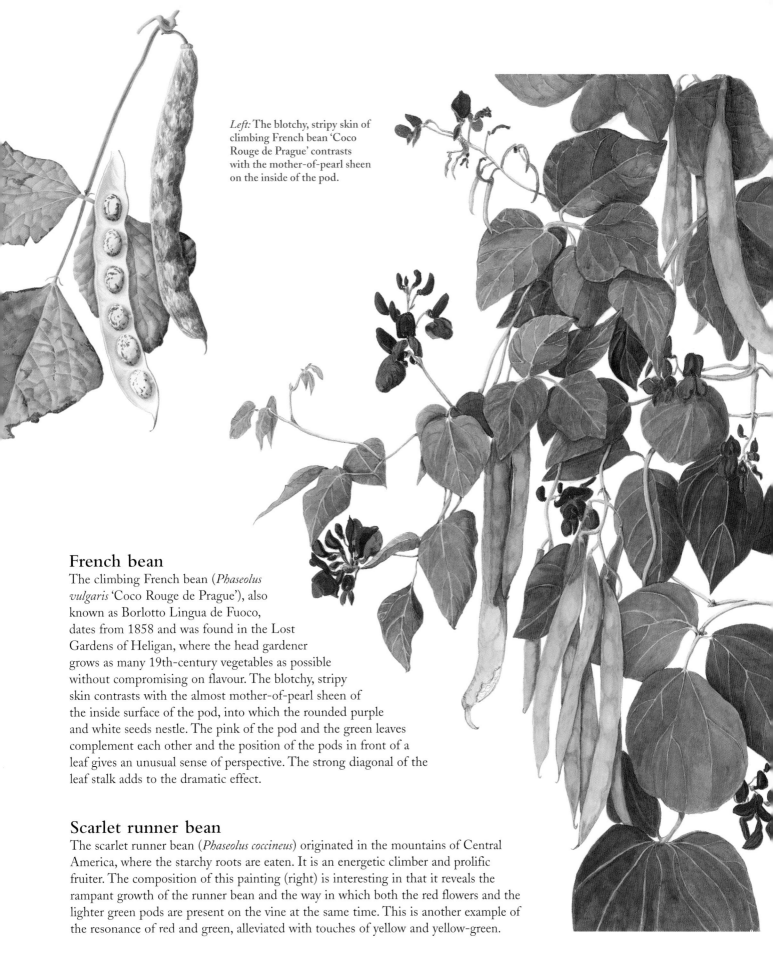

Left: The blotchy, stripy skin of climbing French bean 'Coco Rouge de Prague' contrasts with the mother-of-pearl sheen on the inside of the pod.

French bean

The climbing French bean (*Phaseolus vulgaris* 'Coco Rouge de Prague'), also known as Borlotto Lingua de Fuoco, dates from 1858 and was found in the Lost Gardens of Heligan, where the head gardener grows as many 19th-century vegetables as possible without compromising on flavour. The blotchy, stripy skin contrasts with the almost mother-of-pearl sheen of the inside surface of the pod, into which the rounded purple and white seeds nestle. The pink of the pod and the green leaves complement each other and the position of the pods in front of a leaf gives an unusual sense of perspective. The strong diagonal of the leaf stalk adds to the dramatic effect.

Scarlet runner bean

The scarlet runner bean (*Phaseolus coccineus*) originated in the mountains of Central America, where the starchy roots are eaten. It is an energetic climber and prolific fruiter. The composition of this painting (right) is interesting in that it reveals the rampant growth of the runner bean and the way in which both the red flowers and the lighter green pods are present on the vine at the same time. This is another example of the resonance of red and green, alleviated with touches of yellow and yellow-green.

12. Presenting your work

Having finished your drawing or painting, you will need to address the matter of what further action you need to take to complete your work. Although by no means definitive, we give various suggestions in this chapter.

Mounting and framing

How you present your work is of paramount importance. Unlike oil paintings, watercolours need protection. Usually this is in the form of a mount and frame. Visit exhibitions and galleries to see how others mount and frame their work. Be critical and make notes. You can pick up many tips by doing this.

Ways to protect your work include window mounting, free standing, float mounting and box mounting. A good exhibition framer will inform you of the wide variety of presentation choices available, and should use archival quality (acid-free) materials, which last for a very long time without deteriorating, thus helping to prevent any changes in the quality and longevity of your painting. Think carefully about the colour and size of the mount, and the colour and thickness of the frame. They should complement your work and show it in the best possible way. Botanical illustrations usually look their best in simple, pale wooden or lime-washed frames with a white or cream mount.

If you choose float mounting, where the paper has four deckle edges that are visible inside the mount, you will need to fabricate at least some of the deckle edges, unless your picture is the size of the full sheet of paper. To do this, place a clean steel ruler where you want the edge of the paper to be and wet the paper with clean water on a big brush, stroking down the edge of the ruler. Allow time for the water to saturate the paper. Then fold the paper and either cut it with a serrated knife or tear it very carefully. Alternatively, tear the paper against the ruler, which should be pressed down extremely firmly. This should be done before painting. It takes a bit of practice, but the results can be very good.

Exhibiting

The easiest way to exhibit your work is with a group of similar artists, such as (in England) the Society of Botanical Artists, the South West Society of Botanical Artists or a local painting group. It is rewarding, but much harder work, to stage your own exhibition unless you are lucky enough to be able to find a gallery to represent you and your work.

Pricing your paintings is never easy. The price you can charge seldom reflects the time you have spent, unless you are one of the botanical artists whose work is known and highly valued. Remember to take into account your costs, such as materials and framing, insurance (see Useful Addresses, page 142), the commission payable on sale and/or the hanging fee. Having set a price based on all these considerations, it is customary for the same price to be charged even if the sale is private – it is not considered acceptable to undercut galleries and exhibition venues.

Above: Thatching reed (*Chondropetalum tectorum*) is a member of the *Restionaceae* family and is used for thatching in South Africa, hence its name.

Commissions

Commissions result from publicity – either actively sought or by word of mouth. Exhibitions are a good way of getting your work known. You might like to produce a leaflet or brochure as well. Consider having a website to promote your work. Some art suppliers and organizations offer free website space. For a modest outlay you can design your own, although unless you are particularly computer-literate you will probably need a professional web designer to set it up for you.

Limited edition prints

Giclée printing is a process by which you can have as many, or as few, copies made of your artwork as you like. Prints can be made from digital files, slides or from the original artwork, which is scanned and then printed digitally.

Look in your local directory or on the Internet for a suitable printer, and make sure that they use acid-free, archival paper and inks, which ensure protection from fading and ultraviolet light. The printing method used by most printers allows for subtle gradations in colour and tone, thus giving better colour accuracy. The setting up costs can be expensive, but your artwork can be stored as digital files, allowing you to have further copies made as and when you need them. You may need to monitor closely the colour of new prints as they are made because the colour can sometimes vary between one print run and the next.

Greetings cards

There is a steady demand for cards at craft fairs and exhibitions. These can be hand-painted, professionally produced or made more economically using a home computer, scanner and printer.

Below: The colour and powerful energy of this red onion 'Clovelly Court' (left) is surprisingly more forceful as a greetings card in the cropped version (right).

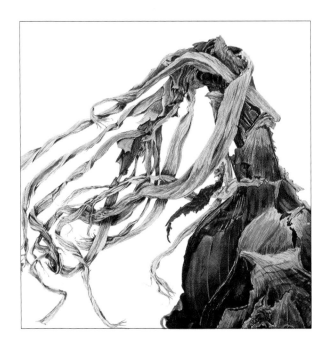

Hand-painted cards

This is time-consuming, and you may get to feel rather like a conveyor belt. They are much appreciated for special occasions such as weddings, landmark birthdays or anniversaries, but are not commercially viable for general sale.

Professionally printed cards

The ideal situation is to produce the original artwork and let someone else do the hard work. You could try approaching card manufacturers to see if they like your designs, but you may find it difficult to break into this market. If you want to embark on card sales on your own, look in the art press, on the Internet or in your local directory to find a printer who is prepared to do relatively small quantities. You should find it possible to have a print run of as little as 50, although generally the cost per card will be greater than if you opt for a larger quantity. Check whether your printer will also supply envelopes of the required size and colour. Your cards may be supplied already folded or flat with a score to allow for easy folding. You will have to allow time to fold, if necessary, and pack into cellophane sleeves with the envelopes (see below for more detailed packing suggestions).

Home-produced cards

If you have time, and are confident of your abilities with a scanner, computer and printer, then home-produced cards might be your answer. Before you do anything else, decide on the size of your card. This could be dictated by the size and shape of the envelopes available.

Make sure, also, that you are able to obtain the clear sleeves in the right size – final presentation and protection from grubby fingers is essential. You will also need some sort of seal for the flap at the back. This could be a simple self-adhesive disc on which you can pencil in the price, or you might like to print out some small labels with your name and contact details. Retail catalogues are available for the purchase of all necessary materials.

Experiment with different weights of card. Print shops and stationers usually have a range from which to choose. Make sure that your printer is able to cope with it. You may need a guillotine for trimming the cards – a scalpel or sharp craft knife and a steel ruler can be used instead.

Below: An example of how an upright subject can look better on a landscape shape.

Pricing your cards

When pricing your cards, whatever type of production method you choose, take into account what it has cost you to produce them, in both time and expenses, and also add any commission payable, such as at an exhibition or craft fair. It is also useful to see what prices are charged for similar cards by other artists at the venue.

Further Reading

Benke, Brita, *O'Keefe*, Taschen (ISBN 3822858617)

Blamey, Marjorie, *Learn to Paint Flowers in Watercolour*, Collins (ISBN 000412121X)

Blamey, Marjorie and Grey-Wilson, Christopher, *Wild Flowers of Britain and Northern Europe*, Cassell (ISBN 030436214X)

Burton, Sue, *The Techniques of Painting Miniatures*, Batsford (ISBN 0713474599)

Contemporary Botanical Artists: The Shirley Sherwood Collection, Weidenfeld & Nicolson (ISBN 0297822705)

Cumming, Robert and Porter, Tom, *The Colour Eye*, BBC Books (ISBN 0563215283)

de Bray, Lys, *The Art of Botanical Illustration – A History of the Classic Illustrators and their Achievements*, Eagle Editions (ISBN 1861604254)

Evans, Anne-Marie and Donn, *An Approach to Botanical Painting*, Evans & Evans (ISBN 0952086204)

Gombrich, Ernst, *The Story of Art*, Phaidon (ISBN 0714815225)

Grierson, Mary, *An English Florilegium*, Thames & Hudson (ISBN 0500234868)

Hickey, Michael, *Plant Names: A guide for Botanical Artists*, Cedar Publications (ISBN 0948640154)

Hickey, Michael and King, Clive, *100 Families of Flowering Plants*, Cambridge University Press, 2nd edition (ISBN 052123283X)

Hickey, Michael and King, Clive, *The Cambridge Illustrated Glossary of Botanical Terms*, Cambridge University Press (ISBN 0521794013)

Itten, Johannes. *The Art of Color* (translated by Ernst van Haagen), John Wiley & Sons Inc. (ISBN 0471289280)

Le Fanu Hughes, Penelope, *History and Techniques of the Old Masters*, Tiger International Books (ISBN 855010135)

Mabberley, David, *The Anatomy of Flowers. Arthur Harry Church*, The Natural History Museum (Merrel Publications) (ISBN 1858941164)

Martin, Rosie and Thurstan, Meriel, *Botanical Illustration Course with the Eden Project*, Batsford (ISBN 9780713490053)

Massey, Patricia, ed., *The Essentials of Ikebana*, Shufonotomo Co. Ltd, Tokyo, Japan (ISBN 20779724823062)

Mee, Margaret, *In Search of Flowers of the Amazon Forests*. Nonsuch Expeditions (ISBN 1869901088)

Robertson, Pamela, *Art is the Flower. Charles Rennie Mackintosh*, Pavilion Books (ISBN 1857933605)

Royal Academy of Arts, *Post Impressionism*, Weidenfeld & Nicolson (ISBN 0297777130)

Sherlock, Siriol, *Exploring Flowers in Watercolour: Techniques and Images*, Batsford (ISBN 0713480246)

Sherlock, Siriol, *Botanical Illustration: Painting with Watercolours*, Batsford (ISBN 071348862X)

Sherwood, Shirley, *A Passion for Plants: Contemporary Botanical Masterworks*, Cassell & Co (ISBN 0304361666)

Stewart, Joyce and Stearn, William T, *The Orchid Paintings of Franz Bauer*, The Herbert Press in association with the Natural History Museum, London (ISBN 1871569583)

Stevens, Margaret, *The Art of Botanical Painting*, Collins (ISBN 0007169884)

Stevens, Margaret, in association with the Society of Botanical Artists, *The Botanical Palette*, Collins (ISBN 9780007247851)

West, Keith, *How to Draw Plants: The Techniques of Botanical Illustration*, Herbert Press (ISBN 071365273X)

White, Christopher, *Dürer: The Artist and his Drawings*, Phaidon (ISBN 0714814369)

Wunderlich, Eleanor B, *Botanical Illustration in Watercolour*, Watson-Gupthill Publications (ISBN 0823005305)

Zomlefer, Wendy B, *Guide to Flowering Plant Families*, Chappell, Hill and London, University of North Carolina (ISBN 0807821608)

Useful information

Recommended Materials

Paper
Hot Press (HP) (see pages 14–16 for qualities)
Arches Aquarelle 300gsm
Fabriano Artistico 300gsm
Fabriano 5 350gsm
Magnani Corona Smooth 310gsm
Royal Watercolour Society (RWS) 300gsm
Saunders Waterford 300gsm
Sennelier 300gsm

Pencils 4H-HB
Caran d'Ache Technograph
Faber Castell 9000
Staedtler Mars Lumograph 100
Staedtler 480
Derwent Graphic

Kolinsky sable brushes
Winsor & Newton series 7
Da Vinci Maestro series 10 or 35
Raphaël series 8404
Escoda series 1212

Paints
Schminke-Horadam
Winsor & Newton
Old Holland Classic
Holbein
Sennelier

Coloured pencils
(not water-soluble)
Caran d'Ache Pablo
Derwent Artists
Derwent Studio
Derwent Signature
Prismacolor Verithin (USA)

Supports for coloured pencil work
Bristol board – 260gsm, very pure white surface, very smooth
HP 140lb (300gsm) watercolour papers such as Arches or Fabriano Classico
Illustration board and museum board, expensive, but good for detailed work

Suppliers
Arts & Graphics Draftline
21 Fore Street, Redruth
Cornwall TR15 2BD
Tel: +44 (0)1209 213534
www.artsand.co.uk
sales@artsand.co.uk

Dick Blick Art Materials
PO Box 1267
Galesburg, Il. 61402-1267
Tel: (USA) 1-800-828-4548
www.dickblick.com
info@dickblick.com

Falkiner Fine Papers
76 Southampton Row
London WC1B 4AR
Tel: +44 (0)207 831 1151
www.falkiners.com
info@falkiners.com

Jackson's Art Supplies
1 Farleigh Place
London N16 7SX
Tel: +44 (0)207 254 0077
www.jacksonsart.co.uk
sales@jacksonsart.co.uk

Ken Bromley Art Supplies
Curzon House, Curzon Road
Bolton BL1 4RW
Tel: +44 (0)1204 381900
www.artsupplies.co.uk
sales@artsupplies.co.uk

Polymers Plus – vellum, magnifiers
PO Box 101, Christchurch
Dorset BH23 7ES
Tel: +44 (0)1202 470783 (24-hour answerphone)
www.polymersplus.co.uk
sales@polymersplus.co.uk

Useful addresses

Eden Project
Bodelva, St Austell
Cornwall PL24 2SG
Tel: +44 (0)1726 811911
www.edenproject.com

The Lost Gardens of Heligan
Pentewan, St Austell
Cornwall PL26 6EN
Tel: +44 (0)1726 845100
www.heligan.com

South West Society of Botanical Artists
www.swesba.org.uk

UK Coloured Pencil Society
www.ukcps.co.uk.

Society of Botanical Artists
www.soc-botanical-artists.org

Eden Project Florilegium Society
www.thewagonhouse.com

Rosie Martin
www.rosiemartin.co.uk

Meriel Thurstan
www.merielthurstan.co.uk

Insurance
Free with membership:
Society for All Artists (SAA)
PO Box 50, Newark
Notts NG23 5GY
Tel: +44 (0)1949 844050
www.saa.co.uk
info@saa.co.uk

Note: Details correct at time of going to press.

Right: Be prepared to lie on the ground, climb a tree or even stand on someone's shoulders to get the right shot!

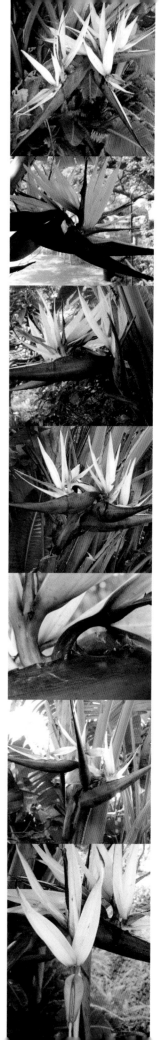

Acknowledgements

We are indebted to so many people, without whom this book would never have been written.

At the Eden Project, Carolyn Trevivian was the motivating force behind the first Diploma course in botanical illustration, when the authors first worked together. Everyone at Eden has been unendingly helpful and supportive, both towards the book and during our courses. We would particularly like to mention Mike Petty, Alistair Griffiths and Tim Pettitt for checking the text, and Kevin Austin who grew some of the interestingly coloured potatoes.

A big thank-you to our publishers, Tina Persaud, Kristy Richardson and Komal Patel, for their support and encouragement via copious emails – and a delicious working lunch.

Pam Taylor, Chairman of the Hilliard Society of Miniaturists, for her notes on vellum and ivorine; Eleni McLoughlin for her research on coloured pencils and Julie Hockin, who shared her lifelong experience of using them; Maggie Campbell-Culver who introduced us to rocket, New Zealand spinach and madder; Sylvia Sroka and Wendy Ramirez who gave willingly of their time and expertise to produce exercises for us; David Barwick and Elizabeth French who generously checked the text for inaccuracies; Peter Cowlishaw for his technical knowledge – to all of these we say a sincere thank you. If any mistakes remain, the authors are solely responsible.

All our students, past and present, at both the Eden Project and Dartington Hall, have been an inspiration and a delight to know and teach. We are honoured to be able to include many of their pictures, and hope that would-be botanical painters will be encouraged by their work.

Picture credits

Particular thanks are due to the following for illustrative material:

Lyn Aldridge 2, 5, 14, 44, 48, 80, 134 (top), 135, 137 (right), 139; **Salli Blackford** 109 (some), 129 (bottom), 132, 140; **Judith Carter** 6, 7, 45, 54, 141; **Rosemary Claxton** 63, 130; **Sue Feast** 33; **Jacqui Fenemore** 110, 111; **Pat Gabbott** 8, 9, 27, 31 (left), 59 (bottom right), 60 (top), 65, 79, 109 (some), 123; **Bobby Harbisher** 55; **Jessie Hill** 13, 26 (bottom), 34, 58, 60 (centre), 66, 76, 77, 78, 105 (right); **Lindsay Jagger** 113 (left); **David Lewry** 30, 56, 57, 60 (bottom), 62 (right), 129 (top), 133; **Rosie Martin** 15, 16, 19 (bottom), 20, 24, 52, 53, 61, 74, 81 (centre), 84, 85, 86, 89, 91 (bottom), 94, 96, 97, 98, 99, 100, 101, 102, 103, 106, 107, 112 (right), 117, 118, 124, 125; **Fran Patterson** 19 (top), 43 (left), 59 (top), 59 (bottom left), 62 (left), 105 (bottom left), 114, 115 (bottom), 116; **Edwina Pickard** 49, 119; **Wendy Ramirez** 35, 36, 37, 46 (top), 50, 68, 69, 70, 71, 87, 88, 90, 91 (top), 92, 93; **Liz Rousell** 12; **Mo Rowe** 40–41; **Sylvia Sroka** 17, 47, 72, 73; **Meriel Thurstan** 18 (left), 21, 22, 23, 25, 26 (top), 28, 29, 31 (right), 32, 38, 39, 42, 43 (right), 46 (bottom), 64, 67, 81 (bottom), 82, 83, 104, 108, 113 (right), 115 (top), 120, 121, 122, 126, 128, 131, 134 (bottom), 136, 137 (left), 138, 143; **Joyce Wilson** 18 (right), 112 (left); **Joe Yunnie** 142.

Page 10: Ms Fr. Fv VI #1 fol.123r Top row: Salt Bush and Anthora. Bottom row: Absinthium and Cardamom, illustration from 'The Simple Book of Medicines' by Mattheaus Platearius (d.c.1161) c.1470 (vellum), Testard, Robinet (fl.1470-1523) / National Library, St. Petersburg, Russia, / The Bridgeman Art Library.

Page 11: Great piece of turf – study of weeds, 1503 (w/c & bodycolour on vellum), Durer or Duerer, Albrecht (1471–1528) / Graphische Sammlung Albertina, Vienna, Austria, / The Bridgeman Art Library.

The picture on page 12 is now held in the RHS Lindley Library. The pictures on pages 42, 120 and 128 are reproduced by kind permission of the Eden Project, where they form part of the Florilegium archive.

Index